IMAGE, INQUIRY, AND TRANSFORMATIVE PRACTICE

Studies in the
Postmodern Theory of Education

Joe L. Kincheloe and Shirley R. Steinberg
General Editors

Vol. 203

PETER LANG
New York • Washington, D.C./Baltimore • Bern
Frankfurt am Main • Berlin • Brussels • Vienna • Oxford

IMAGE, INQUIRY, AND TRANSFORMATIVE PRACTICE

Engaging Learners in Creative and Critical Inquiry Through Visual Representation

Edited by
LYNN SANDERS-BUSTLE

PETER LANG
New York • Washington, D.C./Baltimore • Bern
Frankfurt am Main • Berlin • Brussels • Vienna • Oxford

Library of Congress Cataloging-in-Publication Data

Image, inquiry, and transformative practice: engaging learners in creative
and critical inquiry through visual representation / edited by Lynn Sanders-Bustle.
p. cm. — (Counterpoints; vol. 203)
Includes bibliographical references.
1. Visual learning. 2. Critical pedagogy. 3. Language arts. I. Bustle, Lynn S.
(Lynn Sanders). II. Counterpoints (New York, N.Y.); vol. 203.
LB1067.5 .I43 370.15'23—dc21 2001038901
ISBN 0-8204-5553-9
ISSN 1058-1634

Die Deutsche Bibliothek-CIP-Einheitsaufnahme

Image, inquiry, and transformative practice: engaging learners in creative
and critical inquiry through visual representation / ed. by: Lynn Sanders-Bustle.
−New York; Washington, D.C./Baltimore; Bern;
Frankfurt am Main; Berlin; Brussels; Vienna; Oxford: Lang.
(Counterpoints; Vol. 203)
ISBN 0-8204-5553-9

Cover design by Sophie Appel
Cover concept by Lynn Sanders-Bustle

The paper in this book meets the guidelines for permanence and durability
of the Committee on Production Guidelines for Book Longevity
of the Council of Library Resources.

© 2003 Peter Lang Publishing, Inc., New York
275 Seventh Avenue, 28th Floor, New York, NY 10001
www.peterlangusa.com

Printed in the United States of America

ଛୋ TABLE OF CONTENTS

ഔ LIST OF IMAGES

℘ PREFACE

Lynn Sanders-Bustle

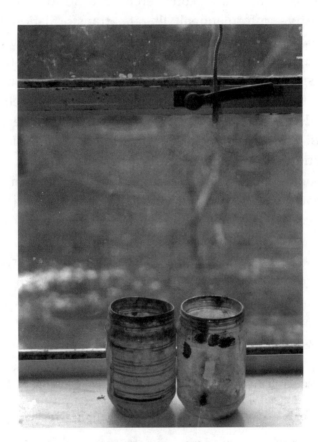

Oftentimes books open with a powerful quote or a strong opening sentence. We choose to open with an image. Take a look. Construct some questions about the image. Imagine who took it. Analyze its aesthetic qualities. What do you think it means? Does it evoke any memories? Is it art? Is it a memento? Is it a record? Is it literacy?

The intent of our book is to contribute to our understanding of image or visual representation as a form of educational inquiry and the complex interpretational web that surrounds it. It is about the power of images to engage deeply, evoke experiences and, in their creation to offer imaginary, constructive, and even transformative meaning to our lives. This work represents our inquiry as educators and researchers who are challenged by the role of image in a society that continues to function within a vast domain of images that extend beyond those that are considered artful to those that are communicative, informational, literate, transformational, and even destructive. Our objectives are threefold: (a) to examine ways that visual images can affect learning for teachers, students, and researchers; (b) to inspire educators to explore the use of visual images in their critical and creative pedagogy as well as in their personal lives; and (c) to encourage researchers to push methodological boundaries by including "multiple forms of representation" (Eisner, 1993).

This book represents our inquiry into the domain of image, a domain that is vast, varied, subjective, and ambiguous (Elkins, 1999). There is nothing tidy about the discussion of image as the careful analytical approach to its understanding shifts and crosses disciplinary borders and recreates itself through discussion. The limitation of text to describe image makes itself obvious as discussions ensue and perspectives loose their footing. Consider for a moment this definition of image provided by *Merriam Webster's Collegiate Dictionary* (Woolf, 1981):

> Image vb imaged; imaging vt 1: to describe or portray in language in a vivid manner 2: to call up a mental picture of: IMAGINE 3 a: REFLECT, MIRROR b: to make appear: PROJECT 4a: to create a representation of; also: to form an image of b: to represent symbolically ~ vi: to form an image.

This definition provides some textual constructs for thinking about image as well as necessary ambiguity to encourage further exploration. In a literal sense image is a "visual representation of" such as a child's tempera painting, a photograph, or graphics on a computer. It may be an image created in our minds through language

"portrayed in a vivid manner" such as the rich images depicted in an Elizabeth Bishop poem. And, as part of the word, *imagine*; image offers the unyielding power to envision alternative and possible worlds. Maxine Greene (1995) encourages educators to look toward the artful qualities of image as a means for releasing imagination and transforming lives.

> The role of imagination is not to resolve, not to point the way, not to improve. It is to awaken, to disclose the ordinarily unseen, unheard, and unexpected. (p. 28)

We have chosen to focus on images as literal visual representations. We use the phrase, "visual representation" to get at the literal interpretation of image and to avoid alignments with disciplines. Oftentimes "images" are linked automatically with the visual, arts, and although an important member of the larger domain, we feel by using the term "visual representation" we expand considerations for its use as both artistic and informational. In fact, Elkins (1999) points out that "most images are not art. In addition to pictures made in accord with the Western concept of art, there are those made outside of the West or in defiance, ignorance or indifference to the art" (p. 3). Like text, the arts have historically identified bodies of knowledge and works that have been considered accepted whereby limiting access and participation in their own way. It is our hope to remove parameters associated with past approaches to the study of image and to open up possibilities across disciplines.

The challenge for us as authors is greater than defining image and even much greater than theorizing, complicating, or challenging its existence among disciplines. The real challenge is to actively explore the interpretive nuances of images as they relate to educational landscapes and the lives of our students. We do so in this anthology by pulling from a range of theoretical perspectives that include literacy, social reconstruction, creative, and critical theory to make a case for images as powerful tools for inquiry. Authors describe and critique how they used images, within a process of inquiry, with students of various ages and backgrounds to evoke personal

interpretations, deconstruct cultural messages, examine processes of oppression, and imagine alternative ways of acting in the world. Each reviews specific methodological and pedagogical strategies they have employed in their work with students.

Before providing a brief synopsis of each of the chapters in the book, I feel it is essential to the understanding of the entire book to communicate the history behind its creation. The pulling together of this book is no accident. It is not the result of call for papers. It is the result of years of conversation and research surrounding visual representation. As friends and colleagues working in different disciplines we have spent a great deal of time discussing varied aspects of image from a range of perspectives that include literacy, the arts, physical education, social reconstruction, and special education. In addition to a shared interest in visual representation, we all recognize the important role that image might play in a larger process of inquiry.

As you read/view, you will get a sense of the strong personal connections we as authors have to our work. We make no separations between personal experience, our research, or our work as educators. Therefore, much of this work has required us to continuously explore what Greene (1994) refers to as our "self-formation."

> Numerous people in education are recognizing the importance of coming in touch with the patterns of their own self-formation if they are to find connection points with other human beings whose memories may link with theirs at certain junctures and perhaps, seem alien at others. (p. 14)

Experiences woven into our self-formation find their way into the work represented in individual chapters as well as the collective work of this book. Understanding our self-formation has better enabled us to reveal "connection points." So, it makes sense that I will begin by recounting aspects of my "self-formation," while showing how my work and the work of other authors have intersected over the years.

Self-Formation and Intersections of Inquiry

My self-formation finds me straddling the fields of art and literacy: one leg locked in my work as an art educator and the other more

recently placed in the field of literacy. It was my work as an art educator that led me to the interesting intersection that exists between literacy and the arts. Certainly, early experiences as a young student in the 1960s and the 1970s presented me with a less than passionate picture of language. Language at the time of my schooling was devoid of creative spirit, dissected, and diagrammed. I was taught to satisfy grammatical examinations rather than to experience rich and powerful forms of expression words could embody. Words were only text, segmented notations, not colors and textures to be tasted, tried on, absorbed. If recollection serves me well, we never moved beyond the rules of language to experience the art of language.

In contrast, my experiences with visual arts provided me with personal and expressive forms of communication. As an art student, I was expected to express myself in my work. If I did not do so, my work was flat, passionless, and stale. I did not understand that I could apply the same passion to words. Art and language remained separate. I could be an artist, not a writer. Writers knew grammar, were readers (which I did not do as a child), capable of speaking with important sounding words, articulate orators, and good spellers. By contrast, artists were free-spirited, emotional, and creative. They were supposed to be different.

So, it follows that I finished art school and became an art educator. For over 8 years, I taught art in the public schools working with all grade levels at over 25 schools as an itinerant and full-time teacher. During my experiences, I was heavily involved in many interdisciplinary units. I became fascinated with intersections that existed between the arts and other disciplines. These intersections existed naturally as learners found creative ways to learn across content areas.

> In the midst of integrated curriculum activities, I began to take a hard look at what my students were doing. My classes were active and fully included. They were messy, dusty, and smelled of papier-mâché, but most of all, students wanted to be there and to create. (Bustle, 1996, p. 3)

Over the years, I slowly crafted ideas about teaching and learning that inspired me to carry an artistic perspective to graduate school.

My doctoral work in the 1990s reaffirmed my ideas and challenged me to articulate beliefs within the larger framework of literacy. I found literacy studies to be a comfortable, yet challenging place to be. I brought with me the tools of my trade—expression and creativity. My introduction to language "arts" hinted at the connections I would later explore. Learning about whole language and poetry helped me make the connection between language and the visual arts. Educators such as Calkins (1994), Atwell (1990), Harwayne (1992), and countless others helped me view language learning as a holistic process rather than a fragmented one to be dissected at the risk of losing expression. Instead, language became an art form—something to be shaped and, created and most important, something that is personal, challenging, and risky. Instead of feeling at odds with language, I became enamored with its creative potential.

I had opportunities to write with the same passion I painted, often splattering words, commas, and sentences across a page. I wrote in sharp staccatos, enjoying a short gasp, a winding idea, or the perfect word. I fought (and still do) to make this rhythmic form of writing legible to others. Weaving pieces of myself into stories, I uncovered remnants of art elements—line, shapes, color, texture—in between the lines of text. Like heavy paint on a palette knife, I wrote clumsy passages. I sputtered and restarted, abusing commas, splicing, and occasionally nicking my finger. I was hooked. I had begun to discover the creative qualities of language and began to make natural connections with the visual arts.

My inquiry into the intersections between language and the arts was encouraged as a student in Rosary Lalik's reading research seminar, in which she used an inquiry approach to help each of us better understand literacy within our own lives. Using narrative as a starting point she asked each of us to write our on literacy stories. As I had not written many stories, I returned to my past to pull out a moment that I felt the most illiterate. Coupling illiteracy with a feeling of inadequacy, I carefully reenacted a middle-school incident in my music class through story. I actually enjoyed the play of words and the creation of an image of my experience through language.

Interestingly enough, it was a music experience that I wrote about in my literacy story. What I learned about my own literacy was not represented in the context of the story per se; rather, I had learned about my literacy through the creative process of writing the story. It was the process of creation and the personal connection I was allowed to make that helped me learn about literacy.

In addition to this story, I was able to create what Rosary described as a representation of literacy research. Much to my surprise, this representation could be visual. I embarked on the careful creation of a painted window collage composed of polymer lifts representing artwork through the ages that related literally and figuratively to literacy. This project forced me to pull together new ideas with a medium with which I had long been associated. Her acceptance of this project as a literacy representation encouraged me to explore the connections between image and literacy further.

While a student in Rosary's class, I met Liz Altieri, a doctoral student whose background was special education. Like me, she did not come from a "reading" background, yet she found her connections easily with literacy as a powerful device for meaning making. She, too, explored the powerful potential of story and image as a means for disrupting common views of disability. Liz also saw the potential for an expanded conceptualization of literacy that tapped into the power of story and images. She was particularly interested in how cultural images of disability shape beliefs, personal interactions, and educational practice. As our doctoral work progressed and our research developed, we explored narrative inquiry as a research methodology that might allow us to incorporate images into our work. Despite varied responses from committee members, we remained committed to better understanding image. We explored "image" as a viable research focus only to find challenges with conceptions and valid research methodologies. These challenges remain with us.

It was also during this same time that I met Kim Oliver in an educational philosophy class. Kim was a physical education major; yet again, we found connections between our work. Probably most

significant was the fact that over the next two years we shared connections in conversations that occurred during our 45-minute daily runs. During our running sessions, Kim and I often discussed the significance of image, story, narrative, and research in our personal and professional lives. By this time, our research had taken shape. Kim's research included working with adolescent girls to better understand how they experienced their bodies. My research had now centered on pre-service teachers' use of image, more specifically photography, to understand literacy. Our running became a moving forum for discussing our research as well as personal challenges. In fact, our continued conversations while running prompted us to consider movement as an alternative sense-making device for understanding i.e., the body narrative (Bustle & Oliver, 2001).

Connected Inquiry

Over time, these connections nurtured friendships, illuminated shared interests, and impacted our research and our teaching in profound ways. We talked of literacies, images, representations, stories, and inquiry. We constantly questioned our practice as teachers. We talked into the late night edges of imagination, possibility, and transformation knowing that images—literal and figurative—had impacted our lives in powerful ways. What transpired was this collective attempt—this book—to share our inquiries.

In Chapter 1, I explore how preservice teachers use photography as a tool of creative inquiry to better understand literacy—in essence, to create a revised "literate image" or personal understanding of literacy (Bustle, 1996). I discuss image as not only a representation or object but also as the result of a process of creative exploration called creative inquiry. Creative inquiry is introduced as a process of inquiry that includes creation, representation, and interpretation as key considerations for a more holistic understanding of visual representations. Using creative inquiry as an interpretive framework I carefully considered the following: (a) the lens or lived experiences

students brought to their inquiry; (b) the students' process of picture-taking as described through language; and (c) their interpretations of the photographs. An examination of this process was supported by language-related engagements such as written reflections and dialogue as well as the photographs themselves. Finally, I show how image impacted student inquiry by: (a) reaffirming and extending prior knowledge; (b) providing a process for "capturing" immediate physical and social environments; (c) functioning as ambiguous prompts for reflection; and (d) helping students redefine their roles as future literacy educators. Such is the re-creation of one's self as a literate person. Such is the re-creation of one's self as a teacher.

In Chapter 2, Kim Oliver takes a critical look at how girls construct the meanings of their bodies, where and how they resist oppressive forms of enculturation, and how teachers can help nurture girls' resistance. She reveals how she uses teen magazines as a methodological research tool and a curricular technique to: (a) help girls reveal meanings about the body that were difficult to express through written or verbal discourses; (b) help girls name oppressive and empowering images of the body within adolescent culture; and (c) encourage critical critique of these visual images with an emphasis on how they are helpful and/or harmful to girl's health and well-being. The data she shares includes the representation of images as well as the girls' critical interpretations of these cultural icons.

Continuing in the spirit of critical inquiry, in Chapter 3 Rosary Lalik explores how two topics—homelessness and literacy—come together in her teaching. Relying heavily on the use of photographs and other forms of visual representation in her teaching, images and artistic processes have been central in her thinking and doing as a literacy educator. Here, she considers ways in which she has used image within an inquiry model of teaching with preservice teachers to evoke students' interests in the topic of homelessness as well as their development as literacy educators. Rosary reveals her struggles to help students experience and construct expanded conceptualizations of literacy and literacy teaching—conceptions often ignored in mainstream discourse about schooling and learning—conceptions

that center on social justice and personal and social transformation.

In Chapter 4, Liz Altieri describes the process she has used to enhance pre-service teachers' understanding of the social construction of disability and its effect on the development of services for people we call disabled—in particular, institutional facilities and segregated educational programs. Students participate in a semester-long, intensive inquiry that is both personal and critical in nature, and the product of this inquiry is an *Images of Disability Portfolio* (Altieri, 1998; Winzer, Altieri, & Larsson, 2000). Over the past six years, Liz has been engaged in a long-term teacher research project that examines the extent to which students' inquiries help them: (a) bring to consciousness and reflect on their beliefs about disability and ability; (b) understand how cultural images of disability shape their beliefs and interactions; (c) come to know disability in new ways; and (d) learn to perceive/imagine the gifts, capacities, and unique potential of individuals with disabilities to actively participate in the life of our communities and to contribute to our own lives. In her chapter, Liz describes the impetus behind her research, and how it continues to transform her as a teacher and teacher educator. She looks in detail at one of the portfolio activities, an assignment using the photographic essay *Christmas in Purgatory* (Blatt & Kaplan, 1974) and shares with us a representative sample of students' creative and critical responses to its disturbing images.

In Chapter 5, I explore the "value" of the visual by examining the role of visual representation in assessment and evaluation. Today, assessment and evaluation lie at the forefront of educational and political debates (Kohn, 2001). Given this trend, I have felt driven to take a closer look at the use of visual representation in schools as well as their role in the assessment and evaluation of learning. Certainly visual representations of all kinds are used across the curriculum for a variety of purposes, yet little is known about how they are valued by teachers or how they are assessed or evaluated. This chapter represents the beginning of an inquiry to: (a) better understand how these four middle-school teachers conceptualize and use visual representations in their classrooms, and (b) to examine the role of

visual representation in assessment and evaluation. Through this research, I hope to encourage educators at all levels to reexamine how and why we use visual image in our own teaching and to consider ways that we can make the use of visual image more "valuable" for all learners.

The Dilemmas of Representing Image

A commitment to the examination of promising frontiers of better understanding image reflects the spirit of this book. It pays tribute to educators and researchers who have "the courage to transgress boundaries" (hooks, 1994) in their practice and dare to work on the edges of "productive ambiguity" as researchers (Eisner, 1997). Given that text in the traditional sense is still largely privileged in the representation of research, we continue to search for fuller ways to represent image in research. Although challenged, we are not frightened by the ambiguities of image and feel that bridges can be constructed between qualitative research paradigms that are largely textual in nature and those less traditional, fixed representations such as image.

Those researchers who experiment at the boundaries continue to inspire our efforts. They include such pioneers as Elliot Eisner who challenges researchers to explore alternative forms of data as a means for getting at what he refers to as "productive ambiguity," where "the material presented is more evocative than denotative, and in its evocation, it generates insight and invites attention to complexity" (p. 8). We have been influenced by those researchers who put thought into action by using alternative research formats such as Ellis (1997) whose evocative autoethnography "adds blood and tissue to the abstract bones of theoretical discourse" (p. 117), and Patty Lather (1997) whose "mosaic, multilayered text" is designed to "interrupt the reductiveness of the restricted economies of representation" (p. 234). Our challenge is to add *image* to the line of alternative formats with which researchers represent their work. This approach certainly dances on the edge of experimentation, and it has presented daunting challenges to us as authors, both in the representation and publication stage. However, we have remained committed to our quest to create a

book about image that includes image. This book is a flight beyond the textual while condemned by the textual, challenged by boundaries yet liberated by hope and shaped by imagination. As you participate in this book as a reader/viewer, take the opportunity to add an interpretive layer to what is represented and to consider your own flights into the possibility that visual representation might offer.

References

Altieri, E. (1998). Using literacy activities to construct new understandings of disability. *National Reading Conference Yearbook, 47,* (pp. 529–541). Chicago: National Reading Conference.

Atwell, N. (1990). *Coming to know: Writing to learn in the intermediate grades.* Portsmouth, NH: Heinemann.

Blatt, B., & Kaplan, F. (1974). *Christmas in purgatory: A photographic essay on mental retardation.* New York: Human Policy Press.

Bustle, L. (1996). Literate images. *Reading in Virginia, 30,* 1–5.

Bustle, L., & Oliver, K. (2001). The role of physical activity in the lives of researchers: A body narrative. *Studies in Philosophy and Education: An International Quarterly.* Dordrecht, The Netherlands: Kluwer Academic Publishers.

Calkins, L. (1994). *The art of teaching writing.* Portsmouth, NH: Heinemann.

Eisner, E. (1993). Forms of understanding and the future of educational research. *Educational Researcher, 22* (7), 5–11.

Eisner, E. (1997). The promise and the perils of alternative forms of data representation. *Educational Researcher, 26* (6), 4–9.

Elkins, J. (1999). *The domain of images.* Ithaca, NY: Cornell University Press.

Ellis, C. (1997). Evocative autoethnography: Writing emotionally about our lives. In W. G. Tierney & Y. S. Lincoln (Eds.), *Representation and the text: Re-framing the narrative voice* (pp. 115–139). Albany: State University of New York Press.

Greene, M. (1994). The need for story. In A. H. Dyson & C. Genishi (Eds.), *The need for story: Cultural diversity in classroom and community* (pp. 11–27). Urbana, IL: National Council of Teachers of English.

Greene, M. (1995). *Releasing the imagination.* San Francisco. Jossey-Bass.

Harwayne, S. (1992). *Lasting impressions.* Portsmouth, NH: Heinemann.

hooks, b. (1994). *Teaching to transgress: Education as the practice of freedom*. New York: Routledge.

Kohn, A. (2001). Fighting the tests: A practical guide to rescuing our schools. *Phi Delta Kappan, 82* (5), 349–357.

Lather, P. (1997). Creating a multilayered text: Women, AIDS, and angels. In W. G. Tierney & Y. S. Lincoln (Eds.), *Representation and the text: Re-framing the narrative voice* (pp. 233–258). Albany: State University of New York Press.

Winzer, M., Altieri, E., & Larsson, V. (2000). Portfolios as a tool for attitude change. *Rural Special Education Quarterly, 19* (3/4), 72–81.

Woolf, H. (Ed.). (1981). *Miriam-Webster's New Collegiate Dictionary*. Springfield, MA: G&C Merriam Company.

℘ ACKNOWLEDGMENTS

Learning is a social act. We acknowledge this as teachers, researchers, and colleagues who understand the importance of relationship. This book is born not only of years of research but of interactions with others who have inspired ideas, encouraged questions, and participated in the marvel of inquiry along with us. It is a collection of both text and images made public due to the generosity of a host of people.

As researchers, we are indebted to participants in our studies for the courage to talk with us, share their thoughts, perspectives, and experiences. Participants in the varied studies represented in this book, include our students, young people, and practicing teachers. We greatly appreciate their time, insights, and glimpses into their experiences. For their contributions to Chapter 1, I want to thank my former students, Beth Alessi, Angie Bowman, Jennifer Boyce, Molly O'Hara, and Kelly Hudson. Their personal explorations of literacy offered many insights into the role of photography and the power of inquiry. Also we are indebted to outstanding educators such as, Donna Logan, Nora Kenney, Susan Mauney, and Linda Olin, whose innovative teaching practices are represented in Chapter 5. My growth is not without their willingness to open their classrooms and share their time, knowledge, and encouragement. Without educators such as these, this kind of research lacks meaning and purpose.

Additional thank yous go out to those whose contributions have impacted specific chapters. In Chapter 2, we thank Wei Bien for the helping with image preparation, David Kirk for providing critique on

an earlier draft of the draft; and The College of Education and the Research Advisory Committee at the University of Alabama, which funded research represented in her chapter. We are grateful to Taylor and Francis, Ltd. *www.tandf.co.uk/journals* for granting us permission to reprint *Images of the Body from Popular Culture: Engaging Adolescent Girls in Critical Inquiry* which appears as Chapter 2 by Kim Oliver. The article was first printed in 2001 as an original source in the sixth volume of *Sport, Education, and Society.*

In Chapter 4, we thank Steven J. Taylor, Director of the Center on Human Policy, and the Human Policy Press, for permission to reprint the photographs from *Christmas in Purgatory.*

We are indebted to Peter Lang Publishing for giving us the opportunity to represent a body of research that we hope will inspire others to consider possibilities for images in their own work. Personally, I want to thank the Chris Myers and Jacquline Pavlovic at Peter Lang for their patience and expertise, and Joe Kincheloe and Shirley R. Steinberg, General Editors of the Counterpoints Series.

And, as editor, I especially want to thank contributing authors, Liz Altieri, Rosary Lalik, and Kim Oliver, for their contributions to the vast field of image. Their pioneering spirit and their endless passion for learning will always inspire and challenge others. As colleagues and friends each has added a striking facet to the shape of this work.

Special thanks to Liz Altieri and Ben Altieri Hiltonsmith for their tireless efforts transforming this manuscript into a camera-ready document. Their devotion to the project evolved largely from their commitment to producing a publication that would reflect the imagic integrity of our work.

And certainly, last but not least, as always, I am indebted to the members of my family who survive the process along with me. Their steadfast tolerance, devotion, and love give me the footing I need to engage in this and continued work.

✧ INTRODUCTION

Theoretical Explorations of Image and Inquiry

Lynn Sanders-Bustle

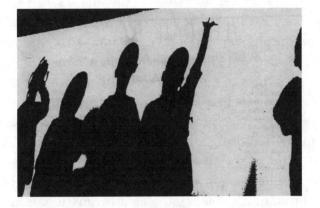

Visual images are no longer banished to the realms of the art world, restricted to the confines of visual literacy, or neatly shoved aside to provide room for the often considered "basics" of teaching and learning. Rather, images have become a basic cultural phenomenon—a ubiquitous and influential aspect of the current age.

> Images in our world today cannot be overstated. We are influenced, taught, and manipulated by all kinds of visual information, including television, computers, signs and symbols, advertisements, body language, and motion picture films. (Hortin, 1994, p. 5)

Given the profound existence of image in our culture, educators must reconsider the forms of representation that dominate sense making into today's world.

Defining *Image*

As introduced in the Preface, the construct we call *image* includes broad interpretations that range from literal images to those that are

"confined to the realm of imagination." Leppert explains,

> Indeed, what images represent may otherwise not exist in "reality" and may instead be confined to the realm of imagination, wish, desire, dream, or fantasy. And yet, of course any image literally exists as an object within the world that it in some way or another engages. (1996, p. 3)

Furbank (1970) recounts the history of the word *image* and discusses its ambiguous nature and broad uses. He points out that, when defining image, one must consider whether the word is used literally as a picture, painting, or photograph, or as a mental picture or a metaphor.

In this book, we refer to images in the literal sense as visual representations. They may take the form of a work of art such as a painting, a photograph, or a glossy magazine advertisement. Yet, we believe that the power of image lies not so much within the borders of a canvas or the edges of a photograph; rather, it lies in images' capacity to engage viewers in a process of interpretation that begins with seeing. This interpretive process is fraught with ambiguous and subjective qualities that bring with them a web of considerations that include the creator's intent, the creative process itself, the representation (the image), and the viewer's interpretation. Add to all of this the limitations of language as a means to communicate, and understanding and interpretation become at best a web. The line between text and image blur as understanding emerges. Leppert reminds us, "We cannot escape the web of representational devices—they are what allows us to make our way in the world" (1996, p. 5). Nor would we want to. What we hope to do is to better understand the multiple threads that make up the web of representational devices that currently privilege some strands over others.

The interpretive quality of image has been explored by many across disciplines. John Berger (1977) defines image as

> sight which has been recreated or reproduced. It is an appearance, or set of appearances, which has been detached from the place and time in which it made its first appearance and preserved—for a few moments or a few centuries. (p. 9)

As an object, an image is a reproduced segment of time and place,

which, as a physical object, remains static in many ways. Leppert (1996) explains, "Images show us *a* world but not *the* world itself. Images are not the things shown but are representations thereof: representations" (p. 5). For example, a picture of a paint jar is not the jar itself. Rather, it is a re-presentation of an object that is named a jar. As explained in the Preface, we use the words *visual representation* and *image* interchangeably throughout this book. Images are visual representations, which are defined by Eisner (1994) as just one of many "devices that humans use to make public, conceptions that are privately held. They are the vehicles through which concepts that are visual, auditory, kinesthetic, olfactory, gustatory, and tactile are given status" (p. 39).

Eisner's definition suggests that an image is the result of a constructive process. They are created by humans to make their ideas public.

> When we look at images, whether photographs, films, videos, or paintings, what we see is the product of human consciousness, itself part and parcel of culture and history. That is, images are not mined like ore: they are constructed for the purpose of performing some function within a given sociocultural mix. (Leppert, 1996, p. 3)

Due to their constructive nature, images function as one person's representation of understanding or, as Berger explains, "Every image embodies a way of seeing" (1977, p. 9). This would lead one to believe that images may offer insights into the mind of the creator, further complicating understanding by the viewer.

Interpreting Image

The public nature of visual representations invites additional layers of interpretation. Just as text invites a reader to interpret prose, an image invites a viewer to interpret visual symbols. To look at image is a constructive event in itself, a reading of sorts whereby the viewer tries to comprehend what the photograph means. This is similar to how readers transact with text as described by Rosenblatt (1978) in reader response theory.

> The reader brings to the work personality traits, memories of past events, present needs and preoccupations, a particular mood of the moment, and particular physical conditions. These and many other elements in a never-to-be-duplicated combination the response to the particular contribution of the text. (pp. 30–31)

Dennis Dake (1995) proposes a "viewer response theory that would move the focus of attention away from the visual object and toward the viewer and their transactional bargains with the object" (p. 10). With this in mind, we recognize that interpretation of a visual representation is greatly impacted by the lived experiences of the viewer, or the experiences a viewer brings to the image.

It is also important to remember that other forms of representation such as language may impact interpretation. Elkins (1999) describes two common conceptions that pose challenges for interpretation.

> One is the impossible ideal of the "pure picture" (the image unsullied by writing or any verbal equivalents, either in the object or in its interpretation): It gives meaning to concepts such as visuality, "visual meaning," and cognate terms, and it animates histories of naturalism and illusion. The other is the ideal—equally impossible in practice—of the picture as a substitute for writing, and hence a carrier of determinate meaning. (p. 55)

This would suggest that the interpretation of an image may be impacted by other forms of representation, distorting the original intent of the creator while adding new interpretational layers.

The Functions of Image

Perhaps it is the complex interpretive quality of images that make them so intriguing, artful, creative, constructive, destructive, and even seductive. Like other powerful visual forms of representation such as television, technology, or film, we are seduced by both the productive and destructive qualities of image. As Shannon explains, images can function as "both a weapon and a tool" (1995, p. 63). Susan Sontag (1977) warns of the danger of images to "transfix" or "anesthetize" (p. 20). The constant onslaught of images can anesthetize rather than raise awareness and compassion. Pornography is one example. "The shock of photographed atrocities wears off with re-

peated viewing just as the surprise and bemusement felt the first time one sees a pornographic movie wears off after one sees a few more" (Sontag, 1977, p. 20).

Less shocking, yet equally as significant, is our day-to-day immersion with what Berger refers to as "publicity images."

> Publicity images are one of the most prolific forms of image with which we are confronted. No other image confronts us so frequently. In no other forms of society in history has there been such a concentration of images such as a density of visual messages. One may remember or forget these messages but briefly one takes them in, and for a moment they stimulate the imagination by way of either memory or expectation....We are now so accustomed to being addressed by these images that we scarcely notice their total impact. (Berger, 1977, p. 129)

Among publicity images are those used in advertising whose purpose "is not biased or neutral. It [the image] specifically exists to get us to do something that we might otherwise not do. It promises future happiness, though by trying to make us dissatisfied with our past and especially, with our present" (Leppert, 1996, p. 3). The impact of cultural images of the body on women's and girls' sense of self is an excellent example. In response to the portrayal of the female body in glossy fashion magazines, young girls and adult women have gone to extreme lengths to control, starve, alter, and mutilate their bodies in hopes of obtaining the perfect body—obtaining happiness.

While cognizant of the destructive qualities of image, I remain enamored by the ability of images to arouse sympathy and action: to give voice, inspire change, and raise awareness. This use of image can be seen as early as the 1890s in Riis and Hine's documentary depicting impoverished lifestyles of New York slums (Curry & Clarke, 1978; Stasz 1979; Sontag, 1977). During the Depression, the Farm Security Administration funded the photographs of Walker Evans and Dorothea Lange. The profound depiction of tenant farmers and their families turned a fresh eye on some of America's worst living conditions (Agee & Evans, 1936). In 1966, in an attempt to "strike a chord of awareness" and incite public action toward the improvement of the treatment of those with disabilities, Burton Blatt and photographer Fred Kaplan (1974) created a startling photographic essay, entitled

Christmas in Purgatory. The book depicted scenes from institutions for the mentally handicapped that revealed images of "dirt and filth, odors, naked patients groveling in their own feces, children locked in cells, horribly crowded dormitories, and understaffed and wrongly staffed facilities" (Blatt & Kaplan, 1974, p. v). On the completion of their essay, Blatt and Kaplan responded in this way:

> Our Christmas in Purgatory brought us to the depths of despair. We now have a deep sorrow, one that will not abate until the American people are aware of—and do something about—the treatment of the severely mentally retarded in our state institutions. (p. vi)

In contrast, Annie Leibovitz and Susan Sontag (1999) recently collaborated on a photographic essay entitled *Women* in which they represented today's women as a diversely rich spectrum of unique individuals. Sontag (Leibovitz & Sontag, 1999) exclaims, "this is what women are now—as different, as varied, as heroic, as forlorn, as conventional as unconventional as this" (p. 20). Images such as those presented in this volume counter oppressive and even conventional images of women offering up a stronger more varied image of what it means to be a woman. "Just as photography has done so much to confirm these stereotypes, it can engage in complicating and undermining them" (Leibovitz & Sontag, 1999, p. 35). These photographs, artful and diverse, represent the productive and critical role that image can play in reshaping culture.

The Power of Image

Images are powerful in their own right, yet our response and reaction to what they represent in our lives might be the most important aspect of their viewing. Perhaps more powerful than the viewing of image is our capacity as human beings to better understand their potential for transformation in our lives and the lives of others. In essence, we must ask, "What do we do in response to images?"

This question has never been so evident for so many given the events of September 11. Many of us have been forced to examine our role as educators within "the bigger picture" of a world event that dealt a heart-stopping blow. This event launched all of us into per-

sonal inquiries that forced us to reconsider "how those of us charged with the task of teaching help to shape its (the world's) making and understanding" (Sullivan, 2002, p. 107).

Like many other educators, I was faced with the task of meeting with my art education students the afternoon following the event that has come to be known as 9/11. *Images* of planes plowing through skyscrapers were fresh in my mind. I use the word *image* purposefully because partly it was the repeated *viewing* of this scene and others that caused my heart to sink and my stomach to ache.

Sullivan (2002) described her reaction in this way:

> It is hard not to see September 11, 2001 as a frozen moment. A snapshot heard around the world. In the minds of many it was a defining time when "everything changed". The freeze frame of hypnotic slow motion sharpened the edges as much as blurred boundaries. While the initial disbelief found voice in an 'us and them' reaction, later calls understandably urged us to keep an eye on the big picture. (p. 107)

I thought about images that were frozen in my mind and how unsettling it was that I watched such an act unfold. I thought about how images of this event would be reproduced, revisited, and consumed in the coming months. Much would be written, but even more would be viewed. That which was viewed would terrify. Most importantly, I wondered how we would make sense of these images as they replayed through our minds. What would we do with all of these images? How would we react?

Like other educators, I thought carefully about what I would say to my students that afternoon. I was full of questions. This new line of inquiry had demanded my attention. Searching for a place to start, I now had stinging visual reminders of where we are as a world and I needed to make sense of these images within my experiences as an educator. What does one say? Are there words for such things? What do we do with these images? I felt as an educator it was my duty to provide answers: to somehow find hope. I asked myself, "What kind of hope comes out of such devastation?" Like always, I used multiple lenses to calibrate what now were racing thoughts.

As an art educator, I looked toward the arts as a means for inspir-

ing hope and creating a better world through our ability to imagine "a better order of things." I wanted to believe that images—even these horrific images—might provide some direction if critically explored. Greene (1991) suggests that we look toward powerful visual representations as a means for seeing, feeling and transforming our world.

> like guerilla fighters being executed in *Disasters of War*, like the photographs of scenes from the Holocaust, there are images and figures that speak directly to our indignation, to some dimension of ourselves where we connect with others. They open our eyes, they stir our flesh, they may even move us to try to repair. (Greene, 1991, p. 8)

The power of image lies in seeing as more than a cognitive act of recognition. There is a felt quality to our engagement with images that "stir our flesh." Greene challenges us to interpret images—good or bad—creatively and critically with the intent of reconstructing and even repairing existing situations.

As an artist, I "summoned up" my own images of what ought to be. I used creativity and imagination as clues for the creation of a better world. I looked toward powerful representations of our past and current culture, such as Picasso's *Guernica*, that might inspire me and others to put new ideas to action. I thought about the word *image* embedded in the word *imagination*. I considered the risk of imagining something that many may feel is unconceivable, not logical, impossible, impractical, or unreachable. I would need to move beyond that which is traditional, status quo, and even standard. I believe in the capacity of the arts in the broadest sense of the word to provide creative, critical, and transformative possibilities for all people.

Next, I imagined what literacy education in our world ought to look like. Intrigued by the imagery of words, I asked my own questions about similarities, differences, and, most importantly the power of image regardless of its form: whether images crowned in the vast halls of art galleries across the world, or children's drawings on what I called as a child, "vanilla" paper, or the sentiently descriptive words found in an Elizabeth Bishop poem. Image has the power to move from one soul to another—textually or visually. It does so because of

its ability to make meaningful personal connections and to cross diverse boundaries that often lie gaping because of obsessions of power that often keep a strangle-hold on that which is defined as knowledge and those who are considered knowledgeable. There is more to literacy than text. There is more to image than objective representation. There is a "bigger picture" that calls for our understanding.

We are challenged to move beyond that which is ugly and destructive and to not lose sight of the "bigger picture." Constant attention to an ever-evolving bigger picture liberates us from the confines of exclusive parameters and frees us as educators to explore possibility. Perhaps this is what we want for our students. A liberation of sorts from ill-defined histories that dictate learning and ultimately shape the quality of our lives and the lives of others. A liberation from monistic views of culture that make distinctions between that which is valued and that which is not, or who is valued and who is not. Who is literate? Who is artistic?

My head swimming, I left home and went to class.

Image and the Task of Educational Transformation

Viewing image as an essential component of the curriculum will require a major shift in the thinking of educators. It will require new and very different inquiries to take place, new strategies to be considered, and a careful exploration of and reaction to a culture that continues to pluralize itself in many aspects. Education at all levels and disciplines must begin to explore the possibilities and challenges visual images offer and continue to evolve to meet these challenges (Eisner, 1984, 1993; Hargraeves, 1994; Hobbs, 1999; Messaris, 1997). In order for visual representation to play a significant role in learning, all members of the educational community will need to question existing beliefs about curriculum and instruction, and possibly break free from some traditional conceptualizations and practices that have lost their resiliency over time.

As the applications of image-based media in both homes and workplaces continue to expand, there is a growing realization that our educational system needs to do more in the way of preparing young people to deal effec-

tively with nonverbal modes of communication—not at the expense of ver-
bal language but as a necessary complement to it. (Messaris, 1997, p. 3)

Understanding is no longer limited to text, nor is it relegated to the pages of books, which are traditionally read from left to right. Understanding information on a computer screen includes the reading of images as often as it includes the reading of text. In many instances images have started to replace traditional texts where information is delivered in bold bytes of information that includes hyper-visuals. Navigated by learners, hypermedia is a network of "linked bodies of materials that include static graphics, animated graphics, still and motion video, sound, and music" in addition to text (Tucker & Dempsey, 1991, p. 5). Technological advancements integrate image with multiple contexts of sound, other images, speech and text releasing what Lister refers to as "multiple, alternative, radical, and unexpected meanings" (p. 323). Instead, "new digital media, in their interactive, multimedia forms, are being celebrated for their capacity to generate polysemic meaning which involve the viewer's active participation" (Lister, 2000, p. 323). Meaning is created from a mix of representations that are not exclusively text, not exclusively image but rather a polysemic technopodge of the two.

This blending of forms is constantly at play in the dominant forms of media represented in today's culture. As a result, film, television, and other forms of mass media offer new challenges for teaching and learning that include a clearer understanding of media literacies as explored in media studies. "Media studies focus on the critical deconstruction of media texts such as print and imagery in popular magazines, TV programs and advertising, movies, billboards, and related forms of media representations" (Luke, 2001, p. 1). I would argue that these are literacies of a new time and they should be considered and valued as "basic" in schools today. Historically, education has valued traditional modes of communication such as reading and writing over other forms. These modes of understanding carried great weight in a world that was at one time limited to textual devices of communication such as books and even radio. However,

changes in communication technologies over the past 100 years have created

a cultural environment that has extended and reshaped the role of language
and the written word. Language must be appreciated as it exists in relation-
ship to other forms of symbolic expression—including images, sound, music
and electronic forms of communication. (Hobbs, 1997, p. 2)

It makes sense as our world continues to change in such drastic
ways that educators reconsider the role of visual representations in
educational venues as well.

Given this view, images have begun to negotiate their way across
disciplinary borders while educational researchers propose new theo-
ries that include multiple notions of sense-making such as multiple
forms of representations (Eisner, 1993, 1994), sign systems (Short &
Burke, 1996; Leland, Harste, & Helt, 2000), multiple ways of knowing
(Leland & Harste, 1994), multiple intelligences (Gardner, 1983), semi-
otic systems (Albers & Murphy, 2000), alternative ways of knowing
(Sweet, 1997; Cecil & Lauritzen, 1994), and multiple symbol systems
(Tierney, 1997), and multiliteracies (New London Group, 1996). Many
of these conceptualizations have evolved in literacy research. This is
important because literacy (traditionally defined as reading and writ-
ing) has long enjoyed a central place in curriculum.

By contrast, image (traditionally aligned with the arts) has long
been undervalued and relegated to the margins of the curriculum. In
essence we are asking educators to embrace a modality commonly
associated with the arts—visual representation—as a primary sense-
making device for our time. It remains to be seen what role visual
representations and the arts will play in curriculum in the future and
just how they will be incorporated into the curriculum. Although
many educators use visual images in their classrooms, their real value
comes to bear as policy makers and politicians continue to standard-
ize learning largely depending on traditional meaning making proc-
esses to indicate intelligence.

Despite pluralistic and inclusive views, today's public schools are
being pressured more and more to measure the success of their stu-
dents through standardized testing rather than through a student's
capacity to construct knowledge. As a result, many students choose
"not to learn" (Kohl, 1994) to protect qualities of their life experiences
that define "their histories, cultures, and day-to-day experiences"

(Freire & Macedo, 1987, p. 121). Because most standardized tests largely measure verbal and mathematical skills; the window for student success becomes limited to more traditional processes for understanding an often exclusive body of knowledge.

Intelligence is ill-defined to exclude others and reduce options for learning. Gardner (1999) suggests that intelligence is not singular but, rather, plural. His theory of multiple intelligences expands the definition of intelligence to include the following: linguistic, logical, musical, spatial, bodily-kinesthetic, interpersonal, intrapersonal, and, most recently, naturalist, spiritual, and existential (1999).

Eisner (1984) argues that

> Reading, writing, and meaningful mathematical learning depend upon conceptual forms that appear first as images. Under every word is an image, an icon, a referent, a shaped form abstracted from the phenomenal world that provides the experiential ground that makes words, sentences, paragraphs, and stories meaningful. (p. 57)

This would suggest that visual intelligence plays a larger role than some might think. And, more importantly when today's culture is image dominant, it is essential that schools move visual representations to the center of the curriculum.

One of our tasks as educators becomes one of teaching students to act as critical viewers and creators of images so that images can be interpreted, complicated, and even undermined. "Images are not simply there for the taking. One must learn how to read them, and the more subtle and complex they are, the more instruction is necessary" (Eisner, 1984, p. 58). This points to a greater need for instruction across all disciplines whereby visual representation and the creation of image become a dominant mode of sense-making. For this to happen, educators will have to dissolve restrictive barriers and expand the parameters of their teaching to include strategies that support the interpretive webs that surround visual representations. Certainly, many traditional "models of teaching" such as rote learning and straight lecture do not support this understanding. Therefore, educators will need to look toward more authentic strategies such as inquiry-based and hands-on approaches to instruction that allow

students spaces to construct their own knowledge. In this next section, we discuss qualities of inquiry-based approaches that support explorations of image in teaching and learning.

Image and Inquiry as Transformative Practice

> All depends upon a breaking free, a leap and then a question. I would like to claim that this is how learning happens and that the educative task is to create situations in which the young are moved to begin to ask, in all the tones of voice there are "Why?" (Greene, 1995, p. 6)

Asking *why* starts us on a journey or process of inquiry—a quest to understand. Whether to understand the inner workings of cells or to understand why children go to sleep hungry at night, Greene defines this as "the educative task." A task that can uncover the answers of not only predefined curricular content but also solutions to critical questions that continue to challenge society and ultimately filter their way down to students in very powerful ways.

As educators, we believe that part of this educative task becomes one of creating situations in which learners are encouraged to creatively and critically explore experiences with a sense of personal investment, expressive freedom, reflection, and, ultimately, transformation. Ayers (1993) refers to this as a "creative task," in which teachers "must figure out how to create a space where students are expected to use their minds well to derive knowledge from information, to invest thought with courage, to connect consciousness to conduct, and so on" (p. 7). Like Freire (1970), who believed that education is a the practice of freedom, bell hooks (1994) suggests that the educative task should enable "transgressions—against and beyond boundaries. It is that movement that makes education the practice of freedom" (p. 12).

It is our belief that pedagogical possibilities of image and inquiry open up spaces for creative, critical, and transformative practice to take place. We focus on the use of image within a process of inquiry not because we feel that it is the only form of representation in which meaning can take place; rather, it is one of many powerful forms. Eisner (1993) reminds us that "different forms of thinking lead to differ-

ent kinds of meaning" (p. 6). However, we do believe that, unlike other more traditional forms of representation that restrict opportunities for learning, the interpretive nature of image offers a pluralistic venue for the exploration of questions. Visual representations invite questions and multiple perspectives, encourage exploration and engagement, and allow learners to "break free" from that which has been done before them. Engagements with visual representations encourage learners to be creative and critical at the same time, to challenge the status quo, and to create possible worlds. In doing so, learners transform understanding and ultimately reconstruct their lives.

Inquiry is an integral part of what we do as educators, researchers, and learners at all levels. Oxford's English dictionary (Simpson & Weiner, 1989) defines inquiry in the following ways: "(a) to search into, seek information, or knowledge, investigate, examine, and (b) to seek knowledge of (a thing) by putting a question: to ask about; to ask something (someone) of a request to be told". Berghoff, Egawa, Harste, & Hoonan (2000) describe inquiry as

> learning driven by the learner's personal question or questions. There are always questions. Our lives are full of ambiguity and we have to continually ask, "What does this mean? (p. ix)

Inquiry invites learners to explore what Kumashiro (2001) refers to as "unknowability, multiplicity, and looking beyond the known" (p. 4). He goes on to explain that,

> Much of what we learn and much of what we teach involves uncertainty. We can not fully know who our students are, we can not control what they learn, we cannot know with certainty that what we want them to learn is what is in their best interest to learn. (p. 9)

Unknowability lies at the core of inquiry—the need to question. Whether teachers or students, "inquiry is a way of knowing, a willingness to undergo a journey, to tolerate ambiguity, to sort through multiple perspectives and trust abductions—those leaps of insights that totally restructure what is known"(Berghoff, Egawa, Harste, & Hoonan, 2000, p. ix).

Perhaps this is why images might best be explored within a

framework of inquiry. The subjective, ambiguous, and artful qualities of image provide a certain level of "unknowability," and in their uncertainty they free up spaces, giving students the freedom to make personal connections and create unique solutions while challenging students to critique existing norms. This is what hooks (1994) refers to as the "practice of freedom." This includes not only the freedom to engage in multiple processes for understanding but also the freedom to challenge existing norms and to create new worlds.

Greene (1988) connects these notions of freedom and critical pedagogy with plurality in this way. "Education for freedom must clearly focus on the range of human intelligences, the multiple languages, and symbol systems available for ordering experience and making sense of the lived world" (p. 125). So, in essence, freedom is encouraged by creating opportunities to creatively explore multiple modes of expression as well as opportunities to critique existing standards.

The Processes of Creative and Critical Inquiry

Inquiry involves both creative and critical elements. We chose to make distinctions in our book between these elements for two reasons. First, we felt that each has useful distinctions as well as shared qualities that help us better talk about and understand visual representations; second, the distinction demonstrates the lens that each researcher brought to their research. It is our belief that inquiry can be creative and critical at the same time. Both are meant to foster growth in a learner through a cycle of experience that invites learner-generated questions, invests the learner personally, engages the learner in active participation, and provides opportunities for reflection. The two are inextricably linked. Creative inquiry often leads to critical inquiry and vice versa. If students are allowed to explore questions in personally invested ways through artful or creative processes they are often better able to perceive distinct and unique qualities of experience to arrive at informed critical decisions.

More important than making distinctions between the two, is the commitment that educators should make to both in their classrooms.

Although Pasmore (1975) makes distinctions between the two, which he refers to as "critico-creative" thinking, he recognizes the value of both in education, explaining that neither

> the free exercise of the imagination or the raising of objections is in itself to be despised; the first can be suggestive of new ideas, the second can show the need for them. But certainly education tries to develop the two in combination. (p. 33)

Additionally, our choice to make distinctions came about because of the varying theoretical foci that researchers brought to their work. For instance, as you will see in Chapter 1, I use a creative inquiry framework that allows me to focus on preservice teachers' use of photography as a tool for exploring literacy. However, this is not to say that the visual lens does not take learners to critical discoveries. In Chapter 2, Kim takes a critical look at how girls construct the meanings of their bodies. She began with the critical goal of helping girls begin to critique popular images of women's bodies. However, she uses collage as a creative process to help the participants arrive at critical understandings.

At this point, I will take some time to discuss some of the distinctions unique to creative and critical inquiry processes. Creative inquiry is a process of inquiry that invites the learner to engage in artful or creative processes as a means for better understanding experience. Creative inquiry is a circular or spiral process of interpretation whereby the learner creates a unique representation of understanding through the personal investment of prior knowledge, active engagement in creative processes for understanding, and the creation and reflection of representations for learning. In this case, the focus is on the creation of an image or a creative response to an image. Therefore, creative inquiry focuses on a holistic approach to understanding that erases false dualisms that exist between cognitive and affective thought. Instead, creative inquiry embraces Dewey's theory of the qualitative whole whereby the affective, or background, of thought feeds the rational, or foreground, of thought (1925/1984) highlighting affective qualities such as need, affect, intuition, selective attention, imagination, and emotion through creative engagement. All of these

elements feed the creative dimensions of the inquiry.

Critical inquiry engages learners in processes that help them develop critical perspectives of their culture whether textual, visual, or experiential.

> The intent of adopting a critical perspective and asking questions then, is to illuminate past and current inequalities, to document their consequences on our lives, and to identify contradictions within current relationships and events as opportunities for change toward more just relations. (Shannon, 1995, p. 64)

Consequently, the development of critical perspectives may lead to social action that might include "dialectical as well as innovative processes for social transformation that induce hope by highlighting possibilities for a more just social world" (Oliver & Lalik, 2001). Michelle Fine (1992) would describe critical inquiry as "activist inquiry," which "seeks to unearth, interrupt, and open new frames for intellectual and political theory and change." She adds that in order for this to take place, inquirers "must embrace alternative processes that move beyond the margins so as to help others do so" (p. 23). In order for transformations to take place, learners must be provided spaces and opportunities to work with "alternative processes" that move understanding beyond traditionally accepted beliefs.

The connection is clear between that which is creative and that which is critical, and how images serve to inspire both ways of thinking in learners. In a larger sense the ability to think creatively and critically are essential to the creation of better worlds. Our world needs leaders who have the imaginative and creative ability to move us forward, not backward. Leaders such as our students, future students, and educators will need to have the courage to create new solutions and opportunities for our world, which has changed considerably since Picasso painted *Guernica*. Leaders such as these will come from the schools we help create, because as Eisner points out, "what schools allow children to think about shapes in ways perhaps more significant than we realize the kind of minds they come to own" (1993, p. 5). This is an issue of literacy, an issue of art, and an issue for our changing world.

References

Agee, J., & Evans, W. (1936). *Let us now praise famous men.* Boston: Houghton Mifflin.

Albers, P., & Murphy, S. (2000). *Telling pieces: Art as a literacy in middle school classrooms.* Mahwah, NJ: Lawrence Erlbaum.

Ayers, W. (1993). *To teach: The journey of a teacher.* New York: Teachers College Press.

Berger, J. (1977). *Ways of seeing.* London: British Broadcasting Corporation and Penguin.

Berghoff, B., Egawa, K., Harste, J., & Hoonan, B. (2000). *Beyond reading and writing: Inquiry, curriculum and multiple ways of knowing.* Urbana, IL: National Council of Teachers of English.

Blatt, B., & Kaplan, F. (1974). *Christmas in Purgatory.* Syracuse, NY: Human Policy Press.

Cecil, N., & Lauritzen, P. (1994). *Literacy and the arts for the integrated classroom: Alternative ways of knowing.* New York: Longman.

Curry, T., & Clarke, A. (1978). *Introducing visual sociology.* Dubuque, IA: Kendall/Hunt.

Dake, D. (1995). *Process issues in visual literacy.* (Report No. IR-016-978). Tempe, AZ: International Visual Literacy Association. (ERIC Document Reproduction Service No. ED380 057)

Desmond, R. (1999). TV viewing, reading, and media literacy. In J. Flood, S. B. Heath, & D. Lapp (Eds.) *Research on teaching literacy through the communicative and visual arts* (pp.23–29). New York: Simon & Schuster Macmillan.

Dewey, J. (1925/1984). Affective thought. In J. A. Boydston (Ed.), *John Dewey: The later works.* Vol. 2, (pp. 104–115). Carbondale: Southern Illinois University.

Dewey. J. (1934). *Art as experience.* New York: Perigree.

Dewey, J. (1938). *Experience and education.* New York: Touchstone.

Edwards, E. (Ed.). (1992). *Anthropology and photography.* New Haven, CT: Yale University Press.

Eisner, E. (1984, Fall). Reading the images of culture. *Momentum,* 56–58.

Eisner, E. (1993). Forms of understanding and the future of educational research. *Educational Researcher, 22 (7),* 5–11.

Eisner, E. (1994). *Cognition and curriculum reconsidered.* New York: Teachers College Press.

Elkins, J. (1999). *The domain of images.* Ithaca, NY: Cornell University Press.

Ferdman, B. (1990). Literacy and cultural identity. *Harvard Educational Review, 60* (2), 181–204.

Fine, M. (1992). *Disruptive voices: The possibilities of feminist research.* Ann Arbor: University of Michigan Press.

Freire, P. (1970). *Pedagogy of the oppressed.* New York: Continuum.

Freire, P., & Macedo, D. (1987). *Literacy: Reading the word and the world.* New York: Greenwood Publishing.

Furbank, P. N. (1970). *Reflections on the word "image."* London: Secker & Warburg.

Gardner, H. (1983). *Frames of mind: The theory of multiple intelligences.* New York: Basic Books.

Gardner, H. (1999). Are there additional intelligences? *Intelligence reframed: Multiple intelligences for the 21st century* (pp. 47–66). New York: Basic Books.

Greene, M. (1988). *The dialectic of freedom.* New York: Teachers College Press.

Greene, M. (1991). Texts and margins. *Harvard Educational Review, 61* (1),
1-17.

Greene, M. (1995). *Releasing the imagination.* San Francisco: Jossey-Bass.

Hargraeves, A. (Ed.). (1994). *Changing teachers, changing times.* New York: Teachers College Press.

Hobbs, R. (1997). Literacy for the information age. In J. Flood, S. B. Heath, & D. Lapp (Eds.), *Research on teaching literacy through the communicative and visual arts* (pp. 7–13). New York: Simon & Schuster Macmillan.

hooks, b. (1994). *Teaching to transgress: Education as the practice of freedom.* New York: Routledge.

Hortin, J. (1994). Theoretical foundations of visual learning. In D. Moore & F. Dwyer (Eds.), *Visual literacy: A spectrum of visual learning* (pp. 5–29). Englewood Cliffs: Educational Technology Publications.

Kohl, H. (1994). *"I won't learn from you."* New York: Charles Scribner's Sons.

Kohn, A. (2001). Fighting the tests: A practical guide to rescuing our schools. *Phi Delta Kappan, 82* (5), 349–357.

Kumashiro, K. (2001). "Posts" perspectives on anti-oppressive education in social studies, English, mathematics, and science classrooms. *Educational Researcher, 30* (3), 3–12.

Leibovitz A., & Sontag, S. (1999). *Women.* New York: Random House.

Leland, C., & Harste, J. (1994). Multiple ways of knowing: Curriculum in a new key. *Language Arts, 71,* 337–345.

Leland, C., Harste, J., & Helt, C. (2000). Multiple ways of knowing: From a blue guitar. In M. Gallego & S. Hollingsworth (Eds.), *What counts as literacy: Challenging the school standard* (pp. 106–117). New York: Teachers College Press.

Leppert, R. (1996). *Art and the committed eye: The cultural functions of imagery.* Boulder, CO: Westview.

Lister, M. (2000). Photography in the age of electronic imaging. In L. Wells (Ed.), *Photography: A critical introduction* (pp. 303–344). New York: Routledge.

Lukas, A. (1985). *Common ground.* New York: Knopf.

Luke, C. (2001). *Re-crafting media and ICT literacies.* Paper presented at the New Literacies and Digital Technologies Conference: A focus on adolescent learners. Athens, GA.

Messaris, P. (1997). Introduction. In J. Flood, S. B. Heath, & D. Lapp (Eds.), *Research on teaching literacy through the communicative and visual arts* (pp. 3–7). New York: Simon Schuster Macmillan.

New London Group. (1996). A pedagogy of multiliteracies: Designing social futures. *Harvard Educational Review, 60* (1), 60–92.

Oliver, K. L., & Lalik, R. (2001). *Bodily knowledge: Learning about equity and justice with adolescent girls.* New York: Peter Lang.

Pasemore, J. (1975). "On teaching to be critical." In R. F. Dearden, P.

H. Hirst, & R. S. Peters (Eds.), *Education and reason* (pp. 415–433). London: Routledge & Kegan Paul.

Prescott, J. (1995). (Ed). *America at the crossroads: Great photographs from the thirties.* New York: Smithmark.

Rosenblatt, L. (1978). *The reader, the text, the poem.* Carbondale: Southern Illinois University Press.

Shannon, P. (1995). *Text, lies, and videotape: Stories about life, literacy, and learning.* Portsmouth, NH: Heinemann.

Short, K., & Burke, C. (1996). Examining our beliefs and practices through inquiry. *Language Arts, 73,* 97–104.

Simpson, J. A., & Weiner, E. S. C. (Eds.). (1989). *The Oxford English dictionary.* Vol. 7 (2nd ed). London: Oxford University Press.

Sontag, S. (1977). *On photography.* New York: Dell.

Stasz, C. (1979). The early history of visual sociology. In J. Wagner (Ed.), *Images of information* (pp. 119–136). London: Sage.

Sullivan, G. (2002). What is the big picture? *Studies in Art Education: A Journal of issues and research, 43* (2), 107–108.

Sweet, J. (1997). The national policy perspective on research intersections between literacy and the visual/communicative arts. In J. Flood, S. B. Heath, & D. Lapp (Eds.), *Research on teaching literacy through the communicative and visual arts* (pp. 286–300). New York: Simon & Schuster Macmillan.

Tierney, R. (1997). Learning with multiple symbol systems: Possibilities, realities, paradigm shifts, and developmental considerations. In J. Flood, S. B. Heath, & D. Lapp (Eds.), *Research on teaching literacy through the communicative and visual arts* (pp. 286–300). New York: Simon & Schuster Macmillan.

Tucker, S., & Dempsey, J. (1991). *Semiotic criteria for evaluating instructional hypermedia* (Report No. IR-015-208). Chicago, IL: Annual meeting of the American Educational Research Association. (ERIC Reproduction Service No. ED337155)

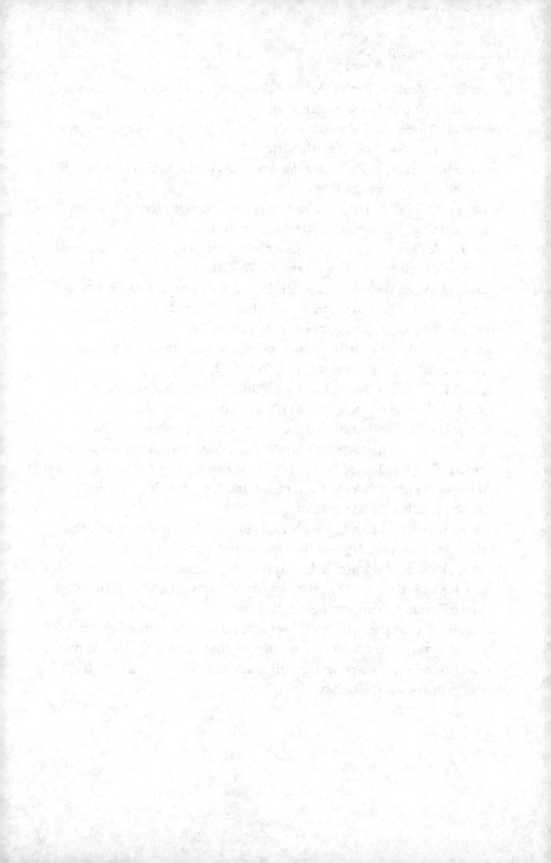

ℰℴ CHAPTER 1

Re-envisioning Literacy
Photography as a Means for Understanding Literate Worlds

Lynn Sanders-Bustle

When I hear the word literacy, I naturally think of reading and writing. But when you think about it and are able to try and capture it in photos, you are able to go beyond. —Julie

Understanding literacy requires thoughtful and personal questioning beyond the text of the word "literacy." Going beyond the text of the word requires individuals to wander around the concept of literacy so as not to be confined by its history. This includes a process of inquiry; a time to question, to explore, and to recreate an understanding of literacy that is more inclusive, creative, critical, and current. Literacy educators at all levels must engage continuously in an inquiry into understanding literacy as it exists in a world that is continuously changing. As Harste (2000) points out, "how we envision literacy makes a difference. If we see it as meaning making and not meaning making plus inquiry, we fail to envision all that literacy might be. If

we see literacy as language and not language plus other sign systems, we also fail to envision all that literacy might be" (p. 1). Harste prompts literacy educators to "envision all that literacy might be" suggesting that literacy includes the "seeing" of possible roles for language. It hints at an imagined literacy that has the potential to "be" something more.

This chapter explores the creative inquiry of two preservice teachers, Marie and Julie, as they use the lens of a camera to "see" what literacy might be. Using a framework of creative inquiry, I discuss the personal inquiries of each student showing how they used photography as a creative process to reaffirm, extend, and connect prior literacy experiences to their immediate literate environments, ultimately recreating personal understandings of literacy as future teachers.

It is my belief that we are constantly engaged in inquiry processes as we live our lives. We seek answers to questions that demand our attention. As teachers, we are constantly caught up in a quest to understand phenomena of lived experiences so we can provide direction, instruction, and answers to our questions and the questions of our students. In this case, preservice teachers seek to answer the question, "What is literacy?" There was a time when this question could have been answered easily, but not today.

Over the past 10 years, the field of literacy has broadened the conceptualization of literacy. This "expanded conceptualization" (Flood & Lapp, 1994) features new and inclusive language such as: new literacies (Lankshear & Knobel, 2000), multiliteracies (New London Group, 1996), multiple literacies (Flood & Lapp, 1994), media literacy (Luke, 2001; Desmond, 1997; Hobbs, 1997), visual literacy (Gallego & Hollingsworth, 2000), the communicative arts (Flood, Heath, & Lapp, 1999). The New London Group (1996) identified two critical aspects of the millennial world that have shaped a pedagogy of multiliteracies. They include an "increasing multiplicity of communication channels and increasing local diversity and global connectedness" (p. 60). Both have powerful educational implications that must include an increased attention to visual representation as one of culture's most dominant modes of meaning making. As technological ad-

vancements bring the world closer together, diverse cultures find themselves in closer communication. This new global closeness requires a better understanding of multiple modes of meaning-making that allow us to better communicate across cultures. Visual representations offer much in the way of dissolving language barriers, expanding possibilities for understanding, and illuminating elements that all human beings share. Garcia and Willis (2001) propose a multicultural view of literacy that

> reflects a complete understanding of culture; a strong commitment to diversity; an understanding of how language and literacy practices are socially mediated and ideologically constructed; a recognition of the multiple forms of literacies; and an enlightened examination of the social, political, and economic contexts that shape language and literacy practices, policies, and research. (p. 26)

An integral piece of this multicultural perspective is the recognition and (I would add) "implementation" of multiple forms that would include image. Although many have recognized the role of multiple forms in culture, visual images remain on the outward fringes of what is considered valuable curricula. In the past, knowledge in schools has been determined largely by one's ability to master traditional language based skills such as reading and writing.

> Literacy pedagogy has meant teaching and learning to read and write in page-bound, official, standard forms of the national language. Literacy pedagogy, in other words, has been a carefully restricted project—restricted to formalized, monolingual, mono-cultural, and rule-governed forms of language. (New London Group, 1996, p. 61)

This monistic approach has been and continues to be "supported by those who are obsessed with the technical aspects of decoding printed language." This includes a "narrow and instrumental definition of literacy as the ability of students to perform on standardized assessments which measure word attack, vocabulary, comprehension, and grammar (Laughlin, Martin, & Sleeter, 2001, p. 92). As a result, a monocultural perspective includes not only a text exclusive perspective but also one that supports and perpetuates a Eurocentric curriculum that informs educational policy. This Eurocentric approach harms students who fall outside the dominant culture significantly

reducing their opportunities to succeed. Sadly, "students whose cultures are not valued or even present in the curriculum may, if they do stay in school, come to feel that something is 'wrong' with their color, their family, and their culture." As a result, they "may hide or deny this part of themselves and embrace 'mainstream' culture to survive or 'succeed' (Nabokov, 1991; Laughlin, Martin, & Sleeter, 2001). This response is due to "monistic" approaches to teaching and learning rather than a pluralistic approach that "liberates" learning and opens up spaces for students to succeed (Laughlin, Martin, & Sleeter, 2001). Part of this liberation involves actively expanding understandings of literacy at all levels of the educational spectrum to include multiple modes of sense-making— particularly those, such as the visual, that dominate the communications environment example visual representation.

> Literacy pedagogy must include an understanding and competent control of representational forms that are becoming increasingly significant in the overall communications environment, such as visual images and their relationship to the written word—for instance, visual design in desktop publishing or the interface of visual and linguistic meaning in multimedia. (New London Group, 1996, p. 61)

The separation between that which is considered visual and that which is considered textual is slowly blurring as we find ourselves constantly immersed in a technology- and media-driven society. Visually stimulating advertising, television, and other forms of visual representation dominate entertainment and technology. Combined images and text offer a new mode of reading. For example, CNN's television screen now sports a layout similar to that of a computer screen. If we get tired of looking at the broadcaster, we can read the streaming line of text below to find the information we desire. E-mail has shaped the way we communicate: we shorten our sentences and speak in codes, dismissing capitalization and punctuation ☺.

Current research explores emerging issues related to "reading" new technological formats that include graphics as well as alternative formats. (Garthwait, 2001; Hammerberg, 2001; Lankshear & Knobel, 2000; LaSpina, 2001). One needs only to examine the format of a Web

page or the layout of recent textbooks to notice the reorganization of information on a page. Digitally constructed space such as hypermedia has redefined how we make sense of information. Garthwait (2001) explains, "Because of its potential for redefining "text" hypermedia authors go beyond the restrictions of using only "words" to convey content by bringing into play other modalities" (p. 241). LaSpina (2001) describes this sharing of word and space as "a new locus for language . . . whereby forms of text (written, spoken, etc.) can reside in the same space with the forms of visual information. . ." (p. 247). Beyond "locus" there is the need for a better understanding of the role of visual representation alongside text. In other words, "visual and graphic information should be rightly viewed as content, not just illustration or necessarily as a simple complement to text" (LaSpina, 2001; Tufte, 1990). In addition, changes like those seen in technology have impacted the role of illustration in contemporary children's literature and its relationship to hypermedia—that is, reading amounts to decoding information redefined as bytes of information that are often nonlinear, nonsequential, and multi-interpretational (Hammerberg, 2001). Add to this a new and more complex understanding of the relationship between text/image and the reader/viewer, and our understanding of literacy becomes increasingly challenging. McEneaney (2001) explains:

> It seems to me this represents the ultimate challenge we face as reading educators is to prepare students to be active critical readers in an environment that is far more dynamic than even the most radical theories of text have proposed, an environment where texts become "readers" and readers become "text." (p. 1)

Given pluralistic views of literacy, educators must reexamine current instructional and curricular strategies and to reconsider what it means to learn. The New London Group proposes a design approach to pedagogy that includes among its resources of design "grammars of language" and "orders of discourse." Grammars might include various semiotic systems such as "film, photography, or gesture." In addition, a design approach would call for "orders of discourse" for exploration. "An order of discourse is the structured set of conven-

tions associated with semiotic activity in a social space—a particular society, or a particular institution such as a school or a workplace, or more loosely structured spaces of discourse of life encapsulated in the notion of different life-worlds". (1996, p. 74). This design highlights contextual and sociocultural aspects of learning while opening up possibilities for "semiotic systems" or sensemaking that might include visual representations.

Finding a Role for the Visual
in Teacher Education and Inquiry

New visions of literacy impact education at all levels including teacher preparation. For teacher educators, the challenge becomes better preparing preservice teachers to broaden their understandings of literacy to include multiliteracies. Included among possible processes to be explored are those that focus on the visual such as those found in what Flood, Heath, and Lapp (1997) refer to as "the visual and communicative arts"; these include illustration, graphics such as hypertext, video, photography, and the arts. In recent years, educators have become increasingly aware of the important role that the arts play in content area classrooms (Cecil & Lauritzen, 1994; Gallego & Hollingsworth, 2000; Sweet, 1997; Towell, 2000). Cecil and Lauritzen (1994) explain, "The arts can enhance literacy and tap linguistic, musical, logical-mathematical, spatial, bodily-kinesthetic, interpersonal and intrapersonal intelligence—all ways through which we believe that children can demonstrate their understanding of ideas" (p. xiii). I would argue that the arts do more than "enhance" that in fact they can serve as representations of understanding while helping to internalize and develop understanding through affective engagement. Dewey (1938) refers to this view when he speaks of "art as experience" where in essence what we hope to do as "live creatures" is to experience the world in an artful manner. Integral to Dewey's aesthetic theories is the belief that having experience is a holistic process that is informed by both cognitive and affective qualities. In fact, Dewey believes that cognition is informed by sentient modalities. This certainly includes the visual ways we engage with

and make sense of the world. I believe it is no mistake that Dewey wrote *Art as Experience* (1934) first, to be followed by *Experience and Education* (1938). When we see education as an art, how we approach education takes on new meaning. The arts have the ability to tap into affective sensibilities that "internalize" understanding, incite empathy, and inform actions. Are these not the qualities of invested teaching and learning?

Given millennial advancements and an expanded conceptualization of literacy, literacy educators must now consider what pedagogical strategies best allow students to learn in meaningful ways. Inquiry-based instruction offers much in the way of investing personal exploration and engaging learners in a variety of processes. For years, inquiry-based instruction has been a part of teaching and learning across the curriculum at all levels. Elements of inquiry based instruction such as authentic learning, questioning, and problem solving are found across disciplines (Koch, 1999; Baroody & Coslick, 1998; Saul, Reardon, Schmidt, Pearce, Blackwood, & Bird, 1993). Glimpses into inquiry processes can be found in frameworks for whole language programs such as the authoring cycle proposed by Short, Harste, and Burke (1998). Most recently Harste (2000) presented what he refers to as the inquiry cycle, adapted from Short, Harste and Burke (1998). This cycle explores multiple sign systems as central to inquiry processes moving beyond inquiry frameworks bound to more traditional language processes.

This is an important step forward, one that needs to find its way into college classrooms. Educators have little problem recognizing the value of creative forms of inquiry in the K–12 curriculum, yet a gap occurs when teacher educators fail to model inquiry processes that include expressive processes for understanding in university classrooms. "Teacher as researcher" theories acknowledge the role that inquiry plays in teachers' better understanding their practice and their students (Freeman, 1998; Patterson & Shannon, 1993; Cochran-Smith & Lytle, 1993). However, inquiry processes are often limited to textual forms of representation such as autobiographical explorations and written reflection leaving a host of literate possibilities unex-

plored. As a result, preservice teachers are often unprepared to teach and assess the very processes students need to understand to succeed in and recreate a millennial world.

Educators can begin by incorporating artful inquiry frameworks into their curriculum encouraging their students to engage with a host of processes that require the exploration of multiliteracies. One such exploration might include the integration of visual representations throughout the inquiry process. Engagement with visual representation as a subjective and affective mode of inquiry opens up spaces for preservice teachers to begin to wrestle with the often ambiguous qualities that define teaching as a care-giving profession. Engagement with images can make us take a hard look and feel at our practice and, in a caring profession such as teaching, care lies at the heart of our actions (Noddings, 1992; Gilligan, 1982/1993).

So, it is not too big of a leap to consider that expressive practice and deep personal engagement with visual representation can help preservice teachers begin to develop not only curricular or pedagogical strategies in the field but also perceptive and critical glimpses into the moral dynamic of teaching. Creative explorations of important topics also give students practice in the process of creation. Without realizing it, teachers are continuously creating solutions, curricula, and positive learning environments. In essence, preservice teachers must take the theory and methodology they learn in their college classrooms and then creatively apply this understanding to day-to-day practice based on their own personal experiences. Often, preservice teachers struggle to negotiate the gap between theory and practice when in fact they must ultimately construct the bridge themselves. The construction of such a bridge requires that personal connections be made between themselves as individuals and their newly emerging selves as future teachers. Expressive processes such as visual exploration give students the space to explore social and physical worlds in which they live based on prior knowledge and interest. Therefore, the bridging of gaps involves the construction of understanding that is freshly representative of unique understanding as learners and new teachers.

In the research represented in this chapter, preservice teachers use cameras to explore their understandings of literacy. The use of photography in research is nothing new. In fact, photography spans multiple disciplines including visual anthropology, sociology, visual ethnography, photojournalism, documentary, art history, aesthetics, and education (Agee & Evans, 1936; Baker, 1996; Berger, 1977; Collier, 1967; Harper, 1979; Prosser, 1992, 1998; Schwartz, 1989; Sontag, 1977). However, photography as an authentic research tool has long been debated because of claims made about the photograph as an objective representation of "truth" (Baker, 1996; Curry & Clarke, 1978; Sontag, 1977; Wagner, 1978). Fortunately, many researchers have abandoned this debate in place of more productive theories.

> The illusion that the photograph provides simple, compelling evidence about the real world is ending. But, it is only the illusion that photographs are somehow automatic—scientific—reflections of the world, which should be abandoned. In its place must come the idea that the photograph can provide evidence of the real world but in a way more akin to the evidence provided by painting or writing. We must finally acknowledge the photographer as a subjective presence even while the science of his or her camera allows us to continue to test in a qualitative way, for authenticity. (Winston, 1998, p. 66)

It is not the intention of this research to dismiss the multiple issues surrounding photography as a research device but to look instead beyond the issues that cloud and often exclude it. Banks suggests that we view photography as "exploration by the visual, through the visual, of human sociality, a field of social action which is enacted in planes of time and space through objects and bodies, landscapes and emotions, as well as thought" (Banks, 1998, p. 19).

With this in mind, I approached this study realizing that the interpretation of a photograph is the interpretation of a complex web of information that that includes (a) the photographer, (b) "photographing" as an act, (c) the photograph as a representation, and (d) the viewer.

Photography is the study of a process that begins with the creative qualities of the photographer such as intuition, interest, need, and emotion. Dake (1995) explains, "Each person constructs his or her

perception through a filter of past experiences, assumptions and purposes. Each person, because of differing experiences and associations, perceives what is 'out there' in a largely unique way. There is not a common world out there, only common ways of transacting, common bargains"(p.10). Images framed and captured by particular individuals represent one point of view or perspective—just one image of experience as told through the eyes of that person. In this study, participants act as the photographers. Contrary to historical roles of researchers as photographers, this research finds great value in having the participants frame their worlds—and, at the same time, their inquiry.

As a process, taking a photograph or the act of 'photographing' engages the photographer in a process of 'attending to' or 'gathering' slices of the immediate environment in unique ways. "Every time we look at a photograph, we are aware, however slightly, of the photographer selecting that sight from an infinity of other possible sights. The photographer's way of seeing is reflected in his choice of subject" (Berger, 1977, p. 10). The act of creating photographs requires the photographer to look carefully at the world, not merely through it. For instance, if we glance out of the window on the way across a room, we often do so with haste, not noticing what lies beyond the glass. If we choose to photograph what lies outside the window: We are drawn into choices about what we want to show and why. We have already taken a step toward seeing better—to better understanding what lies around us.

> It became clear that there was not just a simple, unitary activity which was called seeing (recorded by, aided by cameras) but "photographic seeing" which was both a new way for people to see and a new activity for them to perform. (Sontag, 1977, p. 88)

Therefore, taking a photograph is a way of acting in the world. For Dewey, acting is a process of choice.

> Acting in the world requires us to make choices from all there is in the world. Prior to anything which may be called choice in the sense of deliberate decision come spontaneous selections or preferences. Every appetite and impulse, however blind, is a mode of preferring one thing to another; it se-

lects one thing and rejects others. It goes out with attraction to certain objects, putting them ahead of other in value. (1934, p. 286)

Consequently, taking a photograph is an act of preference and choice—an intuitive as well as cognitive process of selection. Preferences may appear to be unintentional and unimportant and are often hard to articulate, but can lead to choice as a deliberate, cognitive act. Because preference or selective attention is the result of intuitive or aesthetic responses to the qualities in the environment, the photographer takes photographs based on both affective and cognitive responses. This is important because the camera provides a means in which affective responses can slip into inquiry.

And finally, the photograph itself is a representation of an interpretation created by the photographer. It is what results from the photographer's transaction with the environment. As an object or an artifact, a photograph is a two-dimensional representation of a framed image captured on film. If we assume that photographs are objective and that they portray information, then we can understand them as a way of knowing on the objective level. In actuality, photographs are flat, yet they represent depth and are layered with meaning. Sontag (1977) explains,

> Photographs are perhaps the most mysterious of all the objects that make up, and thicken, the environment we recognize as modern. Photographs really are experience captured, and the camera is the ideal arm of consciousness in its acquisitive mood. (p. 4)

Photographs offer an interesting visual component to inquiry. They function as devices for reflection. As objects or artifacts, individuals can return to them over and over again. They can share them with others, revisit them, and even translate or interpret them through language. Their fixed state allows this to happen. As a public visual representation, they can communicate ideas, inspire, disgust, or move others to action. Although framed as a representation, photographs bring with them ambiguities, surprises, and slices revealing nuances of lived experiences. These diverse and rich qualities help define our qualitative worlds and give meaning the experiences the experiences of our lives. Eisner describes this process as "getting in

touch." "Getting in touch is itself an act of discrimination, a fine-grained, sensitively nuanced selective process in which the mind is fully engaged...the eye is part of the mind" (Eisner, 1993, p. 5). Subtle and not so subtle visual representations pervade our understanding on many interpretive levels, and it is my thinking that they give us a clearer view of the larger contextual picture and inform our under-standing in powerful ways. As representations, they encompass the complexity of experience, representing not only what exists visually in a particular frame but also that which exists along with and beyond it. In contrast to the concept of "capturing" something, photographs encompass a host of qualities that lie beyond the edges of the photo-graph. They revive the smells and tears of a kindergartner, forgotten homework, friends, and fat crayons. Photographs capture a mood, a feeling, or an expression in ways often difficult to express through words. Images are often so closely woven into experiences that they act as visual prompts for a flood of memories, feelings, shifting ideas, wishes, and dreams. They can incite further questions and lead to new inquiries.

Visual Methodology

The research discussed in this chapter is the result of a larger year-long study conducted at a large land-grant university in the south-eastern portion of the United States during the late nineties. Participants included, among others, Marie and Julie, who were sen-iors enrolled in course work at the university while student teaching at local schools. I served as their instructor for a literacy assessment course I had taught during the fall of 1997. Typical of the other stu-dents in my class, Marie and Julie were Caucasian females in their early twenties from middle to upper socioeconomic backgrounds. Highly motivated young women, they were enthusiastic, very bright, and thoughtful.

As part of Marie and Julie's literacy course, I engaged students in an inquiry process that encouraged visual as well as written and spo-ken explorations. Given the popularity of cameras as a tool for repre-senting life experiences, I felt that students would feel more

comfortable taking pictures than drawing. I explored the idea extensively myself, visiting schools with my camera to capture literacy as well as enrolling in a photography course at the university.

As a class assignment, I required students to take at least one roll (24 exposures) of 35–mm film of elements in their environments that represented literacy. My instructions were very general so as not to limit the students' explorations. Throughout the semester, I encouraged students to share and reflect on photographs. To stimulate interest in visual representations of literacy, I shared my black-and-white photographs asking each student to select one photograph that they felt best represented literacy. I wanted students to experience the interpretive qualities of photographs. I wanted students to realize that anyone can read visual images. After selecting a photograph, students crafted written responses using the following questions as a guide: (a) Why does this photograph represent literacy? (b) What emotion does this photograph evoke? (c) What memories does the photograph recall? I wanted the students to practice using visual prompts to inspire reflection. Toward the close of the semester, students created photographic essays by juxtaposing at least eight of their photographs with selected text. In addition to these assignments, Marie and Julie volunteered to continue to take pictures of literacy throughout the spring semester. Their photographs were shared and discussed with other students participating in the study.

Throughout the year, I collected data that included field notes and Marie's and Julie's photographs, written interpretations of photographs, photographic essays, written reflections such as literacy autobiographies, reflection journals, and literacy portfolio entries, as well as spoken discourse collected from a series of four individual and two group interviews.

My goal was to examine the role of photography in the literacy inquiry of each of the students. Although photography was the primary focus of this study, I quickly realized that I would need to interpret a much more complex web of data beyond photographs. I knew that photographs as objective images served as only one layer of a larger interpretive framework. I discovered that I also needed to

analyze each participant's spoken discourse and written reflections to better understand the photographs. Continued visitations of data left me straddling between image and text—looking at pictures, writing about pictures, reading and writing about spoken discourse that interpreted photographs, and reading written reflections about pictures and revisiting pictures. The analysis of written reflections such as autobiographies provided personal context for inquiry serving as autobiographical touchstones that shaped individual attention to environmental evidences of literacy and helped me better understand connections. Further, the analysis of spoken discourse highlighted "the act of taking" pictures, in which, Marie and Julie articulated reasons for "taking" specific pictures in social and physical environments. And, finally, the photographs themselves served as creations or representations of understanding as well as valuable prompts for reflection.

From this complex web of data, a creative inquiry process emerged as a framework to talk about the use of photographs. I define creative inquiry process as recursive spiral of growth that includes three main components. They include (a) the self (the photographer), (b) expressive engagements with creative processes in the physical and social world (the act of taking photographs), and (c) the representation/reflection of understanding (the photograph). It is important to point out that these elements are far from linear or delineated. Lines between them are not distinguishable yet qualities of each shape the overall process.

Using the creative inquiry framework, I was then better able to understand the role photography played in the individual inquiry of each participant. In the following section, I represent Marie's and Julie's creative literacy inquiries as unique trajectories of literacy understanding beginning with their entry into inquiry. Each inquiry demonstrates how image impacted inquiry by: (a) reaffirming and extending prior knowledge; (b) providing a process for "capturing" the immediate physical and social environment; (c) functioning as ambiguous prompts for reflection; and (d) helping students redefine their roles as future literacy educators.

Julie's Creative Inquiry: Feeling Literate

> The ultimate end, the print, is but a duplication of all that I saw and I felt through my camera. —*Edward Weston*

Julie brought to her inquiry a literate history she represented in her literacy autobiography as frustrating; a personal history that was as much about how she "felt" as a literate being as it was about being able to read or write. She described her early attempts reading in this way—

> *I remember being in school and just trying to read words and just looking at each word and trying to sound them out and then having to read them altogether. Trying to get the context of the whole sentence and the words and then writing and reading and not knowing what I had just read.*

These "felt" challenges translated into self-esteem issues and constant comparisons of her self to others. Julie's past experiences played an early role in her inquiry process as evidenced in her first definition of literacy, in which she makes connections between being successful and being literate—

> *Literacy to me is more than just reading. It is listening and writing. Without having the many aspects that are encompassed in literacy, I believe it would be difficult to succeed in life.*

In the first roll of photographs Julie took during her fall student teaching placement, she focused on children engaged in traditional literacy activities in the classroom, such as writing, reading, or working on the computer. Moving with the cautious eye of a self-proclaimed researcher, she methodically took distant shots of the entire class or small groups of students reading or writing. Her photographs were blurred and dull in color as she struggled with indoor lighting and composition. Her photographs revealed a sterile learning environment.

Later, during the same placement, Julie took her camera outside, where she focused on children at play. Her pictures were vibrant, expressive, and full of activity. She compared the playground photographs to those she had earlier taken indoors. By taking photographs

of students playing outside she explained that she "started *noticing* their personalities." In contrast to the traditional classroom, the playground was an active place where children could express themselves freely. Julie's second placement environment offered a contrast to her first placement. The same energy she had captured out of doors was reflected in her new classroom which she described as a "literacy rich" environment:

I can't really describe a word...How could I describe it? I mean it's just surrounded by things on the walls and things and...just displayed. Like there are tons of bulletin boards and that's something that is changed weekly...So, you really can't see it, but the paintings are on one side and on the other side are flamingos...I liked it because it seemed more of an environment which I thought was literacy rich.

By using her camera to explore her immediate classroom environments she began to notice qualities of environments that make them "literacy rich." Julie's new placement encouraged her to explore more hopeful visions of literacy through the lens of her camera. She was able to capture students enthusiastically engaged in literacy activities. She began to take risks zooming in on her students while creating photographs with daring vantage points and interesting compositions. Over time, Julie made a connection between literate environments and students' feelings of success and self-image. She related her literacy inquiry to her feelings of inadequacies as a young reader asking, "What was it about reading that I didn't like? Was it my lack of confidence in my ability to read or understand?" Reflections on her photographs allowed her to make connections between personal literate history, classroom environments, and her students.

She began to envision literacy success as the product of literacy rich environments that provide "a safe zone" where students can "feel" comfortable, successful, and empowered.

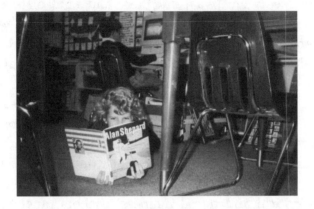

I think that you need to give them [students] the environment they need so they can feel comfortable enough, so they can trust you to be able to do whatever. So they won't feel like they are embarrassed . . . kind of like a safe zone to feel like they are unique.

Later that spring, Julie discussed the role photography played in her inquiry.

When I hear the word literacy, I naturally think of reading and writing. But when you think about it and are able to try and capture it in photos, you are able to go beyond. That literacy is part of a big picture. To a point, it is quite difficult to put into coherent sentences.

Julie's description of the picture-taking process highlights two important qualities of image. She communicates the value of "creating" photos as an active process for understanding and, second, she illuminates the capacity of images—as prompts for reflection—to function in ways different from language. Images can force learners to "go beyond" to a place where the rules of language don't restrict understanding, places where one is forced to think through the lens of camera rather than through words a place where understanding is no longer limited to language and thought processes often restricted by language are disrupted, causing us to think in different ways. We re-

focus, struggle, and ultimately grow. One might say or *hear* the word, "literacy" or one might try to "capture it" as an image. "L-i-t-e-r-a-c-y looks like this—snap@#!"

Taking photographs helped Julie imagine herself "as a teacher"—to "see what [was] out there and kind of construct what [she] would like to have." In a final journal entry, she wrote, "As a teacher, literacy includes the environment of the classroom and beyond, the self-esteem of the student and teacher, the behavior, and the methods used to facilitate the empowerment of students as individuals." Julie had come to "see" literacy as a complex process of meaning making that shapes understandings of ourselves as literate individuals—a process that is impacted greatly by the environment in which students learn. By applying personal literate experiences to her inquiry through a visual process, she recreated her vision of literacy to include the critical and moral nuances teachers must better understand in order to inspire students to craft their personal images of literacy.

Marie's Inquiry: Literacy as Vision, Compassion, and Perception

> Good photographs start with perceptive minds rather than with merely perceptive eyes. —*David Yarnold*

Marie began her inquiry with a broad definition of literacy shaped by meaningful personal experiences with text as a powerful and expressive source of comfort and inspiration. In an early fall interview, she explained,

> *I think literacy is not just words on a paper, but also just the words you speak, and I now see literacy through music and artwork and . . . It's just all around you. It's anything I think that has some sort of expression to it . . . It is anything with meaning.*

In her literacy autobiography, Marie articulated her ability to poetically express thoughts in words, while alluding to, at times, the constraining nature of words.

> *I find solace in writing. The most important and beautiful writing I have accomplished is scribble in my journal, not a typed research paper. When I free myself of the rules and regulations of writing I create a portrait of the depths of my soul.*

Marie's approach to inquiry and picture-taking reflected the fact that she valued the expressive qualities of language. She embraced the taking of photographs much as she approached writing, poetically searching for expressive and inspirational images within the social and physical environments. Rather than focusing on traditional evidences of literacy, she freely snapped photographs of those qualities in the environment that captured her interest visually and/or emotionally. She took pictures of objects such as books, a globe, toys, and pictures on the wall. She took pictures of children playing, drawing, and working on class assignments. Unlike Julie, her early photographs were not restricted by a traditional definition of literacy.

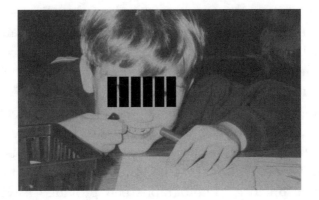

Throughout her inquiry, Marie remained fascinated with close-up shots of children's faces and expressions. Repeatedly, she talked about photographs she had taken of a kindergartner named Bradley (pseudonym).

> *Just if you look at his eyes . . . figured this out last semester [fall]. A lot of my literacy . . . what kind of draws me in, is like inspirational and emotional. And if you just look at his eyes . . . He's so beautiful.*

In the spring, Marie described expressions of children as "devices for the telling of stories." Her pictures reaffirmed her earlier literacy definition, yet prompted further examination of inspirational qualities as evidenced in facial expressions.

> *Children possess a phenomenal ability to tell a story through facial expression alone.*

Adults do this too—but not as masterfully as the young. I think as we are taught to hide certain emotions. We are conditioned to modify or bury our emotions until appropriate. Children rather freely express their emotions through descriptive facial expressions.

She questioned the relationship between literacy and emotions, asking,

Is there literacy through emotion? Is there literacy through tears, and laughter? Or is emotion a form of literacy? I have found that in my lowest moments (now) that I reach and find solace in reading and writing. I also find solace in tears. Is there a connection? I don't know.

Marie's reflections prompted me to consider the relationship between emotion and literacy. I began to wonder if words slowly replace expression and ultimately emotions. Words have rules that provide restrictions. As a result, do words eventually restrict expressions and ultimately emotions? Expressions become grammar, periods, and exclamation marks! If you feel it, yet can't describe a feeling do you silence it through language? Do you silence an emotion? Questions such as these highlight the value of alternative processes and forms of representation in the inquiry process. Without processes that explore affective aspects of understanding educators at all levels may not have opportunities to develop what I refer to as perceptive practice. For Marie, photographs had provided a means for engaging in "perceptive practice." Photographs had provided a window into the moral domain of teaching that requires "perceptive minds as well as perceptive eyes." Those aspects of teaching that encompass affective qualities of students and their learning.

Marie explored the physical environment with the same passionate and perceptive eye she used to explore the faces of children. Although some pictures captured objective representations of literacy such as books, bulletin boards, or signs, many were abstract in nature. Marie often responded to objects based on visual or intuited aesthetic qualities such as "bright colors," "interest," "a feeling," or some unknown response, which she later described in interviews.

During her second placement, Marie described the photograph above as "interesting." Attracted to the contrast between the top and bottom shelves of books, she explained, "This is my life last month. This is my life now. 'Chaos versus rigidness.' " Rather than focusing on the books as representations of literacy, she interpreted the photograph as a visual contrast that represented her life. The photograph had served as a prompt for connecting her life to the physical environment. In essence, Marie was "reading" a collection of books. She saw more than books; she was able to perceive an order or lack there of in a collection of objects in her visual world. As Marie's inquiry progressed, her definition of literacy expanded to include the word "perception." In an interview, she struggled to articulate the connection between literacy and perception.

> *Literacy is perception. I think that literacy is always around you, but without someone perceiving it . . . I don't think it matters. It's not saying anything . . . there is not expression. I think literacy is how people perceive. Literacy is how we read into things. I think we could also do the same with a picture on the wall and perceive it differently and what it means in different ways. So, I think that, that in some round about way, it's not just what is there but it is also our perceptions.*

Marie's explanation highlights two important qualities of literacy. First, she legitimates literacy as a process that asks readers to understand multiple forms of representations (Eisner, 1993) such as a poem, a story, or a photograph. Second, she recognizes the role of the reader/viewer in determination of meaning. Like readers who "actively" transact with text (Rosenblatt, 1978; Karolides, 1992), viewers

transact with visual cues in a unique interpretive manner. Berger (1977) explains, "Although every image embodies a way of seeing, our perception or appreciation of an image depends also upon our own way of seeing"(p. 10).

Like Julie, Marie began to connect new understandings of literacy to her aspirations as a teacher. In a final journal entry, she wrote, "I want children to explore literacy and define it for themselves. I will create an exciting and entertaining classroom filled with enriched activities and lessons that will enable each child to define literacy on a personal level." As the year and her inquiry came to a close, Marie poetically defined literacy in this way:

> Literacy stretches beyond reading and writing and into a world of much greater depth. Literacy encompasses an individual's ability to perceive and interpret a painting, picture, dance, folktale, and so forth. Literacy is not limited to word written in black. Literacy is color: Literacy is interpretation of the world.

Marie's conception of literacy was holistic: one quality running into another closely tied up in the reactions to objects, nature, herself, and others. She photographed environmental qualities she reacted to out of felt connections such as "love," "interest," or "feeling." For Marie, who had entered her inquiry with an expanded conceptualization of literacy, her challenge then became one of finding the words to describe a deeper and richer understanding of literacy that includes morally perceptive and aesthetic aspects of literacy education.

Conclusion

> Teaching requires invention and reinvention, dynamic involvement with growing and changing bodies of knowledge, complex connection of human beings making new discoveries with traditional way of thinking and knowing. So reinventing is what we're about and where we begin. (Ayers, 1995, p. 9)

Teaching is a continuous creative process of inquiry that requires an understanding of social and physical environments and our ability to create meaning of visual and aesthetic cues that guide our thinking as educators. With ambiguity and subjectivity, photography opened up spaces for Marie and Julie to reaffirm, deepen, and recreate under-

standings of literacy and to make authentic connections between themselves, the highly complex concept of literacy, and their physical and social environments.

It is my belief that teachers must experience teaching as a creative act—whether it involves creating a safe and welcoming space for children, creating engaging lesson plans, or creating uniquely tailored strategies that meet the needs of a diverse classroom. Creating classrooms that empower, celebrate multiple perspectives, and invite imagination requires teachers to employ intuition, perception, and imagination not only to make curricular decisions in the traditional sense of the word but also to make perceptive and emotive decisions regarding the well-being on their students. Teaching includes being able—morally and aesthetically—to read/view highly complex landscapes that often define learners; to open one's eyes and mind, study, feel, perceive, and act in ways that will transform the world. And, as Dorothea Lange sought to do through her depiction of migrant workers in the 1930s to encourage others to ask questions. "Whether of a board fence, an eggshell, a mountain peak or a broken sharecropper, the great photograph first asks then answers two questions, 'Is that my world? What, if not, has that world to do with mine?"

References

Agee, J., & Evans, W. (1936). *Let us now praise famous men*. Boston: Houghton Mifflin.

Ayers, W. (1995). *To become a teacher: Making a difference in children's lives*. New York: Teacher's College Press.

Baker, G. (1996). Photography between narrativity and stasis: August Sander, degeneration, and the decay of the portrait. *October Magazine, 76,* 73–113.

Banks, M. (1998). Visual anthropology: Image, object, and interpretation. In J. Prosser (Ed.), *Image-based research* (pp. 9–19). London: Falmer Press.

Baroody, A., & Coslick, R. (1998). *Fostering children's mathematical power: An investigative approach to K–8 mathematics instruction*. Mahwah, NJ: Lawrence Erlbaum.

Berger, J. (1977). *Ways of seeing*. London: British Broadcasting Corporation.

Cecil, N., & Lauritzen, P. (1994). *Literacy and the arts for the integrated classroom: Alternative ways of knowing*. New York: Longman.

Cochran-Smith, M., & Lytle, S. (1993). *Inside/Outside: Teacher research and knowledge*. New York: Teachers College Press.

Collier, J. Jr. (1967). *Visual anthropology: Photography as a research model*. New York: Holt, Rinehart & Winston.

Curry, T., & Clarke, A. (1978). *Introducing visual sociology*. IA: Kendall/Hunt.

Dake, D. (1995). *Process issues in visual literacy* (Report No. IR–016–978). Tempe, AZ: International Visual Literacy Association. (ERIC Document Reproduction Service No. ED380 057)

Desmond, R. (1997). TV viewing, reading, and media literacy. In J. Flood, S. B. Heath, & D. Lapp. (Eds.), *Research on teaching literacy through the communicative and visual arts* (pp. 23–29). New York: Simon & Schuster Macmillan.

Dewey, J. (1934). *Art as experience*. New York: Pedigree.

Dewey, J. (1938). *Experience and education*. New York: Touchstone

Eisner, E. (1993). Forms of understanding and the future of educa-

tional research. *Educational Researcher, 22* (7), 5–11.

Flood, J., Heath, S. B., & Lapp, D. (Eds.). (1997). *Research on teaching literacy through the communicative and visual arts.* New York: Simon & Schuster Macmillan.

Flood, J. & Lapp, D. (1994). Broadening the lens: Toward an expanded conceptualization of literacy. *Perspectives on literacy research and practice, 44,* 1–33.

Freeman, D. (1998). *Doing teacher research: From inquiry to understanding.* New York: Heinle & Heinle.

Gallego, M., & Hollingsworth, S. (Eds.). (2000). *What counts as literacy: Challenging the school standard.* New York: Teachers College Press.

Garcia, G., & Willis, A. (2001). Frameworks for understanding multicultural literacies. In P. R. Schmidt & P. Mosenthal (Eds.), *Reconceptualizing literacy in the new age of multiculturalism and pluralism* (pp. 3–31). Greenwich, CT: Information Age Publishing.

Garthwait, A. (2001). Hypermedia composing: Questions arising from writing in three dimensions. *Language Arts, 78* (3), 237–244.

Gilligan, C. (1982/1993). *In a different voice.* Cambridge, MA: Harvard University Press.

Hammerberg, D. (2001). Reading and writing "hypertextually": Children's literature, technology, and early writing instruction. *Language arts, 78* (3), 207–215.

Harper, D. (1979). Life on the road. In J. Wagner. (Ed.), *Images of information* (pp. 25–42). London: Sage.

Harste, J. (2000). Six points of departure. In B. Berghoff, K. Egawa, J. Harste, & B. Hoonan (Eds.), *Beyond reading and writing: Inquiry, curriculum, and multiple ways of knowing* (pp. 1–16). Urbana, IL: National Council of Teachers of English.

Hobbs, R. (1997). Literacy for the information age. In J. Flood, S. B. Heath, & D. Lapp (Eds.), *Research on teaching literacy through the communicative and visual arts* (pp. 7–13). New York: Simon & Schuster Macmillan.

Karolides, N. (1992). *Reader response in the classroom.* White Plains, NY: Longman Press.

Koch, J. (1999). *Science stories: Teachers and children as science learners.* New York: Houghton Mifflin.

Lankshear, C., & Knobel, M. (2001, January). *Do we have your attention? New literacies, digital technologies and the education of adolescents.* Paper presented at the State of the Art Conference, Athens, GA.

LaSpina, J. (2001). The locus of language in digital space. *Language Arts, 78* (3), 245–254.

Laughlin, M., Martin, H., & Sleeter, C. (2001). Liberating literacy. In P. R. Schmidt & P. B. Mosenthal (Eds.), *Reconceptualizing literacy in the new age of multiculturalism and pluralism* (pp. 3–31). Greenwich, CT: Information Age Publishing.

Luke, C. (2001, January). *Re-crafting media and ICT literacies.* Paper presented at the New Literacies and Digital Technologies Conference, Athens, GA.

McEneaney, J. E. (2001, December). *The Language Arts (Di)lemma.* Paper presented at the annual meeting of the National Reading Conference, San Antonio, TX.

Nabokov, P. (Ed.). (1991). *Native American testimony.* New York: Penguin.

New London Group. (1996). A pedagogy of multiliteracies: Designing social futures. *Harvard Educational Review, 60* (1), 60–92.

Noddings, N. (1992). *The challenge to care in schools.* New York: Teachers College Press.

Patterson, L., & Shannon, P. (1993). Reflection, inquiry, and action. In L. Patterson, C. Santa, K. Short, & K. Smith (Eds.), *Teachers are researchers: Reflection and action* (pp. 7–11). Newark, DE: International Reading Association.

Prosser, J. (1992). Personal reflections on the use of photography in an ethnographic case study. *British Educational Journal, 18* (4), 397–411.

Prosser, J. (Ed.). (1998). *Image-based research: A sourcebook for qualitative researchers.* Bristol, PA: Falmer Press.

Rosenblatt, L. M. (1978). *The reader, the text, the poem: The transactional theory of the literary work.* Carbondale: Southern Illinois University Press.

Saul, W., Reardon, J., Schmidt, A., Pearce, C., Blackwood, D., & Bird,

M. (1993). *Science workshop: A whole language approach.* Portsmouth, NH: Heinemann.

Schwartz, D. (1989). Visual ethnography: Using photography in qualitative research. *Qualitative Sociology, 12* (2), 119–155.

Short, K., Harste, J., & Burke, C. (1998). *Creating classrooms for authors and inquirers.* Portsmouth, NH: Heinemann.

Sontag, S. (1977). *On photography.* New York: Dell.

Sweet, J. (1997). The national policy perspective on research intersections between literacy and the visual/communicative arts. In J. Flood, S. B. Heath, & D. Lapp (Eds.), *Research on teaching literacy through the communicative and visual arts* (pp. 286–300). New York: Simon & Schuster Macmillan.

Towell, J. (2000). Teaching reading: Motivating students through music and literature. *The Reading Teacher, 53* (4), 284–289.

Tufte, E. (1990). *Envisioning information.* Cheshire, CT: Graphics Press.

Wagner, J. (1978). *Images of information.* London: Sage.

Winston, B. (1998). "The camera never lies": The partiality of photographic evidence. In J. Prosser (Ed.), *Image-based research: A sourcebook for qualitative researchers* (pp. 24–39). Bristol, PA: Falmer Press.

ဆ CHAPTER 2

Images of the Body from Popular Culture
Engaging Adolescent Girls in Critical Inquiry

Kimberly L. Oliver

ဆ PERFECT BODIES ဆ

When I think of perfect bodies I see a woman with slim, shaped legs, a flat stomach, slender arms, and plenty of shape (nice sized hips and breasts)—Brandi (written text)

Bodies that are in shape and nice and fit—Jaylnn (written text)

∞ STYLE ∞

It is saying buy and wear our clothes, they're the best—Danielle (written text)

Gives people the idea that they should dress a certain way but that's not true. You should dress reasonably. Everything you wear doesn't have to be expensive—Monique (written text)

> Many aspects of physical culture, particularly those relating to bodies and represented through TV and magazines, are a continuously present resource, which provide adolescents with points of reference for themselves and orientations to each other. Young people are consumers of the products and commodities of popular physical culture....Nevertheless...young people do not use cultural resources uncritically. (Kirk & Tinning, 1994, p. 620)

I am surrounded by images of popular culture that adolescent girls negotiate daily, and I am terrified. I have come to the point in my life where I refuse to participate in and perpetuate this type of cultural oppression of girls and women, (i.e., I will no longer buy or read women's magazines). And, yet, I wonder how adults can help adolescent girls learn to critique these cultural icons (Oliver, 1999), and learn to name and resist the more subtle and harmful messages about the body that are imbedded through popular cultural images (Oliver & Lalik, 2001). I am keenly aware of the historical, philosophical, debilitating mind/body dualism that has created a space for our culture to disembody and objectify human beings and, specifically, women (Dewey, 1932/1985). I understand the theoretical arguments that have filtered through our literature for years on the ways in which our bodies are used as a means of regulating our behaviors (Bordo, 1989; Foucault, 1977; Shilling, 1993; Sparkes, 1996, 1997; Wright, 2000). I am well aware of the feminist critiques regarding how our culture uses women's bodies to continue the oppression of girls and women (Bloom & Munro, 1995), especially in terms of race (Collins, 1991, 1998; hooks, 1989, 1990, 1995; Fordham, 1996; Oliver & Lalik, 2001), class (Collins, 1991; Oliver, 1999); gender (Bordo, 1989, 1997; Wolf, 1991; Oliver & Lalik, 2001), sexuality (Fine, 1992), age, and ability (Sparkes, 1997). I am in agreement with the cries from educators to offer adolescents opportunities to explore and critique the body in popular culture (Armour, 1999; Kirk & Tinning, 1994; Kirk & Mac-

Donald, 1998; Oliver, 1999; Oliver & Lalik, 2001; Tinning & Fitz-clarence, 1992; Vertinsky, 1992). And still I am left wondering when we as a culture—and, more specifically as a collective group of educators and scholars—are going to admit to the devastation that we are creating and take active responsibility for supporting the kinds of change that might create more socially just and healthy environments in which adolescents—girls and boys—can grow up. I am inspired by the words of Maxine Greene (1995): "Imagining things being otherwise may be a first step toward acting on the belief that they can be changed" (p. 22).

My intent in this essay is to begin to trace what has become an ongoing inquiry into the use of image as a research method and a curricular technique aimed at helping adolescent girls name and critique the meanings of their bodies. Within this strand of my research, I am particularly interested in using teen magazines as a research method with a pedagogical intent to (a) tap girls' interests; (b) help girls name their experiences of their bodies; and (c) help girls learn to critique dominant stories and images of the body. By looking at images within adolescent popular culture that girls find interesting and/or meaningful, I will explore why physical educators need to help girls learn to critique these images of the body, and show how I use teen magazines in the process of engaging adolescent girls in critical inquiry. I see this research as a continual process open to new ways of thinking and exploring what it means to use images of the body with girls. Thus, I include a discussion of some of the pedagogical possibilities that this type of curriculum research creates, as well as some of the struggles I have encountered as my use of image with girls has evolved.

Engaging Girls in Critical Inquiry

Although information is always better than silence, we need to think about how girls learn about their bodies and whose interests inform the presentation of this critical information. (Brumberg, 1997, p. 53)

There is not a day that goes by that girls are not bombarded with

messages about their bodies. "Buy this product and your skin will appear smooth"; "Wear this dress and others will notice you"; "Take this pill and you will magically shed the pounds"; "Try this gel and your hair will be straight and beautiful." Adolescence is a time when girls become particularly interested in and often preoccupied with their bodies and the bodies of others (Brown & Gilligan, 1992; Oliver & Lalik, 2000; Pipher, 1994). The glossy teen magazines that girls look at and read depict images of girls deemed socially beautiful and desirable with few, if any, bodily flaws. Yet, the images we find in these magazines are remarkably similar. It is as if through popular physical culture we are mass-producing girls' bodies with the hope of mass-producing girls' sense of selves. Sparkes (1997) claims that what we think we are and who we hope we can become is shaped in part, by the dominant cultural stories that are available to us. When the stories about girls' bodies are narrow in scope, often portraying girls as objects of male desire (Berger, 1972; Bordo, 1997; Wolf, 1991), we limit girls' life possibilities and jeopardize girls' health.

We have been shown consistently how women's sense of self becomes brutalized when the female body is objectified and demeaned in society (Bordo, 1997; Collins, 1991; hooks, 1989; 1995, Fine, 1992). Feminist writers have documented the crucial role that the body plays in the reciprocal relationship between women's private and public identities. Given that we live in a culture that uses images of beauty as a means of controlling women, the body becomes a site for political struggles. Wolf writes, "The ideology of beauty is the last one remaining of the old feminine ideologies that still has the power to control those women whom second wave feminism would have otherwise made relatively uncontrollable" (1991, pp. 10–11). For women of color, this beauty myth is doubly dangerous, for the "universal standard of beauty" sustains white supremacist images as the ideal (hooks, 1995). As women begin to internalize the social meanings that are publicly attached to the body, their private feelings of self-worth are jeopardized. Even for those of us who consciously strive to reject the oppressive ways in which women are represented in culture, we still live with embodied feelings of doubt (Oliver & Lalik, 2000).

Given the ways in which our culture uses women's bodies to perpetuate the oppression of women, we are not surprised at how girls learn to become so concerned with the way their bodies look (Oliver & Lalik, 2001). While we cannot, and should not, assume that girls experience their bodies in the same ways as do women, we do know that the social oppression of girls and women stems, in part, from the visual world constructed in our culture. The images presented on the Web, television, MTV, and videos and in ads and teen magazines are part of adolescents' visual worlds (Kirk, 1999; Kirk & Tinning, 1994; Lankshear & Knobel, 2001; Tinning & Fitzclarence, 1992). This is a stimulating world in which slim and muscular bodies, with White features or characteristics, are constructed as the dominant icon of desirability. Girls' bodies, as portrayed through popular cultural images, become the norms in which girls learn to evaluate themselves and others (Oliver, 1999). The messages girls receive about their bodies through popular cultural images, as well as the ways in which girls learn to think and feel about their bodies, have implications for physical educators (Armour, 1999; Kirk, 1999; Kirk & Tinning, 1994; Oliver & Lalik, 2001).

Cries from researchers in physical education to engage students in critically studying their experiences of their bodies are becoming louder and more sustained (Armour, 1999; Gard & Meyenn, 2000; Kirk & Claxton, 2000; Kirk & Tinning, 1994; Oliver & Lalik, 2001; Wright, 1996). Armour (1999) claims that physical educators could benefit from establishing more of a body-focus in physical education curriculum. Similarly, Vertinsky (1992) claims that physical educators need to pay more attention to the ways in which adolescent girls' cultural perspectives contribute to how they construct their sense of self. Vertinsky believes that creating opportunities for girls to talk about their bodies and analyze social and cultural issues related to health is one step toward helping girls learn to interpret empowering messages and resist destructive ones. Furthermore, if we hope for girls to develop into healthy women, we need to help them learn to critique images of the body within popular culture (Oliver, 1999; Oliver & Lalik, 2001).

While these are noteworthy ideas, it no longer seems sufficient merely to offer such suggestions without also critically studying such possibilities with actual girls (Oliver & Lalik, 2000). Much of our literature on the body remains either abstract or theoretical (Armour, 1999; Sparkes, 1997; Theberge, 1991; Vertinsky, 1992). We have few data-based examples that illuminate what critically studying the body with adolescents might look and sound like (Kirk & Claxton, 2000; Oliver, 1999; Oliver & Lalik, 2001, 2000). Much more research in this area is needed if we hope to begin to develop curricula that may help girls name and critique their experiences of their bodies in ways that might be helpful to their health and well-being. What follows is one study that explores ways of working with adolescent girls with intent to help them name and critique images of the body in popular culture.

One of my hopes in using images from popular culture in this research was to begin to understand how adolescent girls interpreted some of the dominant stories of the body available to them. I believed that by using teen magazines, the girls might begin to name and recognize some of their unassumed beliefs about the body. I wanted to work with them to help them find a language with which they could communicate these beliefs. And eventually I began wanting to help them critically reflect on their beliefs about women's bodies by focusing on how their beliefs, and the beliefs of others, were helpful and/or harmful to girls' health and well-being. This project reflects, in part, the perspective of activist research as described by Michelle Fine (1992):

> Activist research projects seek to unearth, interrupt, and open new frames for intellectual and political theory and change. Researchers critique what seems natural, spin images of what's possible, and engage in questions of how to move from here to there If there is no other task that feminist activist researchers can accomplish, we must provoke a deep curiosity about, indeed an intolerance for, that which is described as inevitable, immutable, and natural. (pp. 222–223)

If we hope to push socially critical pedagogy forward through educational research, such activist research projects seem worthy of further pursuit (Rovegno & Kirk, 1995). That is, we need examples in

our professional literature that bring social, critical, and feminist theories into the classrooms with real students so that we might begin to better understand how these theories can and cannot influence pedagogical practices and curricula designed with and for adolescents.

Setting/Participants

This essay draws on insights from multiple studies with adolescent girls, and data from one particular study. The data comes from a study that took place in a predominately African-American middle school in the Deep South of the United States. Uniquely, Tornado Middle school includes only eighth-grade students. The single grade level is the result of increased efforts to integrate city schools. The logic was that if all students in the same grade were required to attend the same school that the schools would become more integrated. Despite attempts, the school caters to approximately 70% African-American students and 30% European Americans.

Within this study, I worked with two groups of girls (four girls per group) during their regularly scheduled physical education classes. All eight girls had parent permission and were selected because of their interest and willingness to commit to working with me every Friday for the 1998–1999 school year. Fridays were designated for either making up work or as choice days. Although several other girls indicated an interest in working with me, they were not ready to commit giving up their choice day for the entire year.

The girls and I met in a private classroom one day per week for 60 minutes throughout the 1998–1999 academic school year. The goal was to engage in a critical study of the body to supplement the physical education curriculum that the girls currently were receiving. The first group consisted of two African-American girls from working-class families, Monique and Janae. Both girls identified as "dark skinned." The other two girls were European American, one from a middle-class family (Kristi) and one from a working-class family (Danielle). The second group consisted of four African-American girls, two of whom identified as "light skinned," Brandi and Jaylnn, and two of whom identified as "dark skinned," Alexandria and Des-

tiny. All four girls came from various levels of working-class families. The names used in this essay are pseudonyms selected by the girls.

My biography differs from the majority of girls I worked with. I am a 33-year-old white woman who was raised in an upper-middle-class family in Southern California. I currently teach at a research institute in the Deep South of the United States. My abilities to understand these girls' experiences are limited to my outsider stance (hooks, 1995). Given my different social and cultural positioning, I strive to keep the girls' voices in the forefront so that others, with their multiple subjectivities, can interpret the girls' voices in their own ways (Collins, 1998; hooks, 1995).

Ways of Working with Girls

Although the purpose of this essay is to highlight the ways in which I use teen magazines to help girls critique the body in popular culture, it is important to the broader context to understand the other forms of inquiry I was engaging the girls in throughout the course of this research project.[1] Even though I worked with two groups of girls, and there were some differences between what I did with one group as compared to the other, the overall forms of inquiry were similar. I describe the inquiry process (what some would call data collection) rather than the specifics of each group in this particular essay.

I began this study by inviting the girls to write personal biographies, and asked them a series of questions relating to their home life, personal interests, school involvements, and so on. In addition, I asked the girls to create personal maps of where they spent their time and with whom they spent their time (Oliver & Lalik, 2000).

The next task included what I call a magazine exploration (Oliver, 1999). This method will be described in much more detail throughout the remainder of the essay. My hope was to tap and sustain the girls' interests by using one medium from popular culture that emphasizes girls' bodies (Lankshear & Knobel, 2001).

[1]The research methods I describe as part of the inquiry process can also be seen as curricular tasks that can be used with students in schools. Thus, I interchange the terms research methods and curricular tasks.

At the same time as we were engaged in magazine exploration, I gave each girl a journal and asked her to document the times she noticed her body. I encouraged the girls to write about what they were doing when they noticed their bodies, what they were thinking, and what they were feeling. Furthermore, I asked them to write about things that made them feel good and bad about their bodies and explain why. As the girls wrote in their journals, I responded by asking them to elaborate or explain their written ideas in more detail. I also asked them questions to help them think more critically about some of the things they were saying. Journal topics also emerged from group discussions.

In addition to the magazine exploration and journal writing, I gave each girl two disposable cameras. First, I asked the girls to take pictures of things that made them feel good and/or bad about their bodies. Second, I asked them to take pictures of things that sent messages to other girls about their bodies. My hope with the photo analysis was to create a space to explore issues of the body that weren't confined to images created by those who hold social and cultural power (Delpit, 1995).

Finally, I invited each group of girls to engage in a student/researcher designed inquiry project that centered on some aspect that implicates girls' bodies. The first group studied "girls' perceptions of what attracts attention." This topic emerged from the magazine exploration. The second group of girls studied girls' perceptions of the "Beauty Walk." Within the inquiry projects, as a group, we designed surveys to get at other girls' perceptions of one of the two topics. The purpose behind studying "other girls' perceptions" came out of previous research in which we found girls were more willing and able to critique the status quo, or dominant discourses, when talking about "other girls" (Oliver & Lalik, 2000; Oliver & Lalik, 2001). As a group, we pilot tested the surveys on 10 girls in their physical education class to see if the questions made sense to anyone beside ourselves. After minor survey revisions, we surveyed two different physical education classes. The girls then analyzed the surveys, looking for common themes and areas of contradiction.

Based on our findings, we discussed how girls' perceptions could be helpful and harmful to girls' well-being. We tried to imagine ways of thinking that would be more helpful to girls' sense of self.

The major tasks that we engaged in created spaces (Obidah, 1998) for group discussion, reflection, and critical analyses that took us across the year we spent together. All group discussions were audio-taped and transcribed. What follows is a more detailed description of how I use images from teen magazines as means of engaging girls in critical inquiry about the body. This process is about co-constructing bodily knowledge and reflecting critically on this knowledge. The analysis is broken into three main parts: (a) tapping girls' interests; (b) helping girls name how they experience their bodies; and (c) using images to critique dominant stories of the body. Within each of these sections, I will foreground the process by looking at the curricular tasks as well as the verbal engagement through which the girls and I negotiated the tasks together. The data is used to illustrate the peda-gogical possibilities of engaging girls in critical inquiry on body. I conclude the essay by discussing the pedagogical possibilities for studying the body with adolescent girls that emerged and reflect criti-cally on the struggles involved in the process of engaging girls in critical inquiry.

Using Images from Popular Culture

Tapping Girls' Interests

> Go through the magazines and cut out pictures and/or text that are of inter-est to you and categorize your pictures/text any way you want. (Task sheet, 9-25-98)

> *Cute clothes/shoes: When I see cute clothes, I think I want that and the same with shoes.* —Brandi (written text that accompanied a Dillard's department store advertisement for Tommy Hilfiger back-to-school clothes)

When I first began using images in my research, I did so with two main purposes in mind. First, I wanted to tap and sustain girls' inter-ests, and believed that by using magazines from adolescent popular culture I might be able to better understand some of the things girls

found meaningful. Dewey (1916/1944) claims that we are educated by and through our interests. Furthermore, Lankshear & Knobel (2001) claim that within an attention economy if we hope to capture and sustain adolescents' interests, we need to attend to those areas that currently attract their attention. Issues of the body are of significant importance to many girls; hence, this is a topic that attracts their attention (Brown & Gilligan, 1992; Oliver & Lalik, 2000; Pipher, 1994).

In addition, I wanted to use images from teen magazines as a research technique aimed at understanding how adolescent girls constructed the meanings of their bodies. I agree with Maxine Greene (1995) and Elliot Eisner (1993) that multiple forms of representation create spaces for multiple meanings to emerge; thus, using images from popular culture seemed appropriate for several reasons. I thought that magazine images could help girls reveal meanings about the body that were difficult to understand through written or verbal discourses. Further, adolescence is the time when girls are being initiated into a culture that places great importance on women's bodies through visual representations such as magazines, billboards, television, and the Internet (Berger, 1972; Brown & Gilligan, 1992; Lankshear & Knobel, 2001; Pipher, 1994; Wolf, 1991). Understanding the images girls looked at and found interesting seemed important to understanding how they were constructing the meanings of their bodies (Oliver, 1999).

After my initial trial of using teen magazines, I learned that image was a very powerful source of information for the girls I worked with, particularly in making judgments about their self-worth and that of others. I also learned that using images was helpful in understanding some of the girls' experiences of their bodies (Oliver, 1999). It was from the knowledge I gained when I first used images with girls that I began wondering how I could use images more purposefully.

Although inviting girls to "cut out pictures that were interest to them and categorize their pictures" was a good place to begin, it did not appear to be sufficient for understanding some of the more intricate ways girls were constructing the meanings of their bodies. I

wanted to extend the magazine exploration to include a section that asked girls to explore how the images they found interesting related to the body, as well as how they made them feel specifically about their own bodies. I wanted to understand which images made them feel good about their bodies, which ones made them feel bad about their bodies, and why. I thought that this might be useful information for physical educators, that is, to help us to understand some of the aspects of physical culture (Kirk, 1999; Lankshear & Knobel, 2001; Knobel & Lankshear, 2001) that influence how girls think and feel about their bodies. Perhaps we could find more responsive ways of creating curriculum that takes into consideration girls' experiences of their bodies. Often educators focus on issues of the body that deal with physical activity and sport, things that we believe *ought* to be important to adolescents, rather than taking seriously bodily experiences that they think are important. In an attention economy (Lankshear & Knobel, 2001), using girls' interests (i.e., the body) to gain and sustain their attention might be a necessary starting point for helping them learn to value other important areas of physical education such as engagement in lifelong physical activity.

Helping Girls Name How They Experience Their Bodies

Tapping girls' interests with images from popular culture was the starting place. From there, my goal was to use these images as a means to help girls name their experiences of their bodies. That is, the images the girls selected created spaces for conversations about how girls' bodies are portrayed in culture and how these representations influence how these girls were learning to think and feel about their bodies. Part of the process dealt with finding ways to engage the girls in reflective and critical conversations about the images they had selected. The tasks given initially to the girls are an important part of this analysis. However, what is crucial to understanding how the girls responded to these tasks and the artifacts they created, is seen more clearly through the verbal engagement that took place as the girls and I negotiated the tasks together. What became central in these negotiations was the type of questioning required on my part to help the girls

name their experiences of their bodies.

Describing Tasks/Questions

After the girls had selected images they found interesting and categorized those images, I asked the girls to write about what each category meant. On a task sheet, I wrote—

> Explain what each category means and why each picture is in that particular category. (Task sheet, 10-9-98)

The task sheet was an insufficient way to explain what I wanted the girls to do. In addition, I had to explain verbally more than once what I meant.

> Researcher: *On a piece of paper, I want you to describe to me what these categories mean. So if you have a category, food, describe what that means to you...And do it for all the categories...Then we're going to come up with a group description, and then I'm going to have you explain to me why the pictures are in the particular categories.*
>
> Monique: *Okay, do we have to write something about each category?*
>
> Researcher: *Yeah, you have to write what they mean. Be descriptive. Describe what a food category would be. Describe what it has to do with your body. Or what it has to do with how it makes you think or feel about your body.*

So, for example, Destiny selected an image of an African-American woman in a short top and tight shorts that covered three quarters of her bottom, smiling at the camera while using a leg curl weight machine to use as her prompt for the category "Perfect Bodies." She wrote:

> Perfect bodies—perfect bodies are bodies that are thin and thick, well a little mixture of both, not too fat, not too skinny (medium sized breasts, hips, legs, and thighs).

The reason for asking the girls to describe their categories in writing before we moved onto the group discussion and description stemmed from previous experience, in which adolescent girls sometimes have an easier time discussing what they are talking about when they have had an opportunity to write first (Oliver & Lalik, 2001). After the girls had an opportunity to describe what the categories meant to them, we moved onto the group discussion. Once we

began discussing the categories in the small group, my form of questioning shifted from purely descriptive to more of a connective type of questioning. That is, I found I needed to begin by asking questions that elicited description. To help the girls elaborate, I then needed to ask questions that helped them connect what they were saying explicitly to the body.

Connective Tasks/Questions

In order to help the girls make explicit how their categories related to the body, I asked them to tell me "what their categories had to do with the body" and how the pictures they selected "made them think and feel about their bodies." Thus, the majority of questions I asked during our conversations centered on helping them make explicit exactly how these categories and images related to the body, or how they made them think and feel about their own bodies. Two examples of how the girls and I discussed the categories illustrate how I used both descriptive and connective questions to help the girls name their experiences of the body. This is important in helping girls learn not only to name but also critique how their bodies are portrayed in culture, and requires very active participation on the part of the teacher. Part of this active participation comes in the form of strategic questioning aimed at helping the girls elaborate what they are saying (Oliver & Lalik, 2000).

❧ MAIN TRENDS/FASHION STATEMENTS ❧

Researcher: *All right, what shall we do next—fitness, health care, main trends/fashion statements, hair, or hygiene?*

Janae: *Do main trends.*

Researcher: *Main trends? Okay, describe what this category means.*

Janea: *It means trends that are well known and are worn at like that certain period of time. Everybody wears at the same time.*

Researcher: [Taking images in my hand of white girls in 3 to 4 inch heels and short tight skirts and tops.] *I mean, describe to me why—why are these people in main trends or fashion statements?*

Kristi: *Because of their cute outfits.*

Researcher: *Cute outfits?*

Janae: *They're trendy.*

Monique: *I like those shoes.*

Janae: *'Cause like they're dressed according to like the trend everybody wears now.*

While the girls were able to describe the category, I was interested to learn how they thought this related to the body, so I asked a connective question, one intended to help them explicitly relate this category to the body.

Researcher: *How does "main trends" have anything to do with the way you would think or feel about your body?*

Janae: *Make you feel like you standing out.*

Researcher: *Okay, so main trends would make you stand out?*

Janae: *Uh-huh.*

Janae was able to describe what the category meant to her, that is, clothes that are "well known" and was able to say why this category related to the body, "make you feel like you standing out." However, I also was interested in seeing whether the girls could verbalize how this category made them feel about their own bodies. I tried again to redirect the question so that it focused on how they thought about their own bodies.

Researcher: *Okay, how else would it make you think or feel about your body?*

Kristi: *Certain clothes make you feel smaller and certain make you feel bigger.*

Janae: *Yeah.*

Researcher: *Certain ones make you feel smaller and bigger— Explain that.*

Kristi: *Like if you're wearing like a really tight shirt you feel like fat for some reason.*

Researcher: *What kinds of clothes don't make you feel fat?*

Kristi: *Some types can make you feel fat and some can't.*

Researcher: *Okay, so sometimes tight clothes can make you feel fat, sometimes?*

Kristi: *It just depends on what it is. A t-shirt you can't really feel fat in. I mean a t-shirt is just like baggy.*

Again, I tried to find ways of questioning that would help the girls further elaborate what they were trying to explain. This time Janae was able to name specifically why clothes can "make you feel fat."

Researcher: *Why is it that you think clothes will make you feel fat, though? I mean, your body isn't going to change sizes depending on what you put on.*

Janae: *The way they look on you.*

It was through a series of questions that the girls were be able to get to a point where they could actually name why something was a particular way (i.e., clothes can make you "feel fat" because of "the way they look on you"). However, had they been limited only to the task at hand and not had an adult who could help them elaborate by way of questioning, their responses would most likely be less detailed. Greene (1995) reminds us of the importance of being able to name the meanings of our experiences if we hope to make intelligent choices. In this case, it is important to help girls elaborate so that they can critically reflect on what it is they are saying in relation to what it is they believe. Even if what they believe about girls' bodies appears to adults to be "unhealthy" or "oppressive," we have to be able to get at what they think before we can help them learn to question their beliefs (Gee, 2001). This type of questioning is not intended to get girls to say what you want them to say but, rather, to help them elaborate and articulate their thoughts so that as educators we can begin to move them into critical spaces (Dillon & Moje, 1998).

ଛ MAGAZINE QUIZZES/INFORMATION ଛ

Magazine Quizzes/Information—Information and quizzes that interest us. Good information about how we can get boys, weight, hair, clothes, etc. —Alexandria (written description about an article that read: "Top ten secrets to increasing your popularity," [September 1998, *Young & Modern*, p. 90])

Researcher: *What about magazine quizzes? Explain this category to me. What's*

this have to do with your body?

Alexandria: *They could tell you about anything.*

Brandi: *Yeah, like do you have too big hips.*

Researcher: *Do you believe what they say? Like, let's say they had an article in here about what too big hips are, would you believe?*

Alexandria: *No, 'cause that's their opinion—Information, now, that might be helpful.*

We need to help girls learn that any form of information is laced with values, and that just because something is presented as "fact" does not mean that they should take this information as "the truth" and not question its validity (Ladson-Billings, 1994). In other words, we need to help girls learn how to criticize texts and images supposed "facts" about their bodies. This is particularly important for physical educators who hope to guide young people in the process of learning to live healthy lives, because our culture bombards young people with body messages: things such as quick-fix remedies for losing weight or increasing muscle mass, or stereotypical appropriate physical activity for girls and boys. Many of these body messages come in the form of "information."

Researcher: *Oh, here's something.* [I pick up the picture/article.] *It says "Truth: Popular girls are expected to look perfect"* (September 1998, *Young & Modern*). *Do you think that's true, that popular girls are expected to look perfect?*

Brandi: *Not necessarily.*

Alexandria: *Not be perfect.*

Jaylnn: *Most of them— I don't pay any attention.*

Brandi: *I would pay more attention than I would think I did.*

Researcher: *Why do you think that is?*

Brandi: *I don't know. See, when I'm in band, I pay a lot of attention to, guess who? See, I pay a lot of attention to Janae because she's my size, but she's cute for some-body—to be somebody about my size.*

Alexandria: [says to Brandi] *Tell her boys like her—talk to her.*

Brandi: *We're like the same size and I wonder why they [boys] talk to her instead of me sometimes....*

Destiny: *'Cause she dresses and gets her hair done.*

Researcher: *Do you think that boys only look at you because of the size of your body?*

Brandi: *What?*

Researcher: *I said, do you think boys only look at you and are interested in you be-cause of the size of your body?*

Jaylnn: *Most of them.*

Brandi: *Size, face, and body.*

This type of conversation illuminates why girls need to have the opportunity to learn in school that they are more than "just the size of their bodies." And, whereas these girls know this in some ways, their language in this particular conversation reveals the power of the dominant representation of women. That is, that women are seen as "bodies first and people second" (Bloom & Munro, 1995, p. 109). We also can see why it is so important that physical educators are sensi-tive and do not unintentionally perpetuate this oppressive cultural narrative by trying to motivate girls to be active so that they will *look better.*

Naming the Personal

Building on the images that the girls selected, based on their personal interests, I extended this magazine task to look closely at how the pic-tures they selected made them think or feel about their own bodies. Whereas some of my connective questioning included this, I wanted

to try one last way of helping the girls name their experiences of their bodies. On a task sheet, I wrote, "Individually, go through the magazines and/or the pictures that you already cut out and categorize the pictures that make you feel good about your body and make you feel bad about your body. On an index card, write why each picture makes you feel good/bad about your body being as descriptive as possible" (task sheet, 10–23–98).

My hope was to use the cultural images they selected to elicit emotional responses. Thus, I encouraged the girls to describe through writing their responses to the images. The images provided a tangible object with which to reflect on, respond to, and critique. After the girls finished creating categories for their piles of images, I asked them to do the following:

> Okay, what I want you to do is to go through and pick out five categories-whichever ones you want. It doesn't matter. You're going to pick out five topics of categories and describe how each of the categories makes you think and feel about your body. For example, "fitness and health." If I were going to write on fitness and health I would write about how this category makes me think or feel about my body. So pick out 5 of these categories—and if you want to write about more, then that's fine. But write about how they make you think or feel about your body, being as descriptive as you can.

∞ MAIN TRENDS/FASHION STATEMENT ∞

Makes me feel good about myself because I fit in with others. —Kristi (written text)

By looking at the main trend category makes me think about my body because I see the people in the size clothes that I want to wear. The best thing about looking at the main trend pictures is that I have some of the 'trendy' clothes that they wear. —Janae (written text)

Some clothes make me feel bad because I know I will never be able to wear them. —Danielle (written text)

❧ FITNESS & HEALTH ❧

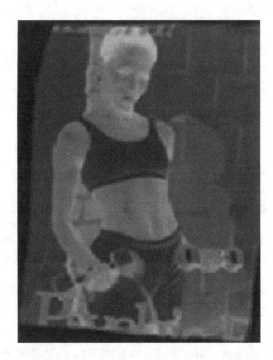

Fitness & Health: With this category it's like, it makes me feel as though I shouldn't be fat and makes me think if I don't exercise, then I'll be fat—Monique

Fitness & Health: I like martial arts. I watch a lot of shows that involve karate or Kung Fu. It is very interesting and makes me want to learn it. —Danielle

"Fitness & Health," "Main Trends/ Fashion Statements," "Cute Hairstyles," "Sayings," and "Magazine Quizzes/Information" were a few of the categories the girls selected. It was very common to read things like:

Hair styles make me feel lovely, and it makes me feel good about my body—Danielle

Hair makes me look good like I'm going out into public. It makes me feel good because I attract attention to the people around me—Janae

The woman with the pretty hair is how I want my hair styled—Monique.

Looking at the images of African-American women these girls se-
lected, it was clearly noticeable that most of the images depicted black
women with straight hair. This created a space for us to discuss issues
of race and racism. No longer oblivious to this subtle form of white
supremacy, I asked Destiny, Brandi, Alexandria, and Jaylnn, "Why do
you think most of the black women have straight hair?" I wondered
whether these girls even questioned this—they certainly had not in
our group discussions. I selected one of the pictures of an African
American woman with kinky shoulder-length hair that the girls had
cut out to represent "perfect bodies" and asked them to comment on
her hair. Brandi responded, "It looks nappy. I don't know if it is, but
it looks like it."

"I think it looks natural," I said, only to hear from Brandi, "It
don't look right." Brandi, Alexandria, Destiny, and Jaylnn went on to
discuss how straight hair "looked better," "was neater," "classier,"
and more "sophisticated." Alexandria claimed that if you do not
straighten your hair, like this person "it look like you don't care for
you body—like you just don't put the time out for yourself. You want
to look good but you won't do you hair or anything." One of the
more frustrating aspects of this type of work was to watch the girls
reject images of women who did not conform to racist standards of
beauty (hooks, 1995).

Using Images to Critique Dominant Stories of the Body

Go through the magazines and cut out pictures and/or text that send mes-
sages to girls about their bodies. Categorize your pictures and/or text any
way you want. Write descriptions about each category. What messages are
being sent to girls about their bodies? How are these messages helpful
and/or harmful to girls? (task sheet, 3-19-99).

In this next magazine exploration, I looked at my attempt to help girls
name and critique some of the dominant stories of the body in popu-
lar culture. My hope was to begin to help girls critique how the cul-
tural images of girls' bodies were helpful and/or harmful to girls'
health and well-being. As Greene (1995) claims, it is only after we can

name the meanings of our experiences that we can become more criti-
cal and imagine alternative or better possibilities. The girls were mak-
ing small strides toward identifying what they were learning, both
directly and indirectly, about their bodies through the images and
text in teen magazines. I thought that if they could begin to name spe-
cifically what was being implied girls should wear, or look like, or act
like, or be like, maybe a space would open in which they could begin
publicly challenging some of the more life-limiting messages (Gee,
2001). This part of the critical inquiry process was the most difficult.
In many ways, I was asking these girls to go against traditional cul-
tural values and norms. Any time you ask others to go against the
"norm" or the status quo, you create certain tensions (Cochran-Smith,
1995).

Creating Critical Spaces

I began by giving each girl a copy of the task sheet (see above) and
followed it with this explanation:

> Researcher: *What I want you to do first is to go through the magazines and to cut
> out pictures or text, text meaning advertisements and the words, or titles, or what-
> ever. Cut out pictures or text that sends messages to girls about their bodies—So
> anything you see that tells girls something about their bodies.*

> Kristi: *Like something they need?*

> Researcher: *Anything. I mean just anything that you see in here that is, uhm, a
> message, whether it is a direct message or a subtle message to girls about their bod-
> ies. Whether it be what they should do, what they need, what they should look like,
> any of that... And then as a group we are going to categorize the pictures.*

Monique, Danielle, Janae, and Kristi claimed that girls receive
messages about their bodies from a variety of sources. The categories
the girls created to explain the messages that girls receive about their
bodies through images in popular culture included: "fitness";
"hair/hair products"; "style"; "body products"; "quizzes"; and "peo-
ple." It took a while for the girls to figure out which categories they
should create for their pictures. Once the categories were created, I
gave them a piece of paper and said:

Researcher: *All right, this is what you are going to do next. And you each get to do this on your own—I want you to write a description for each category—What messages are being sent to girls about their bodies? I want you to look through the pictures and the text that you have cut out for these. I want you to write a description about the category and what messages are being sent to girls about their bodies? You're going to have to critically analyze what messages are being sent to girls about their bodies because of these pictures and the texts. This is going to require thought—What you probably need to do is to spend a little bit of time looking at some of these pictures and talking about each one of them. Or pick out three and talk about them.*

Monique: *What do we have to write on?*

Researcher: *Okay, I want you to pick out your favorite picture from each category.*

Kristi: *Just one picture, okay?*

Researcher: *Yeah, make sure you write on the picture you pick out—Once everybody has their picture I'll tell you what we're gonna do. I want you to think about why you liked this picture and what messages are being sent to girls about their body —So go through and figure out, actually write down —what messages are being sent to girls about their bodies from your picture. Label your pictures on your sheet so you can remember the picture.*

Trying Again

The effort on my part to reword and re-explain what I wanted the girls to do was extensive. I simply did not have the language I needed to connect with them, to help them think more critically about what they were learning through the images they found interesting. This section illuminates two of the many attempts it took to get the girls to make very small steps toward critiquing the images.

After the girls had been working for a while, Kristi showed me what she had written. She was holding a picture of a young woman in a bikini, and her accompanying text read, "I like the bathing suit she is wearing." I tried to get Kristi to tell me what messages are being sent to girls about their bodies from this particular picture, so I asked:

Researcher: *Right, but see, this is your opinion on why you like the picture. Now*

tell me what the picture says to you about——I mean, what message is being sent to you from this picture?

Kristi: *But that is what it's saying to me——that I like the bathing suit she's wearing.*

Researcher: *When you look at this picture, when you look at the bathing suit picture, what messages are being sent to you about your body? Just looking at this picture.*

Kristi: *I want to write this down 'cause I want to remember some of this stuff.*

Researcher: *Ahh.*

Kristi: *Okay, that she's smaller than me.*

Researcher: *So what's the message?*

Kristi: *I cut it out just 'cause I liked the bathing suit.*

Kristi was able to name why she liked the picture (i.e., the girl was smaller than she was), but she was unable to name the possible messages being sent to girls about their bodies (e.g., that this is an appropriate size for a girl, or girls need to look like this if they want to wear this swimsuit). Not ready to give up trying, I moved to a new strategy. I thought we would talk about the messages as a group.

Researcher: *Now what I want you to do is to pick out one picture. Oh, umm, I don't know——Pick out any picture you want just one of your pile——I want you to explain to everybody what the category says to girls or what message is being sent to you about your body.*

Janae: *Are you asking me? —— [She picks up a picture from her hair category] I said it's important to keep up with your hair.*

Monique: *To keep it decent.*

Researcher: *Okay, so the message is it's important to keep your hair looking decent? All right. What's decent? Does this show what decent is?*

Janae: *Yeah.*

Researcher: *Now let me ask you, what if I did not have naturally straight hair, what message is that telling me?*

Kristi: *Then you get to pull out a curling iron every morning.*

Janae: *That you should have neat hair.*

Researcher: *Okay, but tell me, her hair is straight. What if I didn't have straight hair?*

Janae: *If it was curly?*

Researcher: *Okay, so my hair doesn't have to look like this to look decent?*

Janae: *Uh-uh. You need to just look good.*

The girls continued to struggle through the task of describing which messages were being sent to girls about their bodies. The above examples were typical of the types of spaces I tried to create to help the girls think beyond mere description or why they selected the images.

Seeking Further Critique

❧ HAIR & HAIR PRODUCTS ❧

You need to purkify (make yourself pretty or purky). It makes you fell good or pretty. It is harmful as it might get stuck in your hair. —Danielle (written text)

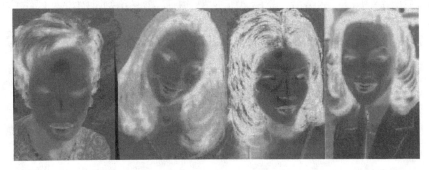

Grooming your hair is a # 1 thing. Too much combing the hair is dangerous. Products help keep your hair healthy. You have to be careful what kind of products you

use. —Janae (written text)

Helpful—It makes you feel good about your self when your hair is done. Bad—when the image goes to your head and if your hair comes out from all the chemicals. —Monique (written text)

❧ FITNESS ❧

Fitness: Taking care of your body is a precious part of you so keep it well. Exercise strengthens anyone's mind. —Janae (written text)

Fitness: It says you should keep in shape to make you look and feel good. It is helpful to keep healthy to have a long life and harmful as you might work yourself too hard. —Danielle (written text)

Fitness: I think that fitness is telling girls that they should keep their body up. Everyone can't run as fast as the other but you should keep in shape for a good healthy life. It is helpful my moving you to keep in shape and harmful by the image they show you of someone and you may diet all year and never be that size and it could make you feel bad about yourself. —Monique (written text)

The final aspect of this magazine task involved the girls identifying how their images could be both helpful and harmful to girls. As with trying to help them name their experiences, I needed to ask questions that encouraged the girls to think critically about their images and the messages imbedded within the images. I provide examples both of the girls' written text and one of our conversations about the text to show what their critique actually looked and sounded like. I use the "Hair/Hair Products" category, as these girls talked consistently about hair, and it was one of their biggest categories with respect to the number of images.

Researcher: *Now, tell me why the categories are helpful and/or harmful to girls. This is the critical part. I want you to critique the pictures and critique the messages as helpful and harmful, actually both, not either/or, but they could be helpful and they can be harmful. Tell me how.*

Kristi: *That thing means the same as that one, they make you look better.*

Researcher: *Okay, then how can it be harmful?*

Kristi: *You could die.*

Researcher: *Okay, um, but no, I want you to tell me helpful and harmful.*

Kristi: *How would hair products make you feel harmful?*

Researcher: *Show me your hair product. Is this your hair product? How is it helpful? How could it be harmful?*

Kristi: *You could choke on it.*

Researcher: *No, I mean in terms of the messages, are these things that girls should wear right? Here are things to make you look pretty. How is that harmful?*

Kristi: *If you got to have it so bad. I don't know.*

Researcher: *Why should you need things to look pretty? Why couldn't you just look pretty the way you are with no things? ——Do you think some people might look at this and say, well, if I don't have this, I'm not gonna be in?*

Concluding Thoughts

The purpose of this essay is to look at how images from popular culture can be used to engage adolescent girls in critical inquiry about the body. Images from teen magazines can be used to (a) tap girls' interests; (b) help girls name how they experience their bodies; and (c) help girls learn to critique dominant stories of the body. Within this study, there were pedagogical possibilities that emerged as well as struggles involved with engaging girls in critical inquiry.

Pedagogical Possibilities

If, as Armour (1999) argues, body-work is the primary rationale for physical education's place in the school curriculum, then it seems essential that, as physical educators, we should pay close attention to the kinds of body-work that we foster and the forms of embodiment we produce (Wright, 2000).

The kind of body-work that using images from adolescent popu-
lar culture fosters creates a number of possibilities to engage girls in
critical dialogues about issues surrounding their bodies that they find
relevant to their lives. This is important, insofar as the ways girls
learn to think and feel about their bodies' shapes, in part, how they
learn to think about themselves (Sparkes, 1997). Obidah (1998) talks
about the importance of schools acknowledging students' literacy
currency. She writes,

> Literate currency exemplifies the theoretical lenses through which adoles-
> cents assess the rest of the world as it relates to themselves. Awareness of
> students' literate currency may lead to teachers making space for it in the
> process of everyday schooling, and thus strengthening the potential for ado-
> lescents' engagement. (p. 56)

How girls experience their bodies and how these experiences
shape the ways they engage in schooling practices can be seen as a
form of literacy currency. That is, girls are bringing to physical educa-
tion their experiences of their bodies, and these experiences influence
how they will interpret physical education. If we fail as educators and
scholars to take seriously the ways in which girls' bodies shape their
perceptions of their schooling experiences, we miss opportunities to
help girls learn to live healthy lives.

One of the pedagogical possibilities that emerged from using im-
ages from popular culture to engage girls in critical inquiry was that it
provided spaces for these girls to bring up topics that *they* connected
with their experiences of their bodies. Obidah (1998) defines "making
space" to mean "allowing students' uncompromised voices to enter
(critique, query, challenge) and alter conceptions of school knowledge
'taught' to them" (p. 56). In critiquing images in teen magazines, is-
sues such as race and racism, consumerism, gender stereotyping,
sexuality, and teenage pregnancy all emerged as body-related topics
and later became the springboard for critical discussion, reflection,
and journal writing.[2]

For example, Alexandria was busy writing about one of the pic-
tures she had selected and looked up and said, "I have a concept I

[2] An analysis of these themes is beyond the scope of this essay.

would like to talk about." She went on to explain that "some girls at our school are pregnant." The group began discussing how they were curious to know what it "felt like to be pregnant" and how important it was to have their "mothers" to talk with because "they don't talk about it [teenage pregnancy] at school." Brandi mentioned that when they were in fifth grade they saw a film, but that "then most people didn't have questions and everyone was embarrassed to ask questions." She continued by saying, "Now everybody got all these questions and there ain't nobody to ask." Questions they wanted answered included things such as "How to prevent AIDS"; "How to keep myself out of those [when you know you're going to be like forced into it] kinds of situations"; "What kind of people to watch out for"; "When to make an exit"; "How to make an exit"; "How to take care of a baby"; and "Know where to turn if you get pregnant."

One of the things that we as physical educators ought to take seriously is the issues girls connect to their bodies. These experiences can then become a place from which we might create curriculum that is more responsive to girls' needs (Oliver & Lalik, 2001). Within this particular study, using images from popular culture provided a space for these girls to bring up topics that they thought were important. We as educators have to ask ourselves if we listen to what *they* think is important body content.

Although the possibility of making spaces for girls' concerns with the body emerged, one of the criticisms of this type of work is that it is not physical activity. If educators take time to work with girls in classroom settings, it decreases their opportunities to engage in physical activity. This is true. However, rather than fearing that engaging girls in critical inquiry of the body will take away from students, we might be better off seeing this type of work as a way to supplement the physical activity portion of the curriculum. In other words, providing students with opportunities to reflect critically on their experiences of their bodies might help them become more physically educated. Spending two to three days per month, or even one day per week, might go a long way in guiding adolescent girls in the process of developing healthy habits. Journal writing, magazine

critiques, and student-designed inquiry projects that focus on topics adolescents connect with their bodies might help physical education become more relevant to the lives of young people. We know that secondary physical education currently is not meeting the needs of students (Kirk & Tinning, 1994). Furthermore, Brooker and Macdonald (1999) claim that physical educators need to create opportunities for students to heighten their critical capacities.

Having girls study their experiences of their bodies is one way to help them become more critically aware. Teachers also could use these strategies to engage students in studying physical activity and sport-related themes and the ways in which these themes relate to the ways students are learning to feel about their bodies. For example, students could study topics such as: (a) How do girls who play sports feel about their bodies? (b) How are girls who play sports represented in culture? (c) How do girls who exercise regularly feel about themselves? (d) How do teens your age feel about physical activity? and (e) Does regular physical activity help girls gain more self-confidence? Allowing students' interests and concerns about their bodies to enter the curriculum is one step toward making physical education more relevant to adolescents' lives.

Struggles in Critical Inquiry with Girls

On the one hand, using images from teen magazines to tap girls' interests and to help them begin to express aspects of their visual worlds that they found meaningful was a crucial starting point for them naming ways in which they experience their bodies. The girls seemed to love the magazines, were captivated with the images, and found images to be a very powerful source of information and knowledge about the body. On the other hand, despite the pedagogical possibilities of using images from popular culture to engage adolescent girls in critically studying the body, there also are many struggles involved in this type of curriculum work.

One of the constant struggles for me was to listen to the girls limit their own life possibilities by narrating or buying into some of the more oppressive narratives that were imbedded within the magazine

images and text. There were numerous times I wanted to say, "Can't you see how this can hurt you?" but knew that to push too far would not be helpful. Rather, I tried to create opportunities for the girls themselves to examine the images or critique the assumptions in ways where I was not merely telling them what to think or how to feel. Dillon and Moje (1998) encourage educators and scholars to ask some hard questions about how to work with adolescents. They ask, "How do I negotiate the fine distinction between valuing what adolescent students have to say and moving them toward challenging, disrupting, and reconstructing their experiences and discourse?" (p. 222).

As I continued to ask the girls to critique the images they were selecting, I found myself writing about my frustration with this task. I wanted them to have a much more sophisticated understanding of what the images were implying about women in general and particular groups of women specifically. I tried to remain ever so conscious of where the girls were in the process (Ladson-Billings, 1994) and tried to think of multiple ways to help them think about the images they had selected. Dillon and Moje (1998) claim that it is not sufficient to merely learn to hear and value students' voices. They write, "We need to ask how their voices also reflect and perpetuate dominant discourses, and we need to help them ask the same types of questions" (p. 222). Engaging girls in critically studying images of the body makes spaces for both students' voices to be heard and space for helping them begin to challenge the dominant discourses, specifically in relation to girls' and women's bodies.

What I began to realize as I continued to work toward helping these girls critique images of the body was that I lacked the necessary language to communicate and connect with the girls in ways that afforded them multiple opportunities to explore the issues they were raising. More specifically, I struggled to find the language to help them examine an issue, critique an assumption, and elaborate a point.

For example, when I was trying to help Kristi describe how the image she had selected of the girl in the bikini could be helpful and harmful to girls, I struggled to find the language I needed to help her

critique her image. What was important was that rather than giving up when I did not have the language I needed was the struggle to create it. This in part helped me to remember just how much time, patience, and persistence is needed to work with girls as they develop their critical capacities. I found it helpful and important to remember that this is a very slow process as it is countercultural, and sometimes it is simply about planting seeds rather than seeing final "results." This does eliminate the need to want to know whether or not what you are doing is being helpful to girls developing a sense of self, or whether it is more harmful. It would be far too easy to justify not engaging girls in this type of critical inquiry, given the level of uncertainty or the lack of language. Nonetheless, girls need to begin asking "why" and they need to have multiple opportunities to do so. Greene (1995) writes, "I would like to claim that this is how learning happens and that the educative task is to create situations in which the young are moved to begin to ask, in all the tones of voice there are, 'Why?'" (p. 41).

If as physical educators we hope to create curricula that nurture and extend girls' critical capacities, we need to be able to better hear where and how girls critique oppressive messages and/or representations of their bodies. Having more examples of what early adolescent critique actually looks and sounds like is crucial if we are to take the necessary steps toward helping girls identify how their bodies are represented and used in ways that are harmful to their health and well-being. We need more examples in our academic literature of how physical educators are trying to help girls develop theses critical abilities.

References

Armour, K. M. (1999). The case for a body-focus in education and physical education. *Sport, Education and Society, 4* (1), 5–15.

Berger, J. (1972). *Ways of seeing.* London: British Broadcasting Corporation and Penguin Books.

Bloom, L. R., & Munro, P. (1995). Conflicts of selves: nonunitary subjectivity in women administrators' life history narratives. In J. A. Hatch & R. Wisniewski (Eds.), *Life history and narrative* (pp. 99–112). Washington, DC: Falmer Press.

Bordo, S. R. (1989). The body and the reproduction of femininity: A feminist appropriation of Foucault. In A. M. Jaggar & S. R. Bordo (Eds.), *Gender/body/knowledge: Feminist reconstructions of being and knowing* (pp. 60–82). New Brunswick, NJ: Rutgers University Press.

Bordo, S.R. (1997). The body and the reproduction of femininity. In K. Conboy, N. Medina, & S. Stanbury (Eds.), *Writing on the body: Female embodiment and feminist theory* (pp. 92–110). New York: Columbia University Press.

Brooker, R., & Macdonald, D. (1999). Did *we* hear *you*? Issues of student voice in curriculum innovation. *Journal of Curriculum Studies, 31* (1), 83–98.

Brown, L. M., & Gilligan, C. (1992). *Meeting at the crossroads: Women's psychology and girls' development.* New York: Ballantine.

Brumberg, J. J. (1997). *The body project: An intimate history of American girls.* New York: Random House.

Cochran-Smith, M. (1995). Color blindness and basket making are not the answers: Confronting the dilemmas of race, culture, and language diversity in teacher education. *American Educational Research Journal, 32* (3), 493–523.

Collins, P. H. (1991). *Black feminist thought,* Vol. 2. New York and London: Routledge.

Collins, P.H. (1998). *Fighting words: Black women and the search for justice.* Minneapolis: University of Minnesota Press.

Delpit, L. (1995). *Other people's children: Cultural conflict in the class-*

room. New York: The New Press.

Dewey, J. (1916/1944). *Democracy and education.* New York: Free Press.

Dewey, J. (1932/1985). Ethics. In Jo Ann Boydston (Ed.), *John Dewey: The later works, 1925–1953,* Vol. 7. Carbondale: Southern Illinois University Press.

Dillon, D. R., & Moje, E. B. (1998). Listening to the talk of adolescent girls: Lessons about literacy, school, and life. In D. Alvermann, K. L. Hinchman, D. W. Moore, S. F. Phelps, & D. R. Waff (Eds.), *Reconceptualizing the literacies in adolescents' lives* (pp. 193–224). Mahwah, NJ: Lawrence Erlbaum.

Eisner, E. W. (1993). Forms of understanding and the future of educational research. *Educational Researcher, 22* (7), 5–11.

Fine, M. (1992). *Disruptive voices: The possibilities of feminist research.* Ann Arbor: The University of Michigan Press.

Fordham, S. (1996). *Blacked out: Dilemmas of race, identity, and success at Capital High.* Chicago: University of Chicago Press.

Foucault, M. (1977). *Discipline and punish: The birth of the prison.* London: A. Lane.

Gard, M., & Meyenn, R. (2000). Boys, bodies, pleasure and pain: Interrogating contact sports in schools. *Sport, Education, & Society, 5* (1), 19–34.

Gee, J. P. (January, 2001). *Millennial and bobos, Blue's Clues and Sesame Street: A story of our times.* Paper presented at the New Literacies and Digital Technologies: A focus on adolescent learners Conference, Athens, GA.

Greene, M. (1995). *Releasing the imagination: Essays on education, the arts, and social change.* San Francisco: Jossey-Bass.

hooks, b. (1989). *Talking back: Thinking feminist, thinking black.* Boston: South End Press.

hooks, b. (1990). *Yearning: Race, gender, and cultural politics.* Boston: South End Press.

hooks, b. (1995). *Killing rage: Ending racism.* New York: Henry Holt.

Kirk, D. (1999). Physical culture, physical education and relational analysis. *Sport, Education and Society, 4* (1), 63–73.

Kirk, D., & Claxton, C. (2000). Promoting girls' participation in physi-

cal education and sport: The girls in sport partnership project. *British Journal of Teaching Physical Education, 31* (1), 27–29.

Kirk, D., & MacDonald, D. (1998). Situated learning in physical education. *Journal of Teaching in Physical Education, 17* (3), 376–387.

Kirk, D., & Tinning, R. (1994). Embodied self-identity, healthy lifestyles, and school physical education. *Sociology of Health & Illness, 16* (5), 599–625.

Knobel, M., & Lankshear, C. (2001 January). *Cut, paste, publish: The production and consumption of zines.* Paper presented at the New Literacies and Digital Technologies: A focus on adolescent learners conference, Athens, GA.

Ladson-Billings, G. (1994). *The dreamkeepers: Successful teachers of African American children.* San Francisco: Jossey-Bass.

Lankshear, C., & Knobel, M. (2001 January). *Do we have your attention? New literacies, digital technologies and the education of adolescents.* Paper presented at the New Literacies and Digital Technologies: A focus on adolescent learners, Athens, GA.

Obidah, J. E. (1998). Black-mystory: Literate currency in everyday schooling. In D. Alvermann, K. L. Hinchman, D. W. Moore, S. F. Phelps, & D. R. Waff (Eds.), *Reconceptualizing the literacies in adolescents' lives.* Mohwah, NJ: Lawrence Erlbaum.

Oliver, K. L. (1999). Adolescent girls' body-narratives: Learning to desire and create a "fashionable" image. *Teachers College Record, 101* (2), 220–246.

Oliver, K. L., & Lalik, R. (2000). *Bodily knowledge: Learning about equity and justice with adolescent girls.* New York: Peter Lang.

Oliver, K. L., & Lalik, R. (2001). The body as school curriculum: Learning with adolescent girls. *Journal of Curriculum Studies, 33* (3), 303–333.

Pipher, M. (1994). *Reviving Ophelia: Saving the selves of adolescent girls.* New York: Ballantine.

Rovegno, I., & Kirk, D. (1995). Articulations and silences in socially critically work on physical education: Toward a broader agenda. *Quest, 47,* 447–474.

Shilling, C. (1993). *The body and social theory.* London: Sage.

Sparkes, A. C. (1996). Interrupted body projects and the self in teaching: Exploring an absent present. *International Studies in Sociology of Education, 6* (2), 167–187.

Sparkes, A. C. (1997). Reflections on the socially constructed physical self. In K. Fox (Ed.), *The physical self: From motivation to well-being* (pp. 88–110). Champaign, IL: Human Kinetics Press.

Theberge, N. (1991). Reflections on the body in the sociology of sport. *Quest, 43* (2), 123–134.

Tinning, R., & Fitzclarence, L. (1992). Postmodern youth culture and the crisis in Australian secondary school physical education. *Quest, 44* (3), 287–303.

Vertinsky, P. A. (1992). Reclaiming space, revisioning the body: The quest for gender-sensitive physical education. *Quest, 44* (3), 373–396.

Wolf, N. (1991). *The beauty myth: How images of beauty are used against women*. New York: William Morrow.

Wright, J. (1996). Mapping the discourses of physical education: Articulating a female tradition. *Journal of Curriculum Studies, 28* (3), 331–351.

Wright, J. (2000). Bodies, meanings, and movement: A comparison of the language of a physical education lesson and a Feldenkrais movement class. *Sport, Education, & Society, 5* (1), 35–51.

℘ CHAPTER 3

My Use of Images in Teaching About Literacy
An Autoethnographic Exploration Construed through Image, Soliloquy, Vignette, and Poem

Rosary Lalik

Introduction

The photograph you see above is one I took recently during a walk in my neighborhood. While returning to my home after a visit to a local art museum, I became intrigued by the sight of a woman sitting quietly in front of a store, gazing off at a distance toward her left as if waiting for something or someone to arrive. I took several pictures of

the woman using a digital camera that I had carried with me. The next day, I used the small Epson printer attached to my computer to produce several copies of the pictures I had taken. As soon as I looked at this one, I selected it for the introduction to this chapter.

For me, this photograph suggests the quiet beauty I experienced when coming upon this woman on the street. The brilliant green and brown hues of the tree in the foreground suggest a natural persistence and grace that are re-presented in the contrasting colors surrounding the woman. The woman sits in the background of the photo. Yet, her presence and pose capture my attention and inspire my imagination.

In the photo, the woman's facial features are hidden behind a veil of warm color, creating an impression that this could be any one of us. For a teacher such as I, often absorbed in the study of homelessness, the photo makes a particular impression. That is, it evokes memories of the many homeless people I have come upon in places where I have lived—places as different as Blacksburg, Virginia, a small rural university town, and Washington, DC, an urban population and political center.

From my perspective, the woman in the photo appears at once to be a homeless, aging woman in a wheelchair and a queen mother patiently awaiting the arrival of some long-delayed envoy. Her carefully wrapped turban crowns her head, while the complex, absorbing patterns created by the colorful garments draped over her chair become royal robes. Her composed posture within the frame of the chair suggests that she is resting on some elegant albeit diminutive thrown.

Together these pictorial features conspire to evoke within me a sense of beauty, grace, and dignity. The photo fills me with hope, and it inspires me to imagine that the errand the woman has given her envoy will be completed successfully and with dispatch. As I view the image, I let the story evoked by it play out in my mind. I let myself imagine that this woman has sent a very brave and skillful person to work with others to change the world by eradicating the conditions that contribute to homelessness.

Perhaps the image evokes this particular story for me because homelessness is a topic that I have addressed in my teaching during

the last seven years. It is a topic that is very much on my mind, as is the topic of literacy because in my teaching I try to bring the two together. And the literacy of which I speak involves the use of multiple forms of representation for construing and transforming the world.

In this chapter, I will explore how these two topics—homelessness and literacy—have come together in my teaching. To frame this exploration, I will consider ways I have used visual representations, such as the image introducing this chapter, within an inquiry model of teaching. I have relied heavily on the use of photographs and other forms of representation in my teaching. Images and artistic processes have become central in my thinking and doing as a literacy educator. One might say then that they have become central to my literacy as a literacy educator. Using these forms and processes, along with more conventional texts, I have struggled to help my students experience and construct expanded conceptualizations of literacy and literacy teaching—conceptions often ignored in mainstream discourse about schooling and learning—conceptions that center on social justice and personal and social transformation.

Research Perspective

In this exploration of my teaching, I attempt to use story as a form of scholarship (Featherstone, 1989) by combining "empirical and aesthetic descriptions" (Alvermann, 2000) through processes I adapted from the tradition of autoethnography (Ellis, 1997). In the words of Ellis and Bochner (2000):

> Auto-ethnography is an autobiographical genre of writing and research that displays multiple layers of consciousness, connecting the personal to the cultural. Back and forth autoethnographers gaze, first through an ethnographic wide-angle lens, focusing outward on social and cultural aspects of their personal experience; then, they look inward, exposing a vulnerable self that is moved by and may move through, refract, and resist cultural interpretations. As they zoom backward and forward, inward and outward, distinctions between the personal and cultural become blurred, sometimes beyond distinct recognition. (p. 739)

A broad array of work has been developed within this genre, including, for example, first-person accounts, personal essays, lived ex-

perience, and self-ethnographies. In one type, the confessional tale, the researcher's experience in doing the research becomes the focus of study. Insofar as this work focuses on a teacher's experience of teaching, it may be considered one example of an autoethnographic confessional tale. It is my belief that the processes of autoethnography can help teachers and others to work "through the barriers of unfamiliarity, distance, and difference toward a spirit of collaboration, understanding, and openness to experience and participation" (Ellis & Bochner, 2000, p. 760). Rather than isolating intellect and emotion, it brings those aspects together in explanation and understanding.

Writing about myself has been difficult. Like others in my generation, I had been initiated into a research culture that devalues subjective experiences and the interplay of personal and public (Richardson, 1992), while validating efforts that objectify topics. Doing this analysis, I often felt uncomfortably self-absorbed. At such times, an image of myself narcissistically bending low into a quiet lake mesmerized by my reflected image would assert itself on my consciousness. Yet, I persisted in the research and writing, holding on to the hope that these efforts would allow me to better understand my work as a teacher—work that I often experience more intuitively than cognitively (Neilsen, 1994). I forced myself to remember the words of Ellis and Bochner (1992), "Understanding is not embedded in the experience as much as it is achieved through an ongoing and continuous experiencing of the experience" (p. 98) through processes of representation that often include storytelling.

As I engaged in the actual teaching and work with my students, I was so absorbed in what I was doing that often I had difficulty finding a conceptual frame by which to make meaning of it. Nevertheless, I felt compelled to continue working with students in certain ways. Urged by many of these students to write about this work, I returned to the artifacts I had collected delving into them to describe the experience. In constructing this story of my work, I have tried to convey the sense of contradiction, ambiguity, and immediacy so salient for me in the living of it (Ellis & Bochner, 1992).

While I have not followed Richardson's convention of writing this

story as poetry (Richardson, 1992), I did follow her guidance in using writing as a mode of inquiry. That is, I wrote and rewrote to allow the process to serve as a "method of discovery." I examined my work from a postmodern stance on knowledge and writing. Thus, I am not trying with each successive effort at writing to get successively closer to the truth of the experience. Rather, I am exploring different "contours" of meaning that various writing formats allow. For the purposes of this chapter, I share a soliloquy, a vignette, and a poem. As well, I use two images that relate to important aspects of my work. The first introduces the chapter, and the second forms part of its closing. Various forms of representation allowed me to develop different meanings (Richardson, 1992) and made the option of limiting my expression to a single form untenable, because it would mean leaving out too much meaning to satisfy me.

I began framing this account of my teaching when a friend and colleague, Lynn Bustle, asked me to examine ways I used photographs and other artistic forms in my teaching. My attempt to respond to her request led me to review materials I had collected from a particular graduate course I had taught between 1992 and 1998, *Comprehending Processes and Teaching Reading in Content Areas*. I could have considered other courses, but this one, in particular, intrigued me. I felt at once puzzled, frustrated, compelled, and enthused by my work in the course. Thus, I hoped that the writing about this work would help me better understand it so that I could move beyond what had become in my teaching a wall of competing emotions. I hoped, too, that through my telling of this story (in this chapter), other teachers and teacher educators might be helped "to feel and think about themselves and others in new ways" (Ellis & Bochner, 1992, p. 99).

To conduct this study, I gathered documents I had been collecting since 1993. I found course syllabi, transcribed interviews with students, students' self-evaluations, copies of students' completed course assignments including instructional unit plans, letters and other artifacts from former students, and two teaching logs. I also found a paper about an early version of the course that I had written with several former students (Lalik, Langston, McLachlan, & Pacifici,

1993).

I sat on the floor of my study for days, reading through papers and sorting pictures for a display. As I pored over these documents, I began reliving the course experience. I felt embarrassed and pained when I came upon a document in which a former student criticized an aspect of my teaching. I questioned the authenticity of praise when it appeared in students' descriptions of my work. I spent time wondering what these students would say now, wondering where they are and how, if they are teaching, they work with kids. I also wondered about what their students learned from them.

I noted themes and constructed notes to record them. Finally, I drafted this narrative of my work as a way to elaborate on the themes, issues, and concerns my document study had stirred (Alvermann, 2000). I present my account in the first person to highlight the point made by Richardson (1997): "We are always present in our texts, no matter how we try to suppress ourselves" (p. 2). I begin my narrative by looking at myself as an educator. In turn, I describe my role in the course, including my use of photographs, and I relate students' participation. I conclude with a brief reflection on what I have learned from this consideration.

A Teacher's Story in Soliloquy

Who I Am?

I am a teacher educator. It's my job to help teachers to create and sustain classroom environments where children can grow in literacy. At my university, we used to call ourselves reading teacher educators; now we say we are members of a Literacy Studies Group. I like the word literacy, although I am not certain what it means or how I can use it in ways that are likely to help teachers and children. Even so, I do have meaning preferences for the word.

I read. It is my habit to read and write a good bit, although I do not think this means that I am literate. Reading and writing help me

make sense of the world. For me, they are engaging processes. They move me through great symphonies of thought and wonderment. As I read, authors often speak to me. Their tones are sometimes clear, sometimes melodious; at other times they speak in muffled whispers, unfamiliar scales, and even cacophonic screams.

Some writers scream against my deafness. James Gee's (1990) stern voice spurned the injustice that he saw and heard at school. "Literacy at school," he raged in my imagination, "just one more violent tool of disfigurement, a trumped-up charge, a vengeful lynching mob to crush the children and their family discourses." And so, I asked, "Am I not innocent of this charge on account of my full ignorance? I intend no ill; I only want to help."

Denny Taylor and Catherine Dorsey-Gaines (1988) spoke in softer voices. They told me family stories—stories of those who struggled with life, inventing poetry from misery, crafting musical instruments from empty larders. The echo of their literary refrain persists, "They like to say school matters; they like to say it makes a difference if you graduate. They're just kidding; making light of trouble; they're just kidding, surely see the pattern."

In the background, there was another tone that kept the beat. Graff (1987) warned us listeners mournfully, "Literacy has all kinds of purposes. It can mean problems. Wake up. It's a mixed bag. Wake up!"

Regardless of the painful clamor, I am very hopeful when I read. Between some writer and me there may come some note of precious insight. I have found such hopeful notes in many different corners of the world. Some of these are writers whose work I mention later in my narrative. One harbinger of hope, bell hooks (1994), shared many soothing words. Her sense of theory is of special meaning:

> I found a place of sanctuary in "theorizing" in making sense out of what was happening. I found a place where I could imagine possible futures, a place where life could be lived differently. This "lived" experience of critical thinking, of reflection and analysis, became a place where I worked at explaining the hurt and making it go away. Fundamentally, I learned from this experience that theory could be a healing place. (p. 61)

I wondered, "Can I make a healing place from theory—a place to live life differently?"

I write. I said I like to write. I try to write, but I am mute and grossly inarticulate. My words are rough and ignorant; they fall in jagged shards on my office floor, fragmentary, twisted, incoherent. I hide the work. It's a poor effort at real writing; my English teacher told me so. I am stiffly mute. I try to move against the river of convention, the current sweeps me back; I struggle in the flow; I make but little progress.

To try to find my voice, I vow to learn to speak through courses that I teach. "Perhaps I can help my students come to understand one version of this thing called literacy. It's worth a try," or so I tell myself. More aptly, it feels immoral not to try to share what I have come to know.

I Plan to Teach

The course has an official bureaucratic title. It makes a jarring sound. They call it: Comprehending Processes and Teaching Reading in Content Areas. I'm to help teachers understand what comprehension's all about; I'm to help them find ways to teach language processes in all school subjects.

"I need to shape this course, to consider its possibilities, to work against the violence-as-usual of school-literacy teaching." Or so I tell myself. "But I know so little! Surely, I will be naive. I need to study more, to write more papers, to become acknowledged by my colleagues for clear, coherent speech. I should wait until I know much more," Instead, I act compelled by some impatient desire.

I sit alone to make the plan; I come to class and see the students. They are teachers, some beginners; others practicing for many years. They are here, expecting me to be a teacher educator, to help them learn the "what" and "how" and "why" of teaching literacy.

At that moment, hope flickers just a bit. I wonder, "Could we become more literate, altogether as a group?" Maxine Greene (1988) has said that this is true. "Could we begin to read some of our world as

Freire has done?" (Freire, 1985). "Could we write our world a bit, putting perhaps some small hand upon it?" "Are these just whims, reserved for writing gods, but forbidden in the hands of mortals?" Gore (1993) has cried despairingly about the dearth of teaching efforts in this vein. She says the words alone are hollow when we ignore action in our worlds; she calls it maddening. I take to heart the words of Freire (1985), who knew so well how fear of failing silences dreams of life and stops us rigid in our tracks. In spite of all my squeamishness, it seems like time for me to act.

I Teach a Course

Getting started. We sit together in a circle. I ask them to tell their names, to share some things with us. They seem to go along and have a conversation as they share. A few appear absorbed, while others read the watches on their wrists. I want them to make connection, to listen to each other. For some this is a game, a mere contrivance, a way to pass the time until the end of class. Our time is up; they leave the room.

We meet again; I tell them stories of my life and ask if they will also tell. I call these literacy stories; some seem puzzled by my label; yet they go along. They tell their stories; over time, they make a book. We call it, simply, *Stories*. Somehow the word literacy has slipped away. Perhaps it lies crumpled in some dusty corner of the course. I will have to make a search for it.

When we meet again, I ask these teachers to envision an ideal world, and they surprise me. They throw themselves into this work, creating visuals on transparencies to help explain. They share their visions with much charm and grace. They seem engaged, although it's hard to say it makes much sense to them. It uses time. My guess is some think things could be worse; it's better just to go along.

We meet again. I ask them to create a school in which children may likely learn ways to create the ideal world they have imagined. They throw themselves into this work, again creating visuals on transparencies to help explain. They vote to continue past the given time; they share their schools in-depth. The room is full of life. I see

them exchanging thoughts and feelings with rare absorption (Shor, 1992). They are playing; this seems like fun—although fun of rather serious persuasive.

Some ask important questions. "What does all this have to do with that thing, literacy," they ask, "this sharing close beliefs and strong preferences for our world? Where is the structure in this course? How will we learn what to do when we teach literacy at school?"

Others seem relieved. They say they grow from this and feel a confidence in their strength to bring commitment to their teaching. One speaks ardently of her experience, "No, I have grown, I've discovered, questioned, and collaborated. I will be successful by bringing to the classroom my beliefs and my philosophies and my strategies. I will form and modify, as I engage with colleagues, reflect and read, oh so very much to read." This teacher points to Shor (1992), who tells of the complexity of education and how it is a social interaction, mixing thought and feeling.

Using photographs and other means. We reach a time for us to focus on a kind of teaching—one that highlights something literacy can mean. Rather than explain, I'd like to show them. We will study something as a group. We will try to read and write the world from our small place. They will need to trust me, to go along because I will not first explain. Instead, I want them to feel what this is like. We can talk later, or so I hope.

First, I show them photos I have found. Words will not touch them as these photos might. They are so compelling, these sad and vivid pictures of people looking forlorn or desperate. There is an elderly man receiving a tray of food, a family gathered at a shelter's dinner table, a young man and woman overlooking a for sale sign on their farm, a well-dressed man walking past an elderly rumpled man crouched low on a sidewalk. "Look them over carefully and write some captions," is what I say. "Choose one and draft a list of words that come to mind. Then write a longer piece that could explain the image on the page."

They work together in small groups. They share the prose and poetry that they have made. They read with dignity. They listen and respond in-depth to others' offerings.

Some like the picture of an elderly woman sitting pensively on a porch. They say they see a ray of hope and want that hope to live. The image touches them. One says of her experience, "A sense of failure and misunderstanding overcomes me—I chose to ignore the depression I was seeing in the collection. I told a happy story." Others' stories tell a truer tale, and they have much to add to them as we discuss at length.

One Chinese teacher tells us how things could never be so uncaring for the elderly where she grew up. Others say the picture work made for "student centered dialogue" (Shor, 1992), although the teacher gave the pictures out and shaped the work. In one corner of the room someone makes a joke; another shares a snide remark, but most persist in earnest. The room is quiet; they listen with great care to what each group will share.

They comment on each presentation of the image work. I ask them to consider what may be a theme among those photographs. They begin to guess that it's despair. I tell them, "Homelessness, that is a problem—one likely you will see from your teacher's desk within the classroom space. It is rather common for our children."

I do not wait till they agree but ask instead, "Please find out something about homelessness, something to learn without reading from a library book." I give a bureaucratic name to this assignment. I call it a "nonbook learning strategy." The words pierce my mouth and leave an acrid taste. "However did I come up with that?" I ask myself. Perhaps I am having doubts; perhaps I seek to make this work legitimate.

Students seem to go along, yet there is concern. One admits the time is wrong for her, "I had marched in peace demonstrations in the early 1970s and again with the Gulf War. I had marched in the pro-choice and abortion rights demonstration. I had worked in soup kitchens in Washington, DC, and Atlanta, Georgia. Enough already, I am now carving a space to concentrate on my own career."

We meet again; they share what they have found. I am amazed at

their inventiveness. Some do so little, just a thing or two that's quick. Others really probe, rummaging through official and personal resources. One calls for help, as if she is homeless or a friend of someone who is. She counts how many quarters it takes to get her simple questions answered. She wonders how she could survive, if that was all she had. Another sleeps overnight in a car and gives report of how he feels. Another seeks a conversation with a friend who has been thus alone and homeless in his life. Another writes reflections of his time without a home. He doesn't share it yet. He waits until he trusts us more.

We make a list of all we've learned and write the questions on their minds and lips. "These are questions for our further inquiry," I say. I keep those photos posted in the room for them to visit as they learn and wonder. Now and again some spend time reviewing them—these images of others and ourselves.

They work together in small groups to study questions they have raised. The room is filled with stuff that I have brought. We work for weeks. They bring stuff, too. More photos come into our world—more pictures from the books they've read and places they have visited. I read the children's literature—the picture book Eve Bunting (1993) wrote. I show them images that Ronald Himler made to energize Eve's story. In chosen words, she tells about a dad and son, together seeking shelter at an airport.

Students keep a chart to document their journey in this study. From time to time, I ask them to share what they've been up to, what they've learned, and what's new to question. They share their evidence, confirming and conflicting. They weigh the contradictions; they tell of patterns that they see.

One struggles with the contradictions that she feels—

The readings are very intense and lengthy. The coursework seems rather disconnected. Yet the readings from children's literature and our journal sharing seem to put it all together. I am learning a lot through talking and listening to others as they formulate their ideas and try them out.

Re-presenting learning. We meet again. They share their charts and reflect on meanings there. I ask them to transform what they

have learned into a form of art—some poetry perhaps, or theater, dramatic presentation, even music or a drawing, a visual display, perhaps. "Push well beyond what's typical in school," I say. "Do something that you wish—something to make meaning as you want."

Students work together with intensity, although how they feel or think is hidden from my view. One tells me in her journal of images that she recalls:

The homeless issue consumes me. Having lived in a busy metropolitan area for a few years, I saw so many distressing scenes. I passed people holding cups for donations and signs pleading for help as I walked to and from metro stations. I shuddered in the cold months as I saw forms lying on park benches covered with newspapers and tattered blankets, and I felt an aching in my heart and stomach as I watched clouds of vapor above the men, women, and children huddled over the city's steam grates. I wanted to help all these people, but the problem was too vast for me to fathom a solution. I was eager to learn more about this issue so that I might discover a place to start.

Another shares a shift within herself:

During this phase I became very connected to our group. We talked at length about our inability, but eventually came around to discussing the [art] project. Since most of us felt creatively inept, we talked about any idea that came to mind, regardless of how futile it may have seemed. One member of our group is musically inclined, and she proposed that we write a song, just lyrics for now. She promised to find a tune. 'Easy for you to say,' I thought, 'but I'll give it a try.' We left skeptical but excited that we might actually write a song. At our next meeting we talked about themes and feelings, people and consequences. Our musician got us started, and ideas abounded. We were having great fun and our learning began taking on new meaning. I can hardly wait to see what the other groups of people are inspiring. The benefits of community in education and in all aspects of my life are enveloping me. Later, as I witness all the wonderful transformations of our knowledge of the homeless, I sit in awe.

We meet again reflecting on the transformations of their learning they had shared. They used drama and so much music, and they created images of their own with chalk and paint and paper. I tell them that one way of being literate is having knowledge, skill, and moral courage. "Enough courage to change the world toward fairness, beginning with ourselves" (Goodman, 1992), I tell them.

Then I invite them to consider what they have learned about the

homeless, and whether anything has made them want to act. I ask them to return to their groups, to discuss just how they feel. I ask, "Do you want to make an action plan? Do you want to do anything? It's up to you," I say.

One confides much later:

> *I continued to love and wonder about our class process yet question how an actual social action project was going to be possible. It was nearing the end of the semester, and everyone was going crazy with due dates. I was wondering whether a real live classroom teacher would implement this model [of teaching] in the classroom. Would I be able to do this if I were going back to the classroom? This kind of teaching was what I was desperate for four years ago, but would I really be able to switch from a control-focused, technically competent style to this nonlinear, no-text book, student research process?*

Her words evoke for me a point that Greene (1988) has made about how odd the critical and imaginative in teaching and learning can feel, especially to those of us long stifled in technocratic corners.

The student groups surprise me almost every time. I ask them to keep their work to something small. They talk at length and conjure mighty plans. Their work spills far outside our class. They meet in other places; at times they do not even say.

They work along the edges of the problem; they miss the center. They peel potatoes and keep the shelters open. They gather school supplies for children needing them. They write information pamphlets and plan instruction for children and their families. They work with teachers to help them learn how to help our homeless children. They gather clothes and prepare Thanksgiving dinners. They collect money and work with teens to help them see the problem. They are resourceful and very energetic, even as I insist they keep it small. They act, apparently compelled, combining knowledge, skill, and courage.

Most of what they do eases pain, though social structures remain unchanged. Thus, the homeless situation stays in tact. It would have helped for me to talk about the distinction Kozol (1988) drew, pointing to two challenges and two separate tasks for action—one to ease the present misery, the other to alter conditions sustaining misery. Surely this distinction would have helped as they considered what to

do. Working on conditions is a future plan; I must address it.

Besides this work, they must complete a unit that mirrors the one I've taught. I make a rubric with their help. It lists the parts they'll need. They work these units up and share them with the class. They teach about environment and weather, health and sneakers, oil and civil rights. They tell me it is easy; now they have a plan. I wonder: Will they ever use these units after graduation?

When students leave the course, I wonder what all this has meant to them. Every once in a while, someone sends me something through the mail—a book, a newspaper article, a cartoon, a video—all about homelessness in the world. They confide some teaching efforts on their own. One writes to say he planned a unit for all eighth graders on homelessness; he seems excited. Another plans a unit with fifth graders, even after four years have passed.

Others focus on the tested standards in our state, and there are many. They must, they tell me, or they will lose their jobs. Their school will be disgraced. It is the scores that mark success, or so they are told at school and elsewhere. The kind of literacy they learned with me is hard to fit into the spaces of the standards lists, although they tell me they prefer it. Through effort they will find a way, or so they promise. Listening to them, I am convinced more certainly than ever of what Giroux (1988) proclaimed. He called for a renewed teacher education—one committed to recapturing "the idea of critical democracy as a social movement for individual freedom and social justice" (p. 167).

One student teacher tells me how she writes to the president with quotes from Kotlowitz (1991) who told how it is true that in this country there are places where teachers protect their students from flying bullets by using their own bodies as shields.

It pleases me to see their notes. They fly to me across the years. I wonder if they see the other in the homeless or some aspects of themselves, connecting well to others. Matousek's words provide some comfort in this worry, "We must begin to see the homeless not as faulty, deficient human beings, but as metaphors of the fragility of life for all of us, as epiphanies" (1991, p. 14). As I continue to read the im-

ages surrounding me today, I am keenly aware of the need for literacy as I present it to my students. Indeed, we humans could all benefit from an unyielding commitment to equity and social justice.

Reflections

I began this project in an effort to understand and describe how I used image to help my students understand literacy as the development of the knowledge, skill, and moral courage necessary to transform ourselves and our society toward interests of equity and social justice. Through analysis, I learned that photographs and other images are an essential part of a much larger story of my teaching. That larger story includes my commitment to helping teachers understand that literacy may be construed as a transformative sociopolitical activity with personal as well as societal implications, and that teaching and learning may be construed as reciprocal inquiry-inspired transactions among teachers and students.

My teaching often falls outside of the mainstream. Thus, it is sometimes confusing to teachers who do not expect the kinds of activities I ask them to pursue or understand why I am working in such ways or what I am trying to accomplish. Yet, through the use of compelling images and artistic re-presentations of learning, many of my students become deeply engaged in the work of the course and compelled to learn much about the topics under study. Many are eager to integrate some adaptation of this type of literacy teaching with their students. Some dismiss the work as naively utopian; others struggle to find ways to similarly engage their students whether through a study of homelessness or some other social issue. A few keep their fires burning for many years. Occasionally, I imagine that a network of such teachers is growing.

It might be that I could work more effectively with teachers if I talked more directly with them explaining more explicitly and thoroughly what I am trying to do and why it is important. I am now exploring an approach in which I verbally present several views of literacy and model each, asking my students to compare and contrast. I draw on the work of Mosenthal (1999) to begin this approach, be-

cause he has outlined a number of competing agendas for literacy education and schooling. I am just beginning to learn about how my students respond to this approach. One of its advantages may be that by offering my students competing perspectives, I might interfere with my own propensity for presenting my favorite type of literacy as a regime of truth (Gore, 1993).

Vignette as Postscript

As part of revising this chapter, I returned to my study of homelessness. This time I wanted my experience to be deeply personal. Thus, recently, my husband and I began visiting places where homeless adults create spaces for themselves. On Connecticut Avenue, we noticed that on a single park bench punctuating a lovely old bridge edged with elegant wrought iron trim, an elderly man sat quietly. Next to him stood a shopping cart piled high with materials. What they were I could not tell because covering them was a double folded blanket of plastic sheeting—the kind affluent people may find covering their furniture after the movers have prepared it for shipping. The plastic was held in place with cords of tightly knotted rope. The man sat quietly. I wanted to approach him to take his picture and see if there was any use we could be to him.

Together we slowly approached the man. My husband explained that I was doing a project and as part of it would like to take his picture. "Would you mind," my husband quietly asked as I stood next to him. The man looked up at my husband saying he would not mind in the least.

As he spoke, I noticed he'd been working with some materials on his lap. He held paper and drawing pad. Seeing these I burst out, "Oh, you are an artist!"

"Yes," he responded with dignified confidence.

I asked if I could purchase one of his pictures. He readily agreed, showing me two drawing pads and inviting me to choose one among the 30 or so drawings he had made.

I looked through his work. His drawings were done in pencil. Some were simply made, merely black pencil on paper. Others were

done with colored pencils. There were images of the nearby park, images of buildings, images of men and women and children absorbed in various activities. After looking them over several times while pointing out a good number that I especially liked, I selected one and asked him how much he would charge for it.

"Ten dollars!" he matter-of-factly replied.

I paid him and asked him if he would mind signing the drawing I'd selected. He wrote his name, David, on the corner and told us that he would return to that bench for a few more weeks. We walked away promising to visit on another Saturday.

In writing about this encounter, I have been reminded of its appropriateness for a chapter on the power of image. As I found image a process powerful in nurturing a transformational conception of literacy, David apparently found the creation of images a worthy pursuit in his life. Thus, our link as humans is made obvious. At the least, we are linked through image to the world and to each other. Tomorrow is Saturday; I have a promise to keep.

A Last Word

 Justice!
 The word hisses between my tongue and sturdy palette.
 Its taste lingering as vanilla floating against a sprig of salty rosemary.
 Later an acrid smoky fume exudes
 craving a body's meaning.
 How long until my back protests against the yoke of wordy utterance?
 How willing my feet to bear the journey and wear the blisters of commitment?

References

Alvermann, D. (2000). Narrative approaches. In M. Camille (Ed.), *Handbook of reading research* (3rd ed.) (pp. 123–139). Newark, DE: International Reading Association.

Bunting, E. (1993). *Fly away home.* New York: Houghton Mifflin.

Ellis, C. (1997). Evocative autoethnography: Writing emotionally about lives. In W. G. Tierney & Y. S. Lincoln (Eds.), *Representation and the text: Re-framing the narrative voice* (pp. 115–139). Albany: State University of New York Press.

Ellis, C., & Bochner, A. (1992). Telling and performing personal stories: The constraints of choice in abortion. In C. Ellis & M. G. Flaherty (Eds.), *Investigating subjectivity: Research on lived experience* (pp. 79–124). Newbury Park, CA: Sage.

Ellis, C., & Bochner, A. (2000). Authoethnography, personal narrative, reflexivity. In N. K. Denzin & Y. S. Lincoln (Eds.), *Handbook of qualitative research* (2nd ed.) (pp. 733–766). Thousand Oaks, CA: Sage.

Featherstone, J. (1989). To make the wounded whole. *Harvard Educational Review, 59,* 367–378.

Freire, P. (1985). *The politics of education.* South Hadley, MA: Bergin & Garvey.

Gee, J. (1990). *Social linguistics and literacies: Ideologies in discourses.* New York: Falmer Press.

Giroux, H. (1988). *Teachers as transformative intellectuals: Toward a critical pedagogy of learning.* New York: Bergin & Garvey.

Goodman, J. (1992). *Elementary schooling for critical democracy.* Albany: State University of New York Press.

Gore, J. (1993). *The struggle for pedagogies: Critical and feminist discourses as regimes of truth.* New York: Routledge.

Graff, H. J. (1987). *The legacies of literacy: Continuities and contradictions in western culture and society.* Bloomington: Indiana University Press.

Greene, M. (1988). *The dialectic of freedom (John Dewey Lecture Series).* New York: Teachers College Press.

hooks, b. (1994). *Teaching to transgress: Education as the practice of freedom*. New York: Routledge.

Kotlowitz, A. (1991). *There are no children here: The story of two boys growing up in the other America*. New York: Doubleday.

Kozol, J. (1988). *Rachel and her children*. New York: Crown.

Lalik, R., Langston, A., McLachlan, R., & Pacifici, L. (1993, October). *Considering the dialectic of theory and practice: A reflexive conversation on emancipatory praxis*. Paper presented at the Annual Conference of the Journal of Curriculum Theory, Dayton, OH.

Matousek, M. (1991, September/October). The crucible of homelessness. *Common Boundary*, 10–16.

Mosenthal, P. (1999). Critical issues: Forging conceptual unum in the literacy field of pluribus: An agenda-analytic perspective. *Journal of Literacy Research, 31* (2), 213–254.

Neilsen, L. (1994). *A stone in my shoe: Teaching literacy in times of change*. Winnipeg, MA: Peguis.

Richardson, L. (1992). The consequences of poetic representation: Writing the other, rewriting the self. In C. Ellis & M. G. Flaherty (Eds.), *Investigating subjectivity: Research on lived experience* (pp. 125–137). Newbury Park, CA: Sage.

Richardson, L. (1997). *Fields of play: Constructing an academic life*. New Brunswick, NJ: Rutgers University Press.

Shor, I. (1992). *Empowering education: Critical teaching for social change*. Chicago: University of Chicago Press.

Taylor, D., & Dorsey-Gaines, C. (1988). *Growing up literate: Learning from inner-city families*. Portsmouth, NH: Heinemann.

℘ CHAPTER 4

Seeing Disability in New Ways

Elizabeth Altieri

Away in a Manger

Away in a manger
 He kneels there in silence
No crib for a bed
 His hands tightly bound
The little Lord Jesus
 An anonymous face among hundreds
Lay down his sweet head.
 Bows down his wearied head.
The stars in the sky
 His God up in heaven
Look down where he lay
 Reaches down into hell
The little Lord Jesus
 An anonymous face among hundreds
Asleep on the hay.
 Asleep for a while.
The cattle are lowing
 A child is crying
The baby awakes
 The boy he awakes
But little Lord Jesus
 But namelessly, defeatedly
No crying he makes.
 No crying he makes.
I love thee, Lord Jesus
 Who loves you, dear child?
Look down from the sky
 Not one so it seems
And stay by my cradle
 Will sit with you, hold you
Till morning is nigh.
 Till morning is nigh.

—Laura, Spring 1997

 ဆ ဆ ဆ ဆ

The photograph introducing this chapter is from *Christmas in Purgatory: A Photographic Essay on Mental Retardation* (Blatt & Kaplan, 1974). This book, first published by Allyn and Bacon in 1966, used visual

image, powerful and often ironic captions, and traditional text to make public the horror of institutional warehousing in the mid-twentieth century for people with mental retardation and other developmental disabilities (Christensen & Rizvi, 1996). It was reproduced in its entirety in 1967 by *Look* magazine (Trent, 1994) and published by the Human Policy Press in 1974. Because of its usefulness as documentation of the history of people with disabilities and the contribution it made to the deinstitutionalization movement, this book was reprinted in 2001.

The black-and-white photographs that make up the essay are dark and dim, and their contents are not immediately recognizable to a viewer who has never spent time in such an institution. Many of the pictures were taken secretly with a spy camera through a hole in the photographer's jacket pocket (Blatt & Kaplan, 1974). I use a photograph, found on page 19 in *Christmas in Purgatory*, to frame this chapter, and thus it is found at both the beginning and end of this exploration into the use of visual image as a tool for critical and creative inquiry. The picture is of a child lying prone in a meager hospital gown, bound to a bench, a puddle of urine beneath him. It is an arresting image chosen repeatedly by my teacher preparation students for an inquiry they do as an assignment for my introductory class on exceptional children. Beneath the photograph I have provided an example of the creative and powerful representations students have constructed in response to this visual image; in this case, the Christmas carol "Away in a Manger" set against the imagined voice of the child in the photograph. The student, Laura, included the following note:

> This is not meant to be read as poetry or to be put to music. It is, instead, an emotional reaction to the photograph as is, prompted by and juxtaposed to the lyrics of a common Christmas carol.

This chapter will describe how images of disability became a theme of personal inquiry and curriculum development for me as a teacher educator, and how I came to use visual image as a tool of inquiry in an introductory course on exceptional learners to help students "see" disability in new ways. One element of the curriculum,

the learning activity using *Christmas in Purgatory*, will be analyzed and discussed for its potential to shake loose entrenched values and assumptions about how we as a culture have responded to people we have labeled as disabled, and its role in the transformation of understanding about disability, which occurs for learners across the entire semester of the course. The information being shared in this chapter comes from a teacher research project that I have been engaged in for the past six years.

I want to alert my readers to the somewhat unconventional structure of this chapter. One element of my inquiry has been to look at how we can use nontraditional forms of expression to help learners construct rich and complex meaning and to represent what they have learned in ways other than, or in addition to, the writing of expository or authoritative text; I have tried to visually arrange and layer this chapter to model that concept (Ely, Vinz, Anzul, & Downing, 1997). I have used a series of visual images and student responses to interface the more traditional sections of text in which I explain the impetus for my research, the design of my curriculum, the process of inquiry, and the results of my students' creative and critical inquiries in response to *Christmas in Purgatory*. In this way, the interfaces serve to both "cradle" (Sumara, 1997) and disrupt the intertextual understandings generated by the inquiry. I also used the interfaces as a way to more directly represent the meanings, emotions, and questions generated by students in response to the images, to give "pride of place" to their interpretations without me interrupting with an academic perspective on what I thought they "really meant," a research presentation format suggested by the work of Lather (Lather, 1997; Lather & Smithies, 1997).

The interfaces are meant to be evocative for the reader as well, "to generate insight and invite attention to complexity" (Eisner, 1993, p. 9; Ellis, 1997). Each interface of image and text compels the reader to respond to the images and reconstruct the understandings of the students within the context of their own experiences and understandings. Setting the interfaces apart from the academic discourse creates an interpretive space, one in which the reader can engage in creative

and critical inquiry of their own. Taken as a whole, they allow the transformation of the reader's understanding of the socio-cultural-historical construction of disability and our collective and personal response to people we view as disabled.

This chapter reveals my own transformation and that of my students. I will elaborate on why I have chosen "seeing disability in new ways" as a theme for curriculum development and my own inquiry. I will explore some of the critical theories of the social construction of disability that underpin my work. I will unpack the phrase *images of disability* and explain why I see their transformation as important. Specifically, I will describe the curriculum I have developed and the research I have undertaken to understand its impact. Finally, I will elaborate on the specific assignment from *Christmas in Purgatory came*, which uses visual image as a tool for creative and critical inquiry about disability, and address several questions that arise from that assignment and my research: What new understandings has my inquiry generated about my teaching and my students' learning about our cultural response to people with disabilities? What have been students' responses to this activity and other tools of learning and transformation? Where is my inquiry taking me?

ଯ ଯ ଯ ଯ

The Bible—My Family—Society—Democracy—
They've always taught the expectation of equality.
A right and virtue innately given to me as a normal human being.
No one having the authority to take it away.
And if one should dare to try and infringe,
it is my responsibility to stand up and fight passionately.
Encouragement and support I would rightfully receive
for it is a normal thing to react harshly to wrong-doing.
But in the busy rush of my day I do not have to
worry about such injustice .
Once upon a time" —the stories they have told
about the horrendous conditions of the primitive institutions.
They seem like fantasy to my current reality.
Luckily, we are now a more enlightened people,
forcefully rejecting such negativity.

If I lived in those times, when people were treated less than equal,
I would surely fight with all my anger,
especially for the things that directly affected me.
And I would receive encouragement and support,
for I am a normal human being.

Today I caught a glimpse
of what has been kept locked behind closed doors.
Learning the truth of what happened just yesterday,
in a book that revealed a situation even uglier
than the fairy tale I was told.
And my first reaction—anger.
Who could expect any less from a normal human being.

And then I realized that the normalcy of that emotion
was at the root of what I hated to see.
And in the midst of the obscenities
I noticed a picture of exceptional beauty
that held a secret which is not able to be revealed
in normal society.
The righteous men who were born
with no rights, respect, or normalcy
had a smile and a wave to give in return.
Something a normal human being
could never learn.

—Andrea, Fall 1997

 ဢ ဢ ဢ ဢ

The Impetus behind the Research

My first teaching job at age 19 was at a private school serving pre-schoolers with various disability labels and school-aged children who had been rejected by the public school system because of their "special" needs. I have many stories from that time that have shaped who I am as an educator. But the most significant values I gained and things I learned were from the children themselves. I remember being impressed by their capacity for learning and caring, and feeling indignant that others—especially professional "experts" from the fields of education and psychology—couldn't see these children in terms of what they *could* do. This was the first time, but certainly not the last, that I was struck by how much these children constructed as disabled were children, first and foremost; wonderful, loving, curious, rambunctiously eager kids with a range of gifts and a marvelous knack for manipulating their world and the people in it. If only people could see it that way (Carini, 1979).

A Personal Perspective on the
Cultural Construction of Disability

Through my experiences I went on to learn how the construction of a child as disabled through testing and labeling could scour the landscape of a child's future, could deny them a meaningful education, could force them to spend their lives segregated from their communities and, often, even their families. I came to understand firsthand how being seen as "disabled" closed the many doors of opportunity available to children seen as "normal," children deemed *inside* the magic bell curve. The label of retardation meant you were seen as incapable of benefiting from or perhaps even undeserving of those opportunities.

I came to new understandings about the people we call disabled through a variety of relationships: children and adults with complex needs and multiple disabilities who helped me learn how to see every person in terms of his or her capacity, who taught me to reject the premise that there are people so severely handicapped that they can-

not learn or do anything on their own, and who helped me to question why an institution is considered the most "appropriate" setting to meet their needs; students seen by society as uneducable who taught me that every person has the capacity to give, to care, to bring joy into someone's life; adults seen by society as incapable of working productively who showed me and many others that, with support, they could make a meaningful contribution within a real job in their community; adults who had been labeled as severely disabled since childhood who learned how to advocate on their own behalf and who showed me that it is important to acknowledge the preferences and choices of every individual; and finally co-workers and colleagues with disabilities who taught me to feel truly at ease with them as persons, to see their humanness first, but also to acknowledge their differences and make accommodations that facilitated their competence and comfort.

All these people taught me to question the devalued images of disability that we, as individuals and as a society, have created and perpetuated. The quality of our interactions made me begin to question the very construct of disability. Most of all, my experiences led me to completely reject the widely held but specious assumption that segregating people with disabilities is better for *them* and for *us*. This entrenched view of people with disabilities as *the other* (Delpit, 2001; Bogdan & Taylor, 1992) was not something I fully understood until I more fully engaged myself with the critical literature on disability.

A Theoretical Perspective on the
Cultural Construction of Disability

Sociologists, anthropologists, and others in the fields of social science and education have presented cogent arguments over the years to illustrate convincingly that disability is a socially constructed concept (Biklen & Duchan, 1994; Bishop, Foster, & Jubula, 1993; Blatt, 1981; Kliewer & Biklen, 1996; McDermott & Varenne, 1995; Rieber & Carton, 1993; Sarason & Doris, 1979). This is not to deny the existence of physical, sensory, and cognitive differences. But I have come to understand that it is the way we as a culture and as individuals respond

to those differences that creates the perception of deviance and handicap (Sapon-Shevin, 1989).

Seymour Sarason, in a talk at Syracuse University in the early 1980s, was the first person I heard question the way in which we defined and responded to disability as a problem existing within the individual that needed to be fixed or managed. His position was that our culture constructs a person as disabled through arbitrary social constructions that exist in the "minds of the judges" and reflect a particular time, place, and society in which those judgments are made (Sarason & Doris, 1979). The labels that are given to these constructions always reflect value judgments and convey great meaning that tells more about the labeler than the labeled (Potts, 1998; Sarason & Doris, 1979). In the case of disability, those value judgments have been essentially negative and demeaning (Klobas, 1988; Shapiro, 1993).

Historically, we have ascribed a range of devalued social roles to those whose differences we judge as deviant, and people with disabilities have been perceived as objects of pity, charity, ridicule, menace, and dread (Bogdan, Biklen, Shapiro, & Spelkoman, 1990; Wolfensberger, 1972). Smith (1999, p. 128) explained: "What disables individuals is not innate characteristics that limit their ability to function in the world, but rather the attitudes of others around them regarding perceptions of difference." Our long history of harsh judgments and negative perceptions of difference across time, places, and societal eras still shape our responses to people with disabilities today (Meekosha & Jacubowicz, 1996).

Others have maintained that it is our language that has shaped our actions, and the names that we give to categories of people with disabilities serve as tools that construct social and political realities, and justified our unjust response to that class of people (Danforth & Navarro, 1998; Stockholder, 1994; Stubbins, 1988). Stockholder (1994) asserted that this is a result of belief systems that are imbedded in those labels and a well-articulated ideology that frames their use. The devalued characteristics we attribute to those we label mentally retarded and the long history, which continues even today, of segrega-

tion and mistreatment as a cultural response to people we call re-tarded, are but two examples of this. Many other scholars in the field of disability studies also have asserted that labels and categories of disability are sociocultural constructions that function in just the way that Stockholder suggests, and that they have far-reaching, negative implications for the people we categorize and call disabled (Allen & Allen, 1995; Biklen & Duchan, 1994; Bogdan & Taylor, 1992; Ferguson, 1987; Reid & Button, 1995; Sleeter, 1986; Smith, 1999).

Rhodes and Sangor (1975) proposed that our labels of disability influence our actions because they have residual historical meanings imbedded in them: "Alarms about deviancy or alien persons become distilled into public residual labels, collective images which act as common symbols for defense" (p. 104). These labels become fixed and then "function autonomously like alarm systems gone awry" (p. 104). If we ascribe to this theory of Rhodes and Sangor, our seemingly neu-tral-sounding educational labels of disability are actually "distilled symbols which stand for a permeating ethos of protective anxiety" (p. 106). These label-symbols "cool and dilute the fear of what they stand for" (p. 106), but they still raise fear and anxiety nonetheless, and at a subconscious level they negatively color and influence our response.

The values and images imbedded in our labels change over time as well. In the early 1900s, labels such as "the feeble-minded" directly and openly categorized those considered deviant as harmful to the welfare of society and objects of menace, but these were replaced with "scientific" and educational terms (Rains, Kitsuse, Duster, & Friedson, 1975; Wolfensberger, 1972). Christensen (1996) noted that many of these "scientific" terms used earlier in this century as formal labels of disability, such as *moron* and *idiot*, are now used in informal social contexts as insults and put-downs.

I have found the arguments of these critical theorists very con-vincing, and thus I find myself part of a growing movement calling for the deconstruction and dismantling of beliefs built on these de-valued social constructions of people with physical, intellectual, and emotional differences. It will be no easy task to get those in the fields of education and psychology to question our taken-for-granted as-

sumptions about the nature of disability and "truths" that have been amassed through the huge assessment and research industry tied to special education (Brantlinger, 1997; Dyson, 1998; Gallagher, 1998; Martin, 1992; McDermott & Varenne, 1995; Oakes, Wells, Jones & Datnow, 1997).

In the 1970s and 1980s (and still to a certain extent today), much of the empirical research that was conducted on our cultural response to people with disabilities used *attitude* as a variable of investigation (see, for example, Antonak & Livneh, 1988; Hannah, 1988). Bogdan, Biklen, Shapiro, and Spelkoman (1990) expressed their concerns about this kind of research on disability, and criticized the assessment of attitudes toward and beliefs about people with disabilities in the absence of any real contexts for interaction. They asserted that studies of attitude "miss the point" and suggested that it would perhaps be a more useful avenue of inquiry to study the negative images that are associated with disability, and to identify the political and social contexts of these images.

The Impact of Disabling Images

As explained in the previous section, our cultural constructions of disability are, for the most part, stereotypical and devalued, and they shape our personal images of disability through a hegemonic process. Gartner and Joe (1987) called these "disabling images," created by social processes that repeatedly characterize or represent people with disabilities as "invalid." Our structures of separateness have kept most of us from having the kind of intimate relationships and positive interactions that allow for the construction of humanness of people with disabilities (Biklen, 1989). Our reified labels of disability render us incapable of seeing and building on the commonalties that people we call disabled have with those who are not considered disabled, and they block our moral perception; that is, the capacity to see the best in others and imagine their unique potential (Simpson & Garrison, 1995). We "see" or know people with disabilities through a lens that magnifies their difference and crops important elements such as capacity and competence from the picture. Given this, the disabling

cultural symbols and constructions of disability often form the core of our personal images of disability.

The media of our culture transmit these cultural symbols and constructions of disability, and their effect is pervasive and subliminal. Gartner and Joe (1987) identified a number of sources of stereotyped and devalued images. These include our literature; popular entertainment including film and theater; television including comedy, drama, talk shows, documentaries, music videos, news, and commercials; print media including newspaper, magazines, advertisements, billboards, and comics; electronic media including personal and publicly sanctioned Web pages; telethons and other fund-raising campaigns for human services and medical research; and textbooks and training materials used to prepare those who will be certified in some way to work with people considered disabled.

Kriegel (1987) and Margolis and Shapiro (1987) have made strong cases that the stories and grand epics found within our classical literature are rife with devalued representations of disability. Images of "the cripple" as survivor, demonic, and charity cases can be found in works such as *The Adventures of Augie March*, *Moby-Dick*, and *A Christmas Carol* (Kriegel, 1987). Messages about the evil and tragedy associated with disability, and perpetuation of the devalued roles of persons with disabilities as objects of dread, menace, and pity are reinforced by allegorical symbols such as the hump of *Richard III* or *The Hunchback of Notre Dame*. These messages are especially ubiquitous because they are transmitted as values through a long-standing tradition of teaching such classical literature in high schools and colleges across the country (Margolis and Shapiro, 1987).

Avenues of popular culture such as film and television also cast people into the full range of devalued social roles. But the most damaging representation they have served to create and reinforce, and even raised to an art form, is the use of physical and mental disability and deformity to portray the image of monster, to embody evil, and to convey a sense of horror and danger (Bogdan, Biklen, Shapiro, & Spelkoman, 1990). This association is historically strong, and most people, once prompted to do so, can think of many examples from

their present and childhood viewing of movies and television shows (Klobas, 1988; Longmore, 1987).

Expanding Our Understanding of Images of Disability

Because this is a book about image as a tool of inquiry and because I will use the term *images of disability* throughout this chapter, I believe it important to discuss and define these constructs. The word *image* has a number of various and related definitions: a visual or vivid graphic representation of something; a visual impression produced by reflection as from a mirror, or refraction through a lens; a mental picture of an idea or impression. It also can be seen as the embodiment of an idea or concept, or a mental picture that represents that idea or concept (*Compton's*, 1994). Its use in the field of psychology refers to a picture of an ideal that is constructed in and remains in the unconscious but influences our behavior. Two meanings especially pertinent to my use of the word image in this chapter are: "a mental conception or impression held in common by members of a group and symbolic of a basic attitude and orientation" or "a popular conception projected especially through the mass media" (*Merriam-Webster's Ninth New Collegiate Dictionary*, 1991).

In the education literature, the notion of *image* is a popular but loosely defined construct. In her review of narrative ways of knowing teaching and learning, Beattie (1995) defined image as a "meta-level organizing framework" for understanding, and as a component of personal practical knowledge. In Weber and Mitchell's work with drawings and preservice teachers (1995), *image* was defined as conceptions projected by the popular culture that become internalized. This use of image is what Connelly and Clandinin called "picturing" (1988). In their own work, Connelly and Clandinin used this definition of *image*:

> Something within our experience, embodied in us as persons, and expressed and enacted in our practices and actions.... Images are part of our past, called forth by situations in which we act in the present, and are guides to our future. Images as they are embodied in us entail emotions, morality, and aesthetics. (1988, p. 60)

As I began to formulate my ideas about the importance and influence of culturally constructed *images of disability* on teachers, I realized I would need to create a working definition for myself, my students, and my readers. This definition builds on the one above.

> *Images of disability* are representations of disability that are created through a recursive process of experience, social construction and individual internalization. They continually reflect our past personal experiences of disability onto our current experience and are framed by a collage of meaning-laden, emotion-laden, and value-laden cultural symbols or constructions associated with disability. These images of disability are expressed and enacted in our present practices, and point us in the direction of future actions. This definition of image incorporates the constructs of attitude, feeling, belief, perspective, opinion and orientation. (Altieri, 1996)

How I Have Come to This Place in My Teaching and Research

I have been working actively with this concept of *Images of Disability* since the mid-nineties. In the fall of 1995, I was enrolled as a doctoral student in curriculum and instruction in Rosary Lalik's graduate course *Reading Research Seminar*. Lynn Bustle was in that class as well.

Outside of class, Lynn and I were developing a personal relationship and were getting to know each other through our work and shared responsibilities as the two student teaching supervisors for the Patton County Graduate Intern Cohort. But it was the work we did for Rosary's class that created an important and lasting bond. I was greatly influenced by Lynn's "frames of literacy" metaphor and the artful representation she created to visually express that metaphor. Her interest in photography as a tool of literate expression inspired me so much so that I developed my own representation of literacy research using the process of photography as a metaphor. We first connected as inquirers in that class and fueled our mutual intrigue with the notion of image.

The open structure of the class encouraged me to further my understanding of the impact of our devalued cultural images of disability, and for my research paper I explored the usefulness of story and other literacy activities as tools for creating new images of disability

that focus on capacity. Rosary herself was the one to suggest that I revisit *Christmas in Purgatory*, a text we were both familiar with from working as educators in Syracuse, New York. For our class mini-conference on our research, I developed a presentation on images of disability and created several prototype activities to use with teacher preparation students to help them critically examine the socio-cultural-historical construction of disability and create new images of disability. The assignment for *Christmas in Purgatory* to be described in this chapter was one of those.

Over the years, I truly have come to know disability in new ways, and the lessons learned from these life experiences, personal relationships, and scholarly inquiries have fueled my ardent support for the full inclusion of people with disabilities within the life of the community. The present iteration of that passion is my involvement as a leader and participating member of a community of prospective and practicing general educators and special educators who are learning to welcome, nurture, and facilitate learning in the general classroom environment for children who have been labeled and previously excluded from the social and academic life of the school.

In the face of the national call for inclusive education, I am challenged by the entrenched separateness of our structures for educating children and for preparing and certifying teachers. Teacher preparation personnel and prospective and practicing educators who wish to promote inclusive education must become conscious of what maintains those separate structures. One of those forces has been the way in which our culture constructs disability and ability, and we must learn to see and counteract the pervasive and harmful images of children and adults with disabilities that are reinforced by the popular media, and in our schooling and rehabilitation instructional and funding practices, if inclusion and a unified education system is to become a reality.

I cannot and will not disguise the advocacy purpose to my teaching and research, and I intertwine these activities to help me, and hopefully others in the field, to better understand: "How do I help future classroom teachers re-examine and re-cast their current notions

about children with disabilities and their place (or lack of it) in the life of a school? When viewing children with labels of disability, how do I encourage them to shift the lens they use to focus to one of value and capacity, rather than needs and deficit? How do I get them to see that our socio-cultural-historical images of disability are devaluing and dehumanizing, and provide the frame for the unconscious assumptions about individuals with disabilities which limit our actions and responses to them as people?"

᷅᷈ ᷅᷈ ᷅᷈ ᷅᷈

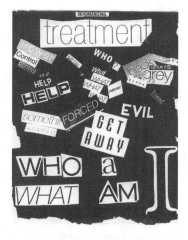

—Annie, Fall 1998

ॐ ॐ ॐ ॐ

Design of the Curriculum

The introductory survey course in "exceptional children" that I have taught at two institutions of higher education is a standard in teacher preparation programs across the country. Typically, the course emphasizes information on characteristics and methods for the various categories of disability or exceptionality, and incorporates visits or field experiences in special education programs. This curriculum structure was put into place over 100 years ago by Lightner Witmer, a psychologist, who created the first applied class on mental retardation for teachers at the University of Pennsylvania (Scheerenberger, 1983).

Historically, state teacher certification bodies and teacher preparation programs have only required or recommended this one course in special education for general educators (Katsiyannis, Conderman, & Franks, 1995). Some have questioned the usefulness of such a course in helping teachers come to feel comfortable and capable including children with labels of disability who would previously have been excluded from the general education classroom, and feel instead that the course actually reinforces devalued images of otherness and instills a deficit-oriented framework about disability that becomes entrenched in traditional school settings (Carter & Anders, 1996; Welch, 1996).

I have tried to design my course to counteract the powerful cultural and historical influences I have presented earlier in this chapter. My purpose has been to make explicit the ways our perceptions about people with disabilities are culturally constructed in socially devalued ways, both in the past and the present, and to provide an alternative perspective on disability, one that emphasizes the humanness and capacity of persons seen as disabled. I developed the following goals for my curriculum:

1. to bring to consciousness and examine our personal assumptions about disability and ability;

2. to critically consider how our cultural images of disability shape our beliefs, our personal interactions, and educational practice;
3. to come to know disability in new ways;
4. to learn to identify and appreciate the gifts and capacities of people seen as disabled, and to perceive/imagine their unique potential as individuals to participate in the life of our communities and to contribute to our own lives;
5. to gain an empathetic awareness of what it means to be a person with a disability in our society, and especially in our schools, today.

My approach to learning and teaching can be characterized as constructivist, and such an approach has been found to be useful in helping "learners internalize and reshape, or transform, new information...and understanding" (Brooks & Brooks, 1993, p. 120). The development of activities to enact the goals of my curriculum was guided by my knowledge of how personal images and new understandings of a concept are socially constructed in interactions with others, and the role of language in mediating our experiences and transforming what we know and believe (Vygotsky, 1978; Wertsch, 1991). I maximized intertextual meaning making, a recursive process of reading, reflecting, connecting, and writing (Bloome & Egan-Robertson, 1993; Hoel, 1997).

Each activity I developed as part of the curriculum included dialogic interaction with others, with images, and with texts, and included a directive to students to consider how their understanding about disability was changing or being reinforced. I created multiple and varied opportunities for students to engage in dialogue with their peers, and by doing so, hoped to engender "possibilities for reengagement, resistance, and reading [themselves] into the process of educational and social change" (Burdell & Swadener, 1999, p. 26). I maximized opportunities for students to share stories of disabilities, their own stories, and those of family members and friends, and those they have read either as class assignments or for their portfolio, to

connect personally and with feeling to the experience of disability (Brody, Witherell, Donald, & Lundblad, 1991; Dyson & Genishi, 1994). Retelling, in one's own words, can be a critically important way of coming to know (Bahktin, 1981), especially when that retelling is shared with others, and so I built such opportunities into my curriculum as well.

I wanted students to use theories about devalued social roles of persons constructed as disabled (Wolfensberger, 1972) and the humanness and capacities of persons seen as disabled (Bogdan & Taylor, 1992) in their writing and talking about the images of disability they encountered in literature, film, and other artifacts of popular culture. So we read and talked about these theories, and I provided directives and questions to encourage the development of a critical eye or viewpoint. The critical discussion framework has been recommended as a particularly useful way to help students challenge biased assumptions that may be unconsciously reinforced by personal reactions to stories and events that are limited by a person's values, beliefs, and experiences (Johnson, 1996; Margolis & Shapiro; Nodelman, 1996).

I developed other activities which I hoped would disrupt students' thinking, and that challenged their taken-for-granted assumptions through the affective mode. To do this, I deliberately required students to use forms of representation other than expository writing. McWilliam (1997) pointed out that the very act of experimenting with *new* forms is disruptive and leads us to question what we consider to be reality. Using alternate forms of representation gives students multiple ways of making sense of the world and the freedom to challenge the given, see in new ways, and question what they have always considered to be the truth (Neilsen, 1996). Eisner explained that,

> Alternative forms of data representation result in less closure and more plausible interpretations of the meaning of the situation....The open texture of the form increases the probability that multiple perspectives will emerge. Multiple perspectives make our engagement with the phenomena more complex. (1997b, p. 8)

Alternative forms can be used to enhance the ability of learners to "think analytically and critically...speculate and imagine...see con-

nections among ideas, and be able to use what they know to enhance their own lives and to contribute to their culture" (Eisner, 1997a, p. 349). The forms that have found to be most useful in enlarging understanding and allowing for new ways of seeing things are story, poetry, pictures, diagrams, maps, demonstrations, theater, and film (Eisner, 1997b).

Just as I have given students the opportunity to represent what they know through various forms, I also have used these same forms as tools in my own teaching. I have used and continue to explore the use of visual images with my students to evoke personal interpretations, deconstruct cultural messages, examine processes of oppression, and imagine alternative ways of acting in the world.

The assignments that I use to accomplish these various goals and purposes include one-page personal and critical reflections or a page of short-answer responses to teacher-posed questions in response to documentary and educational films, popular music selections, and stories presented in class. I engage students in a number of mini-inquiries, for example, the history and use of words that refer to disability, the history of institutionalization through *Christmas in Purgatory*, their family history of disability, and a series of studies that look at how specific disability labels are constructed and maintained, and what we know about people who typically receive that label and the ways schools respond to them. Each student has a choice of one of the two portfolio projects I have developed for this course. These are semester-long projects that capture their learning across the course, and that encompass all the curriculum features I have described above.

The first project is the *Images of Disability Portfolio* (Altieri, 1997; Winzer, Altieri, & Larsson, 2000). The following statement is from the description of the project that I provide to students:

> Here are the unique features of the portfolio: (a) it is a collection of cultural images, media items and events, readings, and personal stories related to disability, and your reactions and reflections on what you are learning; (b) it is a thoughtful, long-term exercise to be completed across most of the semester, and it is therefore cumulative and contemplative in nature; (c) it is to be compiled and submitted as a group project, but will involve both your indi-

vidual contributions and activities completed together as a group.

Students provide a personal reaction, make connections with what they are learning in class, and critically analyze a minimum of 10 texts, cultural artifacts, and/or personal experiences for this assignment. Considerable choice is provided, but students are required to respond to certain artifacts such as a selection of children's literature, television shows, newspaper or magazine articles, and films.

These reflections/analyses are shared with the members of their portfolio group, and they must complete a minimum of six group reflections; these may include discussion of specific individual reflections. At the end of the semester, in addition to the portfolio, each group creates an exhibit board or poster that represents their new understandings and the process of their learning and presents it in a poster-style exhibit/presentation open to their peers and professors in the college community and selected guests.

The second choice is called *Creating New Images of People with Disabilities*, and is a service learning project that requires a minimum of 20 hours of interaction with a child or young adult with a significant disability. The following statement is from the description of the project that I provide to students:

> Here are some of the unique features of the portfolio: (a) it is based on experiential learning and captures the powerfulness of meaningful, personal interactions; (b) it will help you see the importance of socio-cultural learning experiences in coming to see disability in new ways; and (c) it involves service learning that is tied to community need and that serves as a foundation for constructive social change. As part of this project, you will interact weekly with a child with disabilities either in his or her home or classroom. Through your weekly personal interactions with the child, at least two visits to the home, and structured interviews with the family and others who care about the child, you will develop both a written and photographic profile. This profile will focus on the preferences, talents, and potential of the child.

Students complete a positive personal profile (adapted from a similar profile developed by Rainforth, York, & Macdonald, 1992), a funds of knowledge assessment (loosely based on the work of Moll, Amanti, Neff, & Gonzalez, 1992), a shadow study (adapted from the work of Bullough & Gitlin, 1995), and a Circle of Friends analysis

(Snow & Forest, 1987) on the student. They also interview the individuals, their caregivers, and their past and present teachers. The final product is a portfolio that "paints" a picture of the individuals as both ordinary and gifted, and as a valued members and contributors within their school environment, their family, and their community. The goal of this assignment is to create new, positive images through text and photographs. This project functions like a case study, but I have developed it as a form of reflexive and ethnographic inquiry recommended as a valuable teacher development tool (Chiseri-Strater, 1996; Ferguson, 1987).

ജ ജ ജ ജ

How I Created the *Paradise Lost* Print
(text created from an interview with the artist, May 1999)

I started out by leafing through old magazines to get an idea for an assignment for my print making class. I was drawn to a photo of a prison guard with a prisoner. I felt that the meaning of the photo was a "used to" meaning. The guy [prisoner] "used to" have the world and now it is all gone. I decided to work with this meaning for my printmaking assignment.

During this time, I also looked through the photographs in Christmas in Purgatory for our Exceptional Learners class. I decided to turn my idea for a scene from within a prison to one that could also represent what life in an institution was like for people with severe disabilities.

Look at the scene in the print. The circular motion of the patients/prisoners depicts the never-ending routine of a prison or institution. It gives the meaning of people deprived of even simple choices by showing the old stone yard where they are at least able to exercise. But they are kept in the tight circle, not allowed to experiment and explore their differences, not allowed to operate of their own free will.

I guess the real meaning of the print was the whole idea of loss and deprivation. Once you are admitted into an institution or put in prison, the one thing that is the most valuable, the most important thing in the world, your freedom, is taken away from you.

I imagine that most children and adults who are put in institutions or homes must feel as if they are prisoners and that their freedom has been taken away from them.

—Ricky, Spring 1999

 ʀ ʀ ʀ ʀ

My Process of Inquiry

I first learned about and saw firsthand the effectiveness of teacher research as a tool of professional development as a supervisor of graduate interns in elementary education. From the onset of my involvement with the exceptional learners class, I used teacher research to study students' responses to the curriculum and to guide my development of the course. I found it to be a powerful and personal means of coming to know my own teaching and my students' learn-

ing. It allowed me to critically reflect on the instructional interactions and activities I had designed and assess their meaningfulness and effectiveness, and gave me a venue for sharing with others in the field of teacher education some of those insights (Altieri, 1998; Donoahue, 1996). My rationale for using the genre of teacher research was provided by Short (1993), who asserted, "Teacher research can add a new perspective about teaching and learning for *college* educators because it asks them to examine their own teaching and its implications for themselves as well as for the broader educational field" (p. 156).

My methodology is based on a number of recommendations made by narrative researchers in education (Beattie, 1995; Britzman, 1991; Clandinin & Connelly, 1988; Clandinin, Davies, Hogan, & Kinnard, 1993; Hoel, 1997; McEwan & Egan, 1995; Witherell & Noddings, 1991). Alvermann (2001) asserted that narrative approaches are essential in helping us come to know more about how people understand themselves and how they make sense of their experiences. Narrative inquiry has been cited as a particularly rich tool for studying curriculum, teacher practices, learning in the classroom, the exploration and resolution of educational issues, and teacher development (McEwan & Egan, 1995). Given the not uncommon reservations about the validity of narrative methodology, I understand the importance of providing readers with a clear explanation of what narratives and representational forms will be considered data and how they will be generated, a detailed description of the procedures used to collect and analyze the data, and an explanation of how the understandings generated by the inquiry will be represented along with a rationale for the function those forms will serve.

I have been collecting data for 12 consecutive semesters and have studied the responses of the approximately 350 students who have been enrolled in those classes. The inquiry began during the 1996 –1997 academic year at a large public research institution in a fall and spring undergraduate section of a 3-credit-hour class *Educating Exceptional Learners*. After that first year, I collected my data at a small liberal arts college where I was employed in a tenure-track position. Here, the course had the rather archaic title of *Survey of Exceptional*

Children, but the goals and the content remained similar. Typically, the makeup of each class was predominately white, female, and Protestant, and was quite representative of the Appalachian culture of the geographical area. Most of the students were sophomores or juniors working toward elementary or secondary certification.

Early in the semester, I openly acknowledged that I was engaged in teacher research, and trying to model a range of teaching and learning strategies. I obtained their consent to use their written work and tried to make clear that there was no penalty for choosing not to share their work with others.

In an earlier inquiry, I used my teacher research to look at the use of literacy activities, woven throughout the curriculum, to help students construct new understandings of disability. The following description of my method also can be found in the chapter *Using Literacy Activities to Construct New Understandings of Disability* that I wrote for the National Reading Conference 47th Annual Yearbook (Altieri, 1998). Each semester I collected representative samples of student writing in response to the various in-class activities, out-of-class writing assignments, including *Christmas in Purgatory,* and their portfolio project. I created research texts (Clandinin & Connelly, 1994), which consisted of my own interpretive notes written while reading and responding to students' work. These interpretative notes were personal and dialogic in nature (Elbaz-Luwisch, 1997; Hoel, 1997). I wrote back to every student for each writing assignment completed in class or as an out-of-class assignment, and I responded in writing to individual selections within the portfolios. My purpose was to engage in dialogue with the student, reinforcing observations they made and insights they elaborated on, helping them make new connections by tying in personal information they had previously shared or previous connections they had made, and asking probing questions when I felt they had failed to take a critical stance or see obvious contradictions in the artifact, image, or experience they were analyzing.

As I wrote back to students throughout the semester, and read and responded to their portfolios at the end of the course, I also created an interpretive narrative that summarized and analyzed stu-

dents' responses as a whole to each activity. I reflected on the purpose that each activity, and its images and stories, served for students. I worked to identify the issues and even the feelings that were revealed by their written responses, and analyzed how students constructed their written responses to convey new understandings and insight (Coffey & Atkinson, 1996). I looked for the kinds of images of disability students brought forth in their writing, how their understanding of past and current conceptions of disability emerged or did not emerge in their reflections, and if and how they responded to the ways people considered disabled and their families are responded to by school schools and society.

As I responded to the texts and alternate representations created by students, I also reflected on the implications for me as a teacher. Had I met the objectives I set for my course and curriculum? Were the in-class and out-of-class activities and assignments really contributing components? Because the design was so intertextual, could I really tease out the influence of the various tools of learning for the course? In addition to this interpretive narrative, I also recorded the key words and phrases found in students' texts, and created categories of positive and negative social roles and cultural images they used and referred to in their reflections (Turnbull, Turnbull, Shank, & Leal, 1995; Wolfensberger, 1972).

At the end of each semester, after I finished reading, writing, and responding to *all* students' work, I selected and made photocopies of representative examples of responses to each activity and assignment, and I again read and analyzed these samples. I used the following criteria to guide those choices: (a) I chose students' work that represented the range of students' responses to the activity, both positive and negative examples, and responses that were particularly rich with meaning as well as those superficial in nature; (b) I looked for examples of students' questions and misunderstandings; (c) I noted where and how students articulated changes in their thinking about disability; (d) I searched for examples that made me question an activity or my teaching, and that provided me with evidence of the need to change my strategy or the way I presented an activity; and (e) I

looked for evidence of transformation in students' understandings and beliefs, as well as the failure to transform.

೫ ೫ ೫ ೫

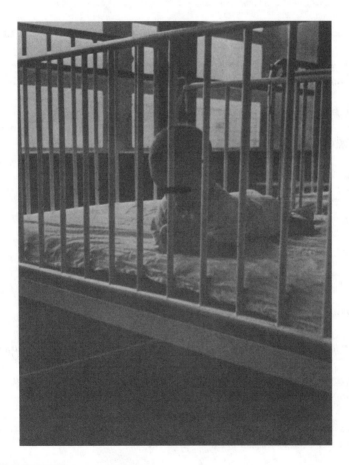

November 15, 1965

Dear Sir,

I am a mother. I am also only 18 years old. I gave birth one year ago on this date. My baby was not normal. The doctors told me he is a Mongoloid, he has what is

called Down Syndrome. They told me I would never be able to take care of him, and that he would never be anything in society. After many weeks of coaxing from my mother, who thinks I am too young to take care of any baby, she put him away somewhere up state. I have recently discovered that my baby could be in your institution. I miss Anthony, sir, and I would like to raise my baby.

Anthony did have a name when he was placed there. My mother says she gave him the name Anthony James when she placed him. He was quite a big baby, with a rather large head of brown hair. He had baby blue eyes. I do hope you have my baby, and you notify me very soon as to when I can come and get him back.

Could you also tell me, Sir, how he has been? Has he said his first word? Is he standing or walking? Is he happy? What kinds of things does he do during the day? Is there a lady there who knows him well? I remember him as being a very active baby, and he smiled a lot before I lost him. Is he still big?

Thank you, Sir, for your time. I am anxiously awaiting your letter, and I am very anxious to come to upstate New York and meet my son. His father and I are ready to have a family. Once again, thank you so much for taking care of him for us.

Signed,
Mr. and Mrs. Harold Jones, III

P.S. Will you please tell him that his Mommy loves him for me?

..

November 30, 1965

Dear Mrs. Jones,

I regret to inform you that your son, Anthony James Jones IV, died of pneumonia on February 12, 1965. We tried our best to ensure his health, but nothing could be done to save him. We did not have an address at that time for your son, which explains why you were not notified of his death.

I apologize for the delay in notifying you. His death certificate is being completed and will be forwarded to you when we receive it.

Signed,
Howard Mattson, Director

—Ashley, Spring 1998

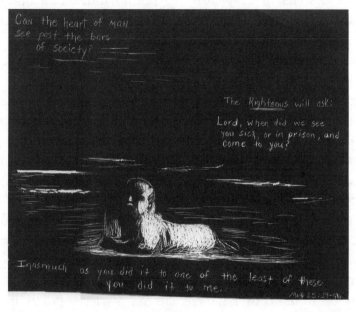

—Crystal, Fall 2001

૭ ૭ ૭ ૭

Creative and Critical Inquiry with *Christmas in Purgatory*

Two of the things I had hoped to learn from my teacher research were which activities were successful at getting students to see disability in new and critical ways, and which activities evoked significant personal responses that seemed to have the most potential for transforming their understanding. I found that one of the most powerful activities has been the creative and critical inquiry I designed using *Christmas in Purgatory*, and students have concurred. At the end of each semester I ask students to analyze in writing how their learning occurred for the class, and discuss the learning tools or activities that they saw as having the most impact. One student articulated this quite well: "I have learned in this class by placing myself in others'

shoes. That is, I tried to relate to people with disabilities by trying to imagine their feelings and emotions, and to picture myself in some of the environments these individuals were in, for example, the institutions in *Christmas in Purgatory.*" Another individual offered, "The *Christmas in Purgatory* assignment was important and stimulating—a good way to start off the class and get us thinking." One person saw that the assignment "offered a new way of learning about disabilities."

A number of students said "it was an eye-opening" and "unforgettable" experience. Others commented on the emotional impact of the book, how it made them cry and how they saw it as a "painful experience." My hope was that it would be the kind of story that would do more than just provoke pity, but be retold and interpreted with "outrage at injustices and violations" (Greene, 1995). One individual wrote, "I learned the most from *Christmas in Purgatory.* First, because it was one of the first things we read, and second, well, I had no idea. I was truly angry after reading that book and doing that assignment, and I ended up rereading it in its entirety."

Early on in the course we engage in a variety of activities including readings, lecture, and film clips that provide historical perspective on Western society's response to people with disabilities. I want students, as future teachers, to understand how the philosophy and practice of eugenics gave rise to practices that "protected" society from those who were seen as defective or deficient or unfit by physically separating and segregating them from the "good" or "normal" people. Eugenics is an important concept to understand, for it served to heighten the view of disability as something to be feared, and cast persons with real or perceived limitations into the role of menace to society (Winzer, 1994; Wolfensberger, 1972). Students need to know that, early in twentieth century, separate classes, "schools," and institutions were seen by eugenicists as a means of improving society and ensuring the purity and superiority of the "Anglo-Saxon race" (Richardson & Parker, 1993; Winzer, 1993). Tyack (1974), in his critical analysis of the social, political, and economic influences on the development of public schools, viewed the development of separate classes

and the systematic process of sorting as an assault on all forms of difference.

I chose to create an assignment around *Christmas in Purgatory* because I wanted my students to "see" this history of injustice stamped into the faces of the people we call disabled. There are two parts to the assignment. In the first part of the assignment, I use questions as writing prompts to elicit critical stance, connection-making, and understanding of historical perspective. Students develop a one-to-two-page typed response using the following questions:

1. What was your reaction to this photographic essay?
2. Why was this essay created and published? How did the subtitles and text, which accompanied the photos, contribute to your understanding of the authors' various intents?
3. How has this book meshed with what you know about the history of people with disabilities and Western society's response to them?
4. Has your conception of mental retardation and disability changed as a result of reading this book? If so, how? What did the book confirm that you already felt you knew about people with disabilities?

I designed the second part of the assignment as a creative inquiry, one that would allow students to demonstrate their own understanding of the messages and the meanings conveyed by this photographic essay. I ask them to select one photograph or series of photographs from the book to respond to, and develop a creative response such as a short story, a poem, a letter, or artistic rendering to represent their understanding of this photograph.

By pushing my students to use different forms of representation, I hoped they would be able to construct new meanings that might never emerge within traditional, objective, "dry" expository text. I relied heavily on the writings of Eisner and Greene to provide a rationale for the development of the alternative representation aspect of the assignment. I also was influenced by Richardson (1994), who described a class of experimental genres that she called *evocative repre-*

sentations and defined as the use of "literary devices to re-create lived experience and evoke emotional response." She described a number of "evocative" forms that could be used to convey the understandings and interpretations of a qualitative researcher. Three forms in particular seemed powerful possibilities for even small-scale inquiry: *narratives of the self* — highly personalized stories about "lived" experience; *ethnographic fictional representations* — understandings generated during the process of inquiry are drawn together to tell a "good story"; and *poetic representation* —creating poetry to honor the voices of those who were the subjects of the inquiry (pp. 521–522).

My rationale for asking students to create an alternative representation of meaning in response to the visual images in Christmas also came from the literature on narrative inquiry. One of the most significant pieces I read was Sumara's article on intertextuality (1997) and the idea that various formats and snippets of meaning can be cradled within something we loosely call a "text." From this, I also came to understand that ideas, memories, stories, understandings, pieces of text, and various quotes can be cradled in a creative representation.

What Have Been Students' Responses to This Activity?

Across the years, students have chosen an array of forms to represent their understanding. Typically, students create text in response to the image. Poetic representations have been the most popular, but their quality has varied greatly. I have found that those students who have taken at least one poetry class in college and who make a significant commitment of time to the creation and revision of their poem are the ones who are most successful with this form. There have been many other forms of expressive narrative, including letter writing and journal entries. Only a smattering of students have tried their hand at the short story as a form of representation. Two have attempted to write a song in response to one or more of the images from *Christmas in Purgatory*, while one student alone has made a connection between the feelings evoked by images from *Christmas* and the lyrics and music of a pop song for a portfolio reflection.

Some students have responded with a visual image in response to

the photographs. Only three students in six years have chosen to create an artistic rendering, each a powerful piece of artful representation. Two of those three images are included in this chapter. The third combined a stark pencil reproduction and elaboration of a photograph in the book with other imagery, and an overlay of poster board cut and painted to resemble a barred metal door that had to be opened to view the drawing. Other students have created collages and combined words and images in their search for meaning.

I observed that some photographs were chosen over and over again by students across semesters from the more than 50 images in the book. The two that have been most frequently selected are the image of the child lying bound to a bench, and the two similar images of a baby in a crib among a row of cribs. Images of children have been chosen more frequently than images of adults, and this does not seem unexpected, given that the majority of the students who take the class are in our elementary certification program. There are images that have never been chosen but, each semester, I always am pleasantly surprised when a previously unresponded-to-image is chosen by one of my students.

What Did Interaction with These Images and the Use of Alternative Representations of Their New Understandings Do?

Because few students have had significant personal relationship with a person with a disability or experienced life as a person with a difference that is not valued by our culture, I did not expect to see first-hand connection-making between their own personal experiences and those of the people they saw in the photographs. But resonance did occur (Conle, 1996), and many students did make connections with other kinds of personal experiences, such as Mark's visits to his grandfather in a nursing home or Brooke's assertion that there were strong parallels between the history of people with disabilities and African Americans, between slavery and institutionalization. Students applied their knowledge and outrage about other horrific experiences that are part of our collective history—slavery, the treatment of American Indians, and the Jewish people and the Holocaust. Typi-

cally, several students each year comment that this activity and others helped them "walk in their shoes." One student said that the activities and projects enabled him to "actually put a face on the learning I was doing through my reflections."

With only a few exceptions, students have had a highly emotional and affective response to the images. This individual's response was characteristic of the reaction students had to the book:

> *Shock, disgust, revulsion, horror, pain, sorrow, "How can I help?" "How could they?" —tears, confusion, anger, guilt, "Why?" "How?" —I could not sit and read this entire essay at one time. At times, it made me literally nauseous. It also burdened me with a great sense of guilt. . . . that my predecessors could be so ignorant.*

This sense of cultural guilt and shame was cited by a number of students. For some, "seeing" injustice stirred a desire to be part of the change that needs to occur today:

> *I feel like what I have learned through this class has given me the power to change things, and make a difference in the school systems where I will work and in the lives of the children I will teach.*

> *I have learned a great deal about the kind of teacher and advocate I want to be...you have taught me a lot about determination, persistence, and sensitivity.*

As compelling as the images are, many students said that the combination of image and text was especially effective. The way Burton Blatt chose to create his representations through the process of selecting photographs, creating titles for them, and adding quotes from the Bible, famous physicians, and humanitarian figures, and leaders in the fields of education and psychology, was in itself a form of creative, alternative representation. One student thought that the authors "used these subtitles as the people's unheard voices." Another thought the quotes initiated an "emotional journey for the reader to travel," and allowed the reader "to feel, not just see." Some students pointed out the ironies; others did not seem to see or understand them.

Where My Inquiry Has Led Me

It has been hard to tease out the role that the *Christmas in Purgatory* assignment has had separate from the cumulative effects of the curriculum and the intertextual, dialogic, critical activities that comprise the entire course. But that assignment is just a part of my emphasis on examining and imagining *Images of Disability*, and I can say with some assurance that transformation does occur. Overwhelmingly, in their end-of-the semester analysis of their learning in the course, students say how much they've learned and how much they've changed. Not surprisingly, students frequently use terms of visual imagery to describe their learning. Below are some examples of the kind of student responses I receive each semester:

> *I never realized how many images of disability are present in the media until I started working on the portfolio. It was an eye-opener.*

> *Through this class, I have learned that I have been blind, and if not blind, then I have had an extremely narrow perception of our culture. My horizons have been broadened, and my senses have been tuned.*

> *I learned that there is more than meets the eye, and not to take everything at face value.... I learned this by trying to be critical of the things I encountered.*

> *This class has taught me to see disability in a different light. I have learned about things that I have always taken for granted.*

> *How did I learn? I learned by experiencing. It may have been hands-on, watching and experiencing emotions (all emotions) from the films and guest speakers. I learned by finding artifacts for my portfolio, and by developing my ideas and my own convictions about such. The most important things I have learned are about myself. I did a lot of searching and thinking about who I have been, who I am, and who I will be as a person, be it as a citizen, teacher, parent, etc.*

> *There are so many ways in which my mind was expanded in just gathering the knowledge I researched. From newspaper articles to magazine articles to poems and artwork, I found such creative ways not only for people to express themselves, but also creative ways for people like me to learn. What can you say in a paper but facts? A picture or a poem express feeling and allow for a different kind of relation to a subject. I hope I can be half as creative in my teaching endeavors.*

> *This was a very demanding course, not only of your time, but also of your emotions. I was forced to look at many things in a completely different light. I was made to see my own stereotypes and negative attitudes toward people with disabilities. I was also forced to look deep inside my heart to see how I really felt about people with disabilities and having them in my classroom as a teacher.*

This class has made me reevaluate my thoughts on life.

I have learned my weaknesses, my judgments, my prejudices.

My mind is not so 'one-sided' now.

Each semester, I have analyzed my students' work and their analyses of their learning, and have made changes and additions in the learning activities for this course. Over the six years, I have added only two activities using visual image. On a small scale was the addition of a requirement for the *Images of Disability Portfolio.* Students must choose a visual image of a person with disability from a media source, an image that would be considered present in the popular culture, and analyze the negative and positive values present in the image.

An addition of a much larger scale was the Service Learning Project, *Creating New Images of People with Disability.* After two semesters of mixed results with the quality of photographs selected for inclusion, I developed a new strategy. Last semester, I had students lay out the photographs they were considering using for their portfolio, and they helped each other check that their images conveyed positive values and did not unintentionally convey Wolfensberger's devalued roles.

In all this time, however, I have not changed the *Christmas in Purgatory* assignment. Even though there are always students whose written responses are not particularly powerful compared to their alternate representation, the extensive feedback I provide helps them realize that cursory assignment completion is unacceptable in this course, and they become aware of the level of deep and critical thinking that is required and rewarded.

Although I continue to wrestle with how to shape my course and this particular assignment to better engage teacher education candidates with the cultural construct of disability through creative and critical inquiry, every semester my students' responses to the photographs in *Christmas in Purgatory* convince me of the power and the potential of this activity to transform.

൭ ൭ ൭ ൭

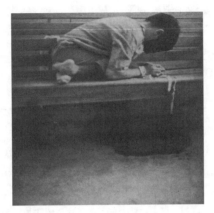

Back Wards

If you wish to come into my cell
during your short visit to the back wards,
walk on through the thousand-eyed brick face
and through death's heavy golden door.
But you'd better pray you come upon me
with your eyes averted, walking backwards.
For I could be you at eight —straight brown hair,
pale white skin, curling toes, and a tender ear,
And should you see me where I do not ever, ever live,
you'll never again be able to choke back words
of how these goddamned straps do cut and bind
my waist and wrists against pine planking.

—Mark, September 2001

References

Allen, B., & Allen, S. (1995). The process of socially constructing mental retardation: Toward value-based interaction. *Journal of the Association for Persons with Severe Handicaps, 20,* 158–160.

Altieri, E. (1996). *Exploring the construction of disability.* Unpublished manuscript. Blacksburg, VA: Virginia Tech.

Altieri, E. (1997, November). *Understanding disability in new ways: Making the journey through a group portfolio project.* Paper presented at the meeting of the Teacher Education Division of the Council for Exceptional Children, Savannah, GA.

Altieri, E. (1998). Using literacy activities to construct new understandings of disability. *National Reading Conference Yearbook, 47,* (pp. 529–541). Chicago, IL: National Reading Conference.

Alvermann, D. E. (2001). Narrative approaches. In M. L. Kamil (Ed.), *Methods of literacy research: The methodology chapters from the Handbook of Reading Research. Vol. III* (pp. 123–139). Mahwah, NJ: Lawrence Erlbaum.

Antonak, R. F., & Livneh, H. (1988). *The measurement of attitudes towards people with disabilities.* Springfield: Charles C. Thomas.

Bahktin, M. M. (1981). *The dialogic imagination.* Austin: University of Texas Press.

Beattie, M. (1995). New prospects for teacher education: Narrative ways of knowing teaching and teacher learning. *Educational Researcher, 37* (1), 53–70.

Biklen, D. (1989). Redefining schools. In D. Biklen, D. Ferguson, & A. Ford (Eds.), *Schooling and disability: Eighty-eighth yearbook of the National Society for the Study of Education* (pp. 1–24). Chicago: University of Chicago Press.

Biklen, D., & Duchan, J.F. (1994). "I am intelligent": The social construction of mental retardation. *Journal of the Association for Persons with Severe Handicaps, 19* (3), 173–184.

Bishop, K. D., Foster, W., & Jubala, K.A. (1993). The social construction of disability in education: Organizational considerations. In C. A. Capper, (Ed.), *Educational administration in a pluralistic soci-*

ety. Albany: State University of New York Press.

Blatt, B. (1981). Toward an understanding of people with special needs. *In and out of mental retardation: Essays on educability, disability, and human policy*. Baltimore: University Park Press.

Blatt, B., & Kaplan, F. (1974). *Christmas in purgatory: A photographic essay on mental retardation*. Syracuse, NY: Human Policy Press.

Bloome, D., & Egan-Robertson, A. (1993). The social construction of intertextuality in classroom reading and writing lessons. *Reading Research Quarterly, 28* (4), 304–333.

Bogdan, R., Biklen, D., Shapiro, J., & Spelkoman, D. (1990). The disabled. Media's monster. In M. Nagler (Ed.), *Perspectives on Disability* (pp. 138–142). Palo Alto, CA: Health Markets Research. (Reprinted from *Social Policy*, Fall 1982.)

Bogdan, R., & Taylor, S. (1992). The social construction of humanness: Relationships with severely disabled people. In P. M. Ferguson, D. L. Ferguson & S. J. Taylor (Eds.), *Interpreting disability: A qualitative reader* (pp. 275–294). New York: Teachers College Press.

Brantlinger, E. (1997). Using ideology: Cases of non-recognition of the politics of research and practice in special education. *Review of Educational Research, 67* (4), 425–459.

Britzman, D. P. (1991). *Practice makes practice: A critical study of learning to teach*. Albany: State University of New York Press.

Brody, C., Witherell, C., Donald, K., & Lundblad, R. (1991). Story and voice in the education of professionals. In C. Witherell & N. Noddings (Eds.), *Stories lives tell: Narrative and dialogue in education* (pp. 257–278). New York: Teachers College Press.

Brooks, J. G., & Brooks, M. G. (1993). *In search of understanding: The case for constructivist classrooms*. Alexandria, VA: Association for Supervision and Curriculum Development.

Bullough, R. V., & Gitlin, A. (1995). *Becoming a student of teaching: Methodologies for exploring self and school context*. New York: Garland Publishing

Burdell, P., & Swadener, B.B. (1999). Critical personal narrative and autoethnography in education: Reflections on a genre. *Educational Researcher, 28* (6), 21–26.

Carini, P. F. (1979). *The art of seeing and the visibility of the person*. Grand Forks: University of North Dakota Press.

Carter, K., & Anders, D. (1996). Program pedagogy. In F. B. Murray (Ed.), *The teacher educator's handbook: Building a knowledge base for the preparation of teachers* (pp. 557–592). San Francisco: Jossey-Bass.

Chiseri-Strater, E. (1996). Turning in upon ourselves: Positionality, subjectivity, and reflexivity in case study and ethnographic research. In P. Mortensen & G. E. Kirsch (Eds.), *Ethics and representation in qualitative studies of literacy* (pp. 115–133). Urbana, IL: National Council of Teachers of English.

Christensen, C. (1996). Disabled, handicapped or disordered: "What's in a name?" In C. Christensen and F. Rizvi (Eds.), *Disability and the dilemmas of education and justice* (pp. 63–78). Philadelphia: Open University Press.

Christensen, C and Rizvi, F. (Eds.), (1996). *Disability and the dilemmas of education and justice* (pp. 63–78). Philadelphia: Open University Press.

Clandinin, D. J., & Connelly, F. M. (1994). Personal experience methods. In N. K. Denzin & Y. S. Lincoln (Eds.), *Handbook of qualitative research* (pp. 413–427). Thousand Oaks, CA: Sage Publications.

Clandinin, D.J., Davies, A., Hogan, P., & Kennard, B. (1993). *Learning to teach, teaching to learn: Stories of collaboration in teacher education*. New York: Teachers College Press.

Coffey, A., & Atkinson, P. (1996). *Making sense of qualititative data: Complimentary research strategies*. Thousand Oaks, CA: Sage.

Compton's Interactive Encyclopedia (Edition 95 for Windows). (1994). [CD-ROM].

Conle, C. (1996). Resonance in preservice teacher inquiry. *American Educational Research Journal, 33* (2), 297–325.

Connelly, F. M., & Clandinin, D. J. (1988). *Teachers as curriculum planners: Narratives of experience*. New York: Teachers College Press.

Danforth, S., & Navarro, V. (1998). Speech acts: Sampling the social construction of mental retardation in everyday life. *Mental Retardation, 36,* 31–43.

Delpit, L. (2001). "Skin-deep" learning. In P. Rodis, A. Garrod, & M.

L. Boscardin (Eds.), *Learning disabilities and life stories* (pp. 157–164). Boston: Allyn and Bacon.

Donoahue, Z. (1996). Collaboration, community, and communication: Modes of discourse for teacher research. In Z. Donoahue, M.A. Van Tassell, & L. Patterson. (Eds.), *Research in the classroom. Talk, texts, and inquiry* (pp. 91–107). Newark, DE: International Reading Association.

Dyson, A. (1998). Professional intellectuals from powerful groups: Wrong from the start? In P. Clough and L. Barton (Eds.), *Articulating with difficulty: Research voices in inclusive education* (pp. 1–12). London: Paul Chapman Publishing.

Dyson, A. H., & Genishi, C. (1994). Introduction: The need for story. In A. H. Dyson & C. Genishi (Eds.), *The need for story: Cultural diversity in classroom and community* (pp. 1–7). Urbana, IL: National Council of Teachers of English.

Eisner, E. W. (1993). Forms of understanding and the future of educational research. *Educational Researcher, 22* (7), 5–11.

Eisner, E. W. (1997a). The promise and perils of alternative forms of data representation. *Educational Researcher, 26* (6), 4–10.

Eisner, E. W. (1997b). Cognition and representation: A way to pursue the American Dream? *Kappan, 78* (5), 348–353.

Elbaz-Luwisch, F. (1997). Narrative research: Political issues and implications. *Teaching and Teacher Education, 13* (1), 75–83.

Ellis, C. (1997). Evocative autoethnography: Writing emotionally about our lives. In W. G. Tierney & Y. S. Lincoln (Eds.), *Representation and the text: Reframing the narrative voice* (pp. 115–139). Albany: State University of New York Press.

Ely, M., Vinz, R., Anzul, M., & Downing, M. (1997). *On writing qualitative research: Living by words.* Washington, DC: Falmer Press.

Ferguson, D. L. (1987). *Curriculum decision making for students with severe handicaps: Policy and practice.* New York: Teachers College Press.

Gallagher, D. J. (1998). The scientific knowledge base of special education: Do we know what we think we know? *Exceptional Children, 64* (4), 493–502.

Gartner, A., & Joe, T. (1987). *Images of the disabled, disabling images.* New York: Praeger.

Greene, M. (1995). Multiculturalism, community and the arts. In A. H. Dawson & G. Genishi (Eds.), *The need for story* (pp. 11–27). New York: Teachers College Press.

Hannah, M. E. (1988). Teacher attitudes toward children with disabilities: An ecological analysis. In H. E. Yuker (Ed.), *Attitudes toward persons with disabilities* (pp. 154–170). New York: Springer Publishing.

Hoel, T. (1997). Voices in the classroom. *Teaching and Teacher Education, 13* (1), 39–54.

Johnson, G. (1996). The possibilities of a critical/literary reading. *Journal of Children's Literature, 22* (1), 14–18.

Katsiyannis, A., Conderman, G., & Franks, D. J. (1995). State practices on inclusion: A national review. *Remedial and Special Education, 16* (5), 279–287.

Kliewer, C. & Biklen, D. (1996). Labeling: Who wants to be called retarded? In W. Stainback and S. Stainback (Eds.), *Controversial issues confronting special education: Divergent perspectives* (pp. 83–95). Boston: Allyn and Bacon.

Klobas, L. (1988). *Disability drama in television and film.* Jefferson, NC: McFarland & Company.

Kriegel, L. (1987). The cripple in literature. In A. Gartner & T. Joe (Eds.), *Images of the disabled, disabling images* (pp. 31–46). New York: Praeger.

Lather, P. (1997). Creating a multilayered text: Women, AIDS, and angels. In W. G Tierney & Y. S. Lincoln (Eds.), *Representation and the text: Reframing the narrative voice* (pp. 233–258). Albany: State University of New York Press.

Lather, P., & Smithies, C. (1997). *Troubling the angels: Women living with AIDS.* Boulder, CO: Westview Press.

Longmore, P.K. (1987). Screening stereotypes: Images of disabled people in television and motion pictures. In A. Gartner & T. Joe, *Images of the disabled, disabling images* (pp. 65–78). New York: Praeger.

Margolis, H., & Shapiro, A. (1987, March). Countering negative images of disability in classical literature. *English Journal*, 18–22.

Martin, A. (1992). Screening, early intervention, and remediation: Obscuring children's potential. In H. Hehir & T. Latus (Eds.), *Special education at the century's end: Evolution of theory and practice since 1970* [Reprint series No. 23] (pp. 407–428). Cambridge, MA: Harvard Educational Review.

McDermott, R., & Varenne, H. (1995). Culture as disability. *Anthropology and Education Quarterly, 26*, 324-348.

McEwan, H., & Egan, K. (1995). Introduction. In H. McEwan and K. Egan (Eds.), *Narrative in teaching, learning, and research,* (pp.vii–xv). New York: Teachers College Press.

McWilliam, E. Performing between the posts: Authority, posture and contemporary feminist scholarship. In W.G. Tierney & Y.S. Lincoln (Eds.), *Representation and the text: Reframing the narrative voice* (pp. 219–232). Albany: State University of New York Press.

Meekosha, H., & Jakubowicz, A. (1996). Disability, participation, representation, and social justice. In C. Christensen and F. Rizvi (Eds.), *Disability and the dilemmas of education and justice* (pp. 79–95). Philadelphia: Open University Press.

Moll, L. C., Amanti, C., Neff, D., & Gonzalez, N. (1992). Funds of knowledge for teaching: Using a qualitative approach to connect homes and classrooms. *Theory into Practice, 31*, 132–141.

Nodelman, P. (1996). *The pleasures of children's literature* (2nd ed.). White Plains, NY: Longman.

Neilsen, L. (1996). Remaking sense, reshaping inquiry: Feminist metaphors and a literacy of the possible. In J. Flood, S. B. Heath, & D. Lapp. (Eds.), *Research on teaching literacy through the communicative and visual arts* (pp. 203–214). New York: Simon & Schuster Macmillan.

Oakes, J. E., Wells, A. S., Jones, M., & Datnow, A. (1997). Detracking the social construction of ability, cultural politics and resistance to reform. *Teachers College Record, 98* (3), 482–510.

Potts, P. (1998). Knowledge is not enough: An exploration of what we can expect from enquiries which are social. In P. Clough & L. Bar-

ton (Eds.), *Articulating with difficulty: Research voices in inclusive education* (pp. 16–28). Thousand Oaks, CA: Sage Publications.

Rainforth, B., York, J., & Macdonald, C. (1992). *Collaborative teams for students with severe disabilities: Integrating therapy and educational services.* Baltimore, MD: Paul H. Brookes.

Rains, Kitsuse, Duster, & Friedson (1975). The labeling approach to deviance. In N. Hobbs (Ed.), *Issues in the classification of children. Vol. I.* (pp. 88–100). San Francisco: Jossey-Bass.

Reid, D. K. & Button, L. J. (1995). Anna's story: Narratives of personal experience about being labeled learning disabled. *Journal of Learning Disabilities, 28* (10). 602–614.

Rhodes, W. C., & Sangor, M. (1975). Community perspectives. In N. Hobbs (Ed.), *Issues in the classification of children* (Vol. I), (pp. 101–129). San Francisco: Jossey-Bass.

Richardson, J. G., & Parker, T. L. (1993). The institutional genesis of special education: The American case. *American Journal of Education, 101* (4), 359–391.

Richardson, L. (1994). Writing: A method of inquiry. In N. K. Denzin & Y. S. Lincoln (Eds.), *Handbook of qualitative research* (pp. 516–529). Thousand Oaks, CA: Sage Publications.

Rieber, R.W., & Carton, A. S. (Eds.), (1993). *The collected works of L. S. Vygotsky. Vol. 2. The fundamental of defectology.* New York: Plenum Press.

Rizvi, F. & Lingard, B. (1996). Disability, education, and the discourses of justice. In C. Christensen and F. Rizvi (Eds.), *Disability and the dilemmas of education and justice* (pp. 9–26). Philadelphia: Open University Press.

Sapon-Shevin, M. (1989). Mild disabilities: In and out of special education. In D. Biklen, D. Ferguson, & A. Ford (Eds.), *Schooling and disability: Eighty-eighth yearbook of the National Society for the Study of Education* (pp. 77–107). Chicago: University of Chicago Press.

Sarason, S. B, & Doris, J. (1979). *Educational handicap, public policy, and social history: A broadened perspective on mental retardation.* New York: The Free Press.

Scheerenberger, R. C. (1983). *A history of mental retardation.* Baltimore:

Paul H. Brookes Company.

Shapiro, J. (1993). *No pity: People with disabilities forging a new civil rights movement.* New York: Times Books.

Short, K. G. (1993). Teacher research for teacher educators, In L. Patterson, C. M. Santa, K. G. Short, & K. Smith (Eds.). *Teachers are researchers: Reflection and action* (pp. 155-159). Newark, DE: International Reading Association.

Simpson, P. J., & Garrison, J. (1995). Teaching and moral perception. *Teachers College Record, 97* (2), 252-278.

Sleeter, C. (1986). Learning disabilities: The social construction of a special education category. *Exceptional Children, 53* (1), 46-54.

Sleeter, C. (1995). Radical structuralist perspectives on the creation and use of learning disabilities. In T. Skrtic (Ed.), *Disability and democracy: Reconstructing (special) education for postmodernity* (pp. 153-165). New York: Teachers College Press.

Smith, P. (1999). Drawing new maps: A radical cartography of developmental disabilities. *Review of Educational Research, 69* (2), 117-144.

Snow, J., & Forest, M. (1987). Circles. In M. Forest (Ed.), *More education integration* (pp. 169-176). Downsview, ONT: G. Allen Roeher Institute.

Stockholder, F.E. (1994). Naming and renaming persons with intellectual disabilities. In M. H. Rioux & M. Bach (Eds.), *Disability is not measles: New research paradigms in disability* (pp. 153-179). North York, Ontario: Roeher Institute.

Stubbins, J. (1988). The politics of disability. In H.E. Yuker (Ed.), *Attitudes towards persons with disabilities* (pp. 22-32). New York: Springer Publishing.

Sumara, J. (1997). A topography of reading. *English Education, 29* (4), 227-242.

Trent, J. W. (1994). *Inventing the feeble mind: A history of mental retardation in the United States.* Berkeley, CA: University of California Press.

Turnbull, A. P., Turnbull, H. R., Shank, M., & Leal, D. (1995). *Exceptional lives: Special education in today's schools.* Englewood Cliffs, NJ:

Merrill.

Tyack, D.B. (1974). *The one best system*. Cambridge: Harvard University Press.

Vygotsky, L. S. (1978). *Mind in society*. Cambridge, MA: Harvard University Press.

Weber, S. J., & Mitchell, C. (1995). *That's funny. You don't look like a teacher: Interrogating images, identity, and popular culture*. Philadelphia: Taylor & Francis, Inc.

Merriam-Webster's Collegiate Dictionary, 9th edition. (1991). Springfield, MA: Merriam-Webster.

Welch, M. (1996). Teacher education and the neglected diversity: Preparing educators to teach students with disabilities. *Journal of Teacher Education, 47* (5), 335–366.

Wertsch, J. (1991). *Voices of the mind: A socio-cultural approach to mediated action*. Cambridge, MA: Harvard University Press.

Winzer, M. A. (1993). *The history of special education: From isolation to integration*. Washington, DC: Gallaudet University Press.

Winzer, M. A., Altieri, E., & Larsson, V. (2000). Portfolios as a tool for attitude change. *Rural Special Education Quarterly, 19* (3/4), 72–81.

Witherell, C. & Noddings, N. (Eds.), (1991). *Stories lives tell: Narrative and dialogue in education*. New York: Teachers College Press.

Wolfensberger, W. (1972). *Normalization*. Toronto: National Institute on Mental Retardation.

ℰℭ CHAPTER 5

Exploring the "Value" of the Visual
Assessing and Evaluating Visual
Representation in Classrooms

Lynn Sanders-Bustle

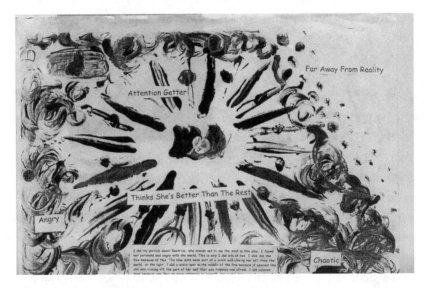

Becoming writers, like becoming artists, requires an understanding of symbols that communicate and express meaning. Creative practice yields unique representations of understanding through text or image. If understanding is revealed visually, then it becomes a visual representation. If understanding is revealed textually, then it becomes textual representation. There is great value in each, and perhaps when employed together, there is even deeper understanding. Perhaps we can paint more passionately if we respond to text such as a lyric or a poem. Perhaps we can write more reflectively if we freely move colors of paint across a page. As educators, we cannot underestimate the value of each or their impact on one another.

The finger painting in Figure 20, created by an eighth grader named Beth, visually represents her understanding of the character Beatrice in Paul Zindel's play, *The Effect of Gamma Rays on Man-in-the-Moon Marigolds* (1999). Beth's painting is like many visual representations created by teachers across the curriculum to engage learners and demonstrate understanding. A simple walk down the halls and through the classrooms of schools reveals a wide variety of visual artifacts such as drawings, paintings, diagrams, photographs, and posters. Some are expressive creations that many would describe as art, while others are informational pieces such as diagrams or time lines. There are visual representations worn proudly on the surfaces of t-shirts or displayed on the covers of notebooks. The variety and sheer number of visual representations is enormous and their role in the lives of learners is vast and often unexplored.

I am convinced that visual representations deserve to be considered "valuable" representations of learning in schools. It makes sense that if learners are asked to engage with visual representations as part of learning experiences, educators must carefully and purposefully consider the role of visual representations and processes in teaching and learning. This chapter represents the beginning of an exploration that, first, seeks to understand how four middle-school teachers conceptualize and use visual representations in their classrooms and, second, examines more specifically the role of visual representation in assessment and evaluation. Through this research, I hope to encourage educators at all levels to consider ways that we can make the use of visual image more "valuable" for all learners.

As I straddle the line between the arts and language arts, I stay committed to those qualities of each that encourage meaningful learning with students. As a former art teacher, charged with the task of assessing and ultimately grading visual representation, the question of how to assess that which many have termed "subjective" was an issue. Yet, at the same time, art as a discipline functioned with its own content that could be addressed in assessment and evaluation. Unlike academic core subjects, however, I did not have the impending shadow of standardized testing to darken my lofty ideals. I could talk

openly about effort, individuality, and growth as evolving artists. I could engage students in what artists called "critiques" of their work. I could spend extra time helping students with their work without worrying that I needed to "teach to a test." In an ideal sense, art was not about standardizing anything. Instead, the goal was to create that which was one of a kind, individual, unique, and different. I realize that this was a luxury. At the same time, my joyous yet fragile existence was not without worry. I knew this kind of revelry could come to a quick end if budgets called for cutbacks or if hours in the day were needed for valued subjects. Yet, within the glory of creation, there was the opportunity for each child to succeed, genuine interest, a celebration of individuality, difference, culture, perspective, and the expressive, deeply felt qualities that inspire and allow us to imagine. These were the qualities I valued and that I sought to share with others. These are just some of the qualities that engagements with visual representation can foster.

Valuing Visual Representation

Authentically incorporating visual representation into teaching and learning requires educators to embrace visual representation as a valued tool for understanding. It is not enough to view visual representation as an accessory, frill, or add-on (Shephard, 1993; Flood, Lapp & Bayles-Martin, 2000). Policy makers often view the arts as a frill when asked to assign a dollar value to areas of the curriculum. And it goes without saying that visual representations are most often associated with visual arts, despite the fact that the visual arts make up only one of many ways in which teachers use visual representations in their classrooms. Unfortunately, because visual representations often are aligned with the arts, they are undervalued or overlooked. The arts are not considered "basic"—often they are positioned on the fringes of the curriculum. Part of this positioning has to do with the subjective and affective qualities of the arts that render them noncommensurable and therefore uncertain. In a culture that values certainty, the ability to represent understanding numerically

provides a rational and acceptable means for determining worth. This happens because "We put our faith in numbers because they remove us from the stressful world of uncertainty into what we believe is the definitive world of truth" (Wassermann, 2001, p. 31). It is this certain (although uncertain) perspective on which standardized tests are based. Standardized tests are designed to measure "certain" knowledge deemed by "standardistos" (Ohanian, 1999) such as E. D. Hirsch "that every school kid needs to know" (1992). This view is limiting in many ways. First, this view limits what counts as knowledge by monopolizing wisdom and sanitizing or failing to represent rich and varied images and stories of diverse cultures. It makes certain images and/or stories more powerful while at the same time marginalizing others. In the book *Lies My Teacher Told Me*, James Loewen (1996) challenges common perceptions of well-known figures in history such as Columbus. He brings to light horrific and little known details about individuals our country has "herofied" for years. At the same time, Loewen demonstrates the degrading ways in which Native Americans have been portrayed. These stories were learned often unchallenged by students who were taught that there are standard questions and standard answers. In addition, a view that values the standardization of knowledge limits possibilities for student success outside of the college track. It makes the assumption that schooling should be about preparation for college, dismissing a host of livelihoods in which students might engage. "Standardistos ignore the fact that we need our students to grow up to become chefs, plumbers, child-care workers, musicians, and poets [and artists] as well as engineers and certified public accountants" (Ohanian, 1999, p. 3). In essence, standardized tests ultimately damage the possible futures of young people. Gardner warns against the kind of thinking that places intelligence within a vacuum of schooling that is unrelated to the making of a good life: "...after all, the score on an intelligence test does predict one's ability to handle school subjects, though it foretells little of success in later life" (Gardner, 1983, p. 3).

Despite current trends in standardization, visual representations have continued to find their way into the core curriculum through a

postmodern approach to literacy and an integrated approach to curriculum. As described in detail in Chapter 1, approaches to literacy from a multiliteracies perspective (New London Group, 1996) now includes visual representations among other symbol systems learners must grasp to be successful in the postmodern world. This is very important, considering the political power literacy continues to enjoy in the educational landscape. As one of the 3 Rs valued by policy makers, literacy (often viewed as reading) is considered to be a necessary skill to succeed in other valued core subject areas. Therefore, the alignment of visual representation with literacy may prove to be one of the most powerful alignments, from which visual representations may benefit in the future.

Certainly, approaches to the visual within a literacy framework vary, ranging from an arts perspective (Cecil & Lauritzen, 1994; Albers & Murphy, 2000; Berghoff, Egawa, Harste, & Hoonan, 2000) to that which couches the visual within contemporary forms of representation such as film, photographs, newspapers, radio, and television (Hobbs, 1997). As contemporary researchers realize the impact of popular culture on the learning of today's students, popular forms of media, often studied within the discipline of media studies, are finding their way into areas of literacy studies.

> In light of accelerated shift toward electronically mediated communication and social exchange in almost every facet of everyday life, the need for an expanded form of literacy, one that takes account of today's diversity of information modalities and media, is more crucial than ever. Media studies must contend with new information technologies and computer education needs the critical analytic tools and cultural framing approach typical of media studies. (Luke, 2001, p. 1)

Most recently, literacy researchers have encouraged an attention to "new literacies," for example, those found in digital technologies such as meta-literacies or cyberliteracies (Lankshear & Knobel, 2000) —all of which consider the impact of visual representations on learning.

On a more traditional note, there is no debate that visual images have a valued role in emergent literacy learning as young children begin making sense of their worlds through visual cues that inform

reading and writing. In fact, emergent literacy development is not unlike early "scribblings" identified by art educators (Wilson, Hurwitz, & Wilson, 1987) as stages of drawing development. In addition, many literacy educators embrace a whole language approach to literacy that finds spaces for creative learning that includes the incorporation of drawing and other visual processes to transform, challenge, and even disrupt the learning of language (Berghoff, Egawa, Harste, & Hoonan, 2000; Whitin, 1996). Whitin (1996) explains, "By sketching, one is forced to interpret the literature, especially when we define sketching as using symbols, color, or line to show the ideas or feelings in a story" (p. xix). Unfortunately, recent trends in standardized testing have heightened traditional approaches to the teaching of reading and writing, which has further marginalized the practice of visual representation in literacy learning at all levels. Marginalization of the visual intensifies as students move into upper grade levels where, over time, they are asked to replace image with text. The value of the visual decreases, while the textual increases. Coupled with an increased focus on the preparation for college entrance exams, students' engagements with the visual in schools have decreased even further. I find it almost ironic that at a time when young people are becoming credible consumers of mass media and popular culture, curricular standards and pedagogical practices move further from real-life engagements with media to more traditional approaches to teaching and learning. Hobbs (1997) explains,

> Our students are growing up in a world saturated with media messages, messages that fill the bulk of their leisure time and provide them with information about whom to vote for and what consumer decisions to make. Yet students receive little to no training in the skills of analyzing or reevaluating these messages, many of which make use of language, moving images, music, sound effects, special visual effects and other techniques that powerfully affect our emotional response. (p. 7)

In addition to newly emerging perspectives in literacy, integrated approaches to curriculum have dissolved stringent disciplinary boundaries in some schools allowing knowledge to become more fluid. Integrated approaches to learning, particularly popular to middle schools, invite visual representations into core subject areas giving

the visual value among core subject areas. This does not necessarily mean, however, that teachers consider the evaluation of the visual as important. Perhaps this truly speaks to the value of the visual.

Now, more than ever, we need to find authentic and purposeful means to assess and evaluate visual components without losing the personal, expressive, and aesthetic qualities that make visual representation so powerful. I refer to both "assessment" and "evaluation," because both words are used interchangeably by teachers in this study. Both concepts are part of what Goodman (1989) refers to evaluation as a dynamic transaction resulting in change or growth. "The dynamic transaction between teachers and students results in change in all the actors and actions involved in the teaching/learning experience. Evaluation—the examination of that change—reveals the development of the learning, the teacher, and the curriculum" (Goodman, 1989, p. 3). This view captures the dynamic quality and the complexity of evaluation that is represented throughout this study. Add to this complexity the interpretive quality of the visual, and our task to better understand the assessment/evaluation of the visual becomes quite challenging.

Key to making the visual more valuable is being purposeful about the way in which we use and assess the impact of visual representation on learning. For purposes of this study, assessment is viewed as ongoing. It is what teachers do all the time as they are continuously monitoring the learning of a student with the idea that teaching is revised and new directions are plotted. Assessment may be accomplished through authentic assessment strategies (Wiggins,1989). An authentic assessment approach

> ...involves dialogue with and among students and includes constant reassessment and ongoing self-assessment. Students are not, in these instances, passive recipients of the wisdom of teachers' judgments about their learning. They are active, engaged, and challenged contributors to their own learning. (Hargreaves, Earl, & Schmidt, 2002, pp. 77)

"Authentic" assessment is constructivist when it refers to "understanding first what students value and then building from there" (Ayers, 1993, p. 113). Hand in hand with a student-centered approach

to assessment is the belief that teachers and students should use a wide range of strategies to assess learning. These might include "alternative assessment," "whole assessment," "outcomes based assessment," "performance assessment," and "naturalistic assessment" (Tchudi & Lafer, 1996; Case, 1992). Most importantly, assessment serves as a tool to determine further teaching and encourage student and teacher learning. By contrast, evaluation requires teachers to assign a value to a work. The value we assign at that moment may represent a final response to student learning. It often requires the assignment of a grade.

Starting the Conversation

To conduct this research, I contacted teachers at a Langston Middle School (pseudonym) located in the small college town where I lived at the time. Past ties as a teacher, a supervisor of pre-service teachers, and a PTA board member gave me access to the site as well as considerable background knowledge related to faculty, the curriculum, and students. Based on these experiences, I recognized those teachers who not only incorporated visual representation into their curriculum but also were well respected as exemplary faculty members. Teachers included Donna, a language arts gifted specialist; Susan, an eighth-grade science teacher; Nora, an eighth-grade language arts teacher; and Linda, a middle-school art teacher. Donna has been teaching now for close to 19 years. She serves as a classroom teacher and a gifted specialist working with sixth, seventh, and eighth-grade teachers and students. Because the middle-school is fully included, Donna often conducts lessons with whole classes essentially working with all students. After school, she facilitates a voluntary writing group made up of approximately 20 sixth, seventh, and eighth graders.

Like Donna, Susan is a veteran of Langston Middle, where she has taught science for over 19 years. Susan is well known for her inventive and hands-on approach to teaching. She is a lifelong learner who has continued to take and teach courses at a nearby university, working closely with faculty members in a variety of research endeavors.

Her latest professional goal includes working toward certification with the National Board for Professional Standards.

Nora has been teaching language arts for 5 years, all of which have been at Langston Middle School. She is particularly committed to human rights, diversity, and multicultural issues, and strives to make those issues an integral part of her language arts curriculum. She works closely with the civics teacher to conduct a yearlong human rights study that includes an extensive exploration of the Holocaust. Nora has a special interest in drama and is currently exploring the use of drama and role-playing in her classroom. In Spring 2000, she directed a group of students in a production of a play based on the book *I Never Saw Another Butterfly* (Volavkova, 1994).

Linda is one of three full-time art teachers at the middle school. She has been teaching for 18 years and is in going on her 12th year at this middle school. Linda teaches 2-D, 3-D, intermediate, and advanced art to seventh and eighth graders. She has been instrumental in the success of the art program, seeing it grow from two to three full-time art teachers and the addition of new courses (intermediate and advanced), which she designed. Linda strongly believes that art is the center of the curriculum and promotes this view through continued involvement in interdisciplinary units.

For approximately one year, I spent time with teachers in their classrooms, assisted with lessons and collected data. Data included samples of student generated work (finger paintings, picture books, and drawings), teacher-generated handouts such as syllabi, project descriptions, and evaluation slips, and my field notes. In addition, I conducted interviews with each participant, took pictures of students working, and videotaped classroom activities.

Using Wolcott's (1994) transformative approach, engagements with data focused on evidence of teachers' perceptions of visual representations, the ways in which teachers use visual representation, and references made to assessment and evaluation. First, I conducted an auditory interpretive analysis, in which I listened to interviews and produced written responses (Charmaz, 2000). Next, interviews were transcribed and reread. I responded to the reading in narrative

form using a "writing as inquiry" (Richardson, 2000) process to further synthesize ideas. Transcripts were coded and indexed (Charmaz, 2000, Coffey & Atkinson, 1996), where codes acted as "organizing principles" to reveal terms and language used by participants (Coffey & Atkinson, 1996, p. 32). I then created a conceptual map (Carley, & 1993; Ryan & Bernard, 2000) as a means for thinking about codes in relationship previously explored questions, and to reveal categories, themes, and patterns. I not only looked at what was being said but also at how participants organized their thoughts, the words they attached to their ideas, and any discrepancies or contradictions that resulted.

In the next sections, I share teachers' conceptualizations of visual representation. I reveal ways in which teachers use visual representation in their classrooms and show how the nature of their disciplines makes their viewpoints distinct. Insight into their conceptualizations is critical to understanding how they implement assessment and evaluation strategies.

℘ DONNA ℘

Incorporating Visual Elements Purposefully within Language Arts Processes

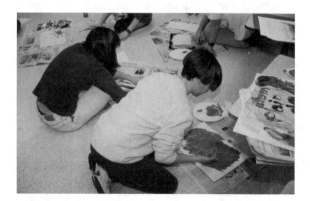

Scattered around the room, students work in various degrees of contortion—laying or crouching on the floor, legs thrown out while they create finger paintings representing their interpretations of Paul Zindel's play *The Effect of Gamma Rays of Man-in-the-Moon Marigolds* (1999). At first they work tentatively, carefully choosing just the right spot to place paint. Time passes and their comfort level soars as they begin to experiment by smearing, finger printing, layering and mixing color. Fingers slide quickly across slick paper. As I move around the room talking to the students, they gladly take me on walking tours of their paintings, thoughtfully describing why they used a particular color or shape to represent characters and/or relationships.

Activities such as these are common practice for Donna, who views visual representation as just one of many "tools" students can use to help them better understand and represent language. Donna recognizes that the kinds of visual tools one chooses and how tools are integrated within overall processes of learning can determine the effectiveness of visual representations. Based on this understanding, she carefully considers which visual medium will work best to communicate understandings she wants students to experience. In this particular project, Donna wanted to help students better understand the relational aspects between characters in the play and to encourage students think more abstractly so that they can represent their ideas more descriptively in their writing. She purposefully chose finger painting, because "finger paint is not literal." By using finger paint, students were forced to work like abstract expressionists, capturing their character in art elements such as line, color, texture, and shape (unlike a paintbrush or a pencil, fingers or hands free you to react expressively rather than literally). This worked well, especially considering the play was more about relationships rather than action.

In addition, Donna has discovered that the placement of the visual within a larger series of activities is critical. For example, she often takes students through a series of explorations in a single project. They may read the text, write reflectively, draw, and write again. In this particular project, students first read the play, and then construct lists of words describing the characters. Next, students select one

character and create a finger painting representing that character. After completing their paintings, students return to their list of words and select words that best support their painting. They write or glue descriptive words from their original list on their painting. Finally, students write a short paragraph describing their painting. I wondered how this kind of scaffolding impacted their ability to find simile or metaphor among visual elements when it could not be found before in language. I also wondered how this approach would impact her writing in the future.

Beth wrote this paragraph describing her painting pictured in Figure 20 at the beginning of the chapter.

> I did my picture about Beatrice, who stands out to me the most in this play. I found her paranoid and angry with the world. This is why I did lots of red. I also did the fire because of this. The blue dots were sort of a brick wall closing her off from the world, or the light. I did a white spot in the middle of the fire because it seemed like she was closing off the part of her self that was helpless and afraid. I did colored lines because she likes to draw attention to herself.

Beth uses her painting as a visual guide for explaining her text. She tries not only to give the visual elements such as color meaning, but also to describe the placement of visual elements to indicate the character's relationship to the world and others. This finger-painting process gives her new visual language to describe and (hopefully) better understand characters and their relationships in the play.

After implementing this as well as other similar projects in several classrooms, Donna came to the conclusion that it is best to create "the picture between the writing," because the visual process helps students tap into the words that they might otherwise be unable to find. Projects such as these have reaffirmed her belief that visual processes provide scaffolding that increases motivation and interest, improves comprehension, and fosters higher-level, abstract, and critical thinking. Like other teachers, Donna sees visual representation as a means for "leveling the playing field" across ability, allowing all students "to shine."

ഇ SUSAN ഇ

Visual Engagement within the Larger
Learning Cycle of Scientific Inquiry

Susan incorporates visual representations within a larger framework of scientific inquiry or a "learning cycle model," in which students often are given an array of activities from which to choose to help them better understand scientific concepts. Susan's conceptualization of visual representation includes, yet is not limited to, two-dimensional works. She defines visual representation as any form of representation that visually engages a viewer and/or creates "active" "interaction" between a viewer and a work or presentation. Susan explains,

> *When I think of visual, I think seeing—it is something that you see and the audience and the rest of the people in the class see.... Visual representation includes "active" visual engagement as mode for understanding where there's actually got to be a little more give and take interaction between the people who are watching it and the people who are a part of presenting it. It is sort of an active connection.*

In essence, visual representations might include performances, demonstrations, PowerPoint presentations, or music videos, as well as two-dimensional representations. These processes are considered visual by Susan because of their ability to engage the eye. "I consider when I have kids coming up with some kind of lab activity or demonstration to illustrate something that they are saying, I consider that a visual representation because it's hands-on and it's three-dimensional." Visual representations also may include two-dimensional representations such as a colorful quilt students created by experimenting with solvents and ink; cartoons or magazine cut-outs demonstrating an understanding of chemical reactions; game boards; or picture books. The picture book in Figure 22 is one example of the kinds of projects Susan's students may create.

By incorporating visual elements into a learning cycle of inquiry, Susan believes that students are given opportunities to tap into "certain interests and talents that they bring to the classroom." Because talents are "not all the same for us," choice is very important. Choice

allows students to decide which mode of learning best fits their mean-ing-making process. Susan explains, "I can't remember how many times in my 19 years of teaching I have seen a talent from a child that I would never had known about unless I had given them an opportu-nity to express themselves in that way." Susan believes that visual engagement can pique curiosity, support differentiation, illuminate talents, and provide a unique "window into a kid's view."

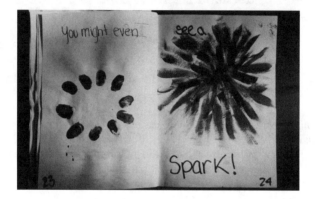

ඥ NORA ඥ

Internalizing Understanding through
Empathetic Engagements with Artful Processes

My Heart Skips a Beat
Gone
How could you be gone?
You fought for your country.
I stood and watched you go.
Each time you left, my heart skipped a beat.
World War II...
I hear on the radio, "The U.S. has entered the War."
You leave, my heart skips a beat...
 —*Sarah*

Riddled with questions, dotted with history, and achingly poign-ant, Sarah creates an image of love and loss through text. This poem was included in a signature book she created for Nora. Representative of the kinds of projects created in Nora's class, it was created from

colored construction paper, mat board, and duct tape. The book houses a collection of "words, pictures, poetry, phrases, research report, and anything else that [the students] think reflects the issue of human rights." It represents a culminating activity to an extensive human rights study that included the study of the Holocaust.

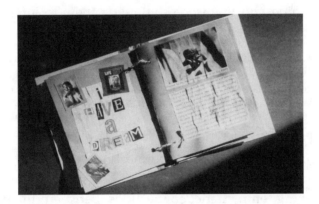

Nora constantly works to "deepen" students' understandings of language arts concepts and human rights issues by weaving together powerful literature, poetry, theater, and visual representations into daily explorations. Although visual representation plays a significant role in her curriculum, Nora speaks more broadly of "the arts" in our discussions. More specifically, she speaks of the emotive power of the arts to help students internalize understanding. "I am totally convinced that having an art type of component is a way for the children to internalize what they've learned. And then have a venue to express that and to show that is another learning mode and it's every bit as important as reading and writing and math and music."

The Holocaust, like other human rights issues, is often fraught with powerful images and textual representations of injustice. As a result, students commonly find themselves emotionally grazed if not deeply wounded by issues never before explored. Nora explains, "You're hearing about all of these atrocities and a lot of these children...it's for the first time and they are blown away...and what do you do with all of this?" This question informs Nora's practice as she looks to the arts as a means for helping students express and internal-

ize understanding on an affective level. "There is nothing...to me there is nothing like art to bring home a feeling. It's almost, it's a necessity, it's like another component." Based on her experiences, Nora believes that while traditional research papers help students collect factual information on their topics of study, artistic or expressive engagements help students make introspective and emotive connections between learning and themselves allowing them to internalize information in deeply personal ways.

> Research just because of what it is, is an objective form for looking into a topic. You don't use the word, "I." You don't say, "I think," "I feel." You don't say, "this is terrible and it makes me cry when I read about it," "People ought not to do these things." Well, that's what I think...that is what the art component does is...it internalizes. They write a research paper where they learn the facts that make you weep. But, they are not supposed to put their feelings into it because it is a research paper.

Internalization and affective connection is essential, considering Nora hopes to engender "empathy" in her students. Nora explains that by making empathetic connections between themselves and atrocities of the past, students might "realize that human rights and the Holocaust is about who they are today and what they do and how they behave." In other words, the arts serve as expressive scaffolding that taps emotive and affective ways of knowing so that students can begin to make empathetic connections to human rights issues.

Nora is successful at using visual representations partly because of the active role students play within the larger context of the classroom community as well as the investment she makes to artful processes during class time. For Nora, success has as much to do with access, respect, and support as it does with the exact representation of content. Nora devotes class time to artful processes and representation, reflecting the fact that she values and is willing to invest in these methods as a means to illuminate emotive elements of understanding. Also, by investing in class time, all students have access to materials that she often provides. "I think that it is also really important that you provide everybody the equal playing field. I can't stress that enough. Everybody must have access to materials." Also, by working in class, students have time to share ideas and to learn from one another, giving Nora the opportunity to kid-watch, talk with, and assess

students as they work.

❧ LINDA ❧

Capturing the Visual as Skill, Perception, and Art

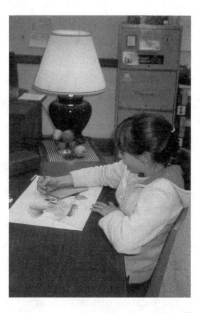

Still-life arrangements are placed strategically around the room. Some are traditional in nature, while others are made up of barebellied trolls, paintbrushes, model cars, and flags. Students crane over pencil drawings continuously glancing back and forth between their drawings and the still life they have chosen to draw. Visually, they explore the intricacies of the arrangements, transferring what they see onto a two-dimensional surface using a variety of techniques they have learned.

Anne chose to represent what may at first glance look like one of the simpler arrangements. A second glance reveals how light from an overhead lamp complicates and strengthens the play of light on the bowl while the reflection of the bowl plays out on the surface of the lamp. Subtleties such as these offer challenges as Anne strives to realistically represent what she sees. To achieve realism in her artwork,

she has studied and practiced the creation of value (light and dark), proportion, placement, and the simulation of texture. She has a repertoire of skills (the content of art) from which to work as she pulls from visual symbols to represent her interpretation.

This project is typical of the projects Linda teaches in her 2-D art classes, where she helps students learn how to represent understanding visually. Visual representation is at the heart of her content, so much so that when asked to define visual representation, she gave me a somewhat perplexed look. I realized that the visual was so much a part of what she does all the time, that I had asked her to describe her entire curriculum with one question. Linda talked through "visual" representation in this way:

> When you have art, you look at what other artists have done, and then you look at different styles. Then you look at those things around and you record those things the way you see them; the students' interpretation of what they see, whether it is representing a two-dimensional or three-dimensional object.

Linda's definition described visual understanding as a process that involves careful looking, the development of skills, and a look at the work of others in the field. Just as students explore poets as a means for better understanding how they might write poetry, students learn about visual representation through the study of artists. And, finally, in order for students to succeed as visual artists, they must develop skills that might include "reproducing implied textures, representing correct proportions, use of space, contrast, and so on."

Linda is passionate about the arts, and she works very hard to inspire all students to be successful. Like the other teachers, Linda understands the ability of the arts to reach "different learning styles" as well as its role in individual expression. "Art is important for several reasons. Some students do not learn by reading. If they just read something and they don't experience it with something hands-on, it's very difficult." At the same time, Linda recognizes the importance of language processes in her classroom and finds a similarity between art and writing processes. "Creating writing is just like the writing process. You break it down into steps. You have a plan—sketches, brainstorming. Even before you write you need an outline." Linda

encourages students to write imaginatively using unique points of view to describe their drawing or painting through a title for their work. Linda has "found that students have an easier time writing after they create their visual image. Because it is something that they have experienced, something that they can see, something that is there, and then they can write about it." Just as visual representation in content area classrooms works as scaffolding for helping students better understand content, language arts processes in the art room serve as scaffolding for helping students better understand art content. In addition, Linda uses it as a process for self-assessment. Like Donna, Linda studies the placement of writing within the larger process of art.

What I Learned

Teachers represented in this study envisioned visual representation as an art, a tool, and evidence of the understanding of content. These variations offer important considerations for assessment and evaluation of the visual. First, teachers describe visual representation as both a process *for* and representation *of* understanding. I make this distinction because visual understanding occurs at both the process and the product level, and even somewhere in-between. Language allows us to make these distinctions; however, the exact time when understanding takes shape along a continuum of learning often is vague. This brings up an interesting dilemma in the discussion of assessment and evaluation.

Second, content area teachers focus on the visual as a process used to enhance learning, rather than as a product to be assessed for visual qualities. Teachers are comfortable that understanding may happen along a continuum and that, to best understand whether a student has learned, they often have to look at several criteria (which may or may not include an assessment of visual elements). Therefore, assessment of learning is often determined by a variety of factors that include language-related activities as confirmation of understanding. For example, although Donna uses visual elements in processes, her

evaluation of learning lies with textual expressions of understanding as she seeks to understand whether students have "made connections" between their visual exploration and their new understanding of language concepts. This is clear in her discussions of evaluation and assessment as she relies largely on "how they describe their work" [the oral] to understand what they have learned. In essence, overall assessment of learning still lies with language. "I think assessment would just be in their discussion [of their visual].... If they can tell me why they choose something and why they put that on there, I think that is what I would assess more than their art work." In fact, Donna goes on to say, "accessing art I think to me is very difficult because what is right and what is wrong?" Susan describes a similar dimension of evaluation. "A student may present a final project for evaluation that does not in itself represent her understanding. Her learning is best demonstrated by her discussion of the project...this conversation is a critical part of the evaluation process." Like Susan, Nora talks about the role of conversation and language-based written reflection as an additional tool for confirming understanding. Part of this process is supported by Nora's commitment to having students work in class. As described earlier, it gives her an opportunity to talk to her students, assess their progress, and evaluate effort. Like her core colleagues, Linda incorporates language processes into her classroom. For example, she provides in-process checklists for students to assess their progress with the idea that they can go back and make changes. For instance, in the still-life critique, Linda asked students to answer the following questions: (a) Do you have at least 10 different values? (b) How many do you have? (c) Have you used gradation in more than one area? (d) Have you overlapped objects? In addition, students complete final critiques as a self-evaluation of their work. Critiques ask students to define terms such as "contour" or "texture" as well as evaluate values and textures represented in their drawings.

All these teachers express the need for visual representation to convey an understanding of content. Susan explains, "Critical to the use of visual or any other representation is the ability of representa-

tions to help a teacher know whether or not they (the students) have in fact assimilated to all the things or the bulk of things you had hoped they had learned. This is where assessment and evaluation tie in." Donna focuses on the content of language such as comprehension and abstract thinking that lead to better writing. She looks for students to "make connections" as they proceed through processes, as well as a change throughout the process asking, "Did they make a connection from their reading to their writing? Do they understand it?" Again, the focus is not so much on the visual; rather, it is on the content of language. Because Linda's content focuses on visual representation, it makes sense that her assessment and evaluation focuses on visual qualities.

Although teachers focus on content, this is not to say that they do not consider visual qualities in their final evaluations. For instance, Susan uses a rubric to evaluate students' picture books. This rubric contains the following criteria: content, language usage, and accuracy of information, illustration, neatness, and overall appearance. Like Linda, Susan asks student to complete a self-assessment of their final project, in which she asks, among other questions, what grade they feel they should receive and why. Nora assesses student signature books by looking at completion, effort, and selection of images. She assesses how well "the selection of images symbolize the topic" as well as craftsmanship. Craftsmanship might include whether or not pictures are carefully "thoughtfully cut out." Effort is defined as "going beyond or doing more." Effort might be demonstrated by "putting pictures on both sides" of the page or word-processing textual entries.

Like Nora, all of the teachers cite effort as important consideration in assessment and evaluation. Teachers are comfortable assessing effort because of their ability to kid-watch, talk to students in-process, and know their students. Susan explains,

You spend a lot of time with these kids over the course of the week, the months, and the school year. And if you are not paying close enough attention to be aware in a reasonable amount of time of where the kids' strengths and weaknesses lie and how you need to work toward that, then you are just teaching to the masses. You are not

really paying attention to the kids as individuals and you know it's easier to do that.

Conclusion

From this study, teachers from each content area offer clues that help us construct possible guidelines for thinking about the assessment and evaluation of visual representation. These guidelines include the following:

1. Reflect on your conceptualization of visual representation and how it fits with your content area.
2. Use language (oral or written) related activities in conjunction with visual representation to better understand learning that has taken place.
3. Carefully consider where, within larger processes, visual representation would best fit to aid in learning and, based on this role, consider the kind of assessment that might best be employed.
4. Carefully consider what visual medium is best suited to the goal of your lesson.
5. Construct and communicate specific guidelines up front to help students with the creation of visuals. "Don't assume too much."
6. Construct and communicate criteria for the assessment of visual representation at the beginning of a project. Criteria can be revisited and reflected on "in-process" by providing checklists and other self-assessment strategies. Criteria may change from project to project, yet they might include: (a) the demonstration of an understanding of content, (b) completion of the project, (c) effort, and (4) visual requirements (for example, include at least 10 images in your signature book).
7. Choose your words carefully. For example, if "craftsmanship" is a criteria, define carefully what this means.

It is my hope that these guidelines might inform your use of vis-

ual representations in the classroom or that they act as prompts for reflection and the development of individual guidelines.

I close hesitantly realizing that I have only begun to scratch the surface of this exploration. However, I do leave this research knowing that there is still so much to be learned. This study has begun to identify intricacies related to the assessment and evaluation of visual representation inviting new questions and further explorations that challenge me to tease out issues related to language, content, and criteria.

References

Albers, P., & Murphy, S. (2000). *Telling pieces: Art as literacy in middle school classes.* Mahwah, NJ: Lawrence Erlbaum.

Ayers, W. (1993). *To teach: the journey of a teacher.* New York: Teachers College Press.

Berghoff, B., Egawa, K., Harste, J., & Hoonan, B. (2000). *Beyond reading and writing: Inquiry, curriculum, and multiple ways of knowing.* Urbana, IL: National Council of Teachers of English.

Carley, K. (1993). Coding choices for textual analysis: A comparison of content analysis and map analysis. In P. Mardsen (Ed.), *Sociological methodology* (pp. 75–126). Oxford: Blackwell.

Case, R. (1992). On the need to assess authentically. *Holistic Education Review, 5* (4), 14–23.

Cecil, N., & Lauritzen, P. (1994). *Literacy and the arts for the integrated classroom: Alternative ways of knowing.* New York: Longman.

Charmaz, K. (2000). Grounded theory: Objectivist and constructivist methods. In N. Denzin & Y. Lincoln (Eds.), *Handbook of Qualitative Research* (pp. 509–536). London: Sage.

Coffey, A., & Atkinson, P. (1996). *Making sense of qualitative data: Complimentary research strategies.* Thousand Oaks, CA: Sage.

Flood, J., Lapp, D., & Bayles-Martin, D. (2000). Vision possible: The role of visual media in literacy education. In M. Gallego & S. Hollingsworth (Eds.), *What counts as literacy: Challenging the school standard* (pp. 62–84). New York: Teachers College Press.

Gardner, H. (1983). *Frames of mind: The theory of multiple intelligences.* New York: Basic Books.

Goodman, Y. (1989). Evaluation of students. In K. S. Goodman, Y. M., Goodman & W. J. Hood (Eds.), *The whole language evaluation book.* Portsmouth, NH: Heinemann.

Hargreaves, A., Earl, L., & Schmidt, M. (2002). Perspectives on alternative assessment reform. *American Educational Research Journal, 39* (1), 69–95.

Hirsch, E. D., Jr. (1992). *Cultural literacy.* Houghton Mifflin.

Hobbs, R. (1997). Literacy for the information age. In J. Flood, S. B.

Heath, & D. Lapp (Eds.), *Research on teaching literacy through the communicative and visual arts* (pp. 7–13). New York: Simon & Schuster Macmillan.

Lankshear, C., & Knobel, M. (2001, January). *Do we have your attention? New literacies, digital technologies and the education of adolescents.* Paper presented at the State of the Art conference, Athens, GA.

Loewen, J. (1996). *Lies my teacher told me: Everything your American history textbook got wrong.* New York: Simon and Schuster.

Luke, C. (2001, January). *Re-crafting media and ICT literacies.* Paper presented at the State of the Art Conference, Athens, GA.

New London Group. (1996). A pedagogy of multiliteracies: Designing social futures. *Harvard Educational Review, 60* (1), 60–92.

Ohanian, S. (1999). *One size fits few: The folly of educational standards.* Portsmouth, NH: Heinemann.

Richardson, L. (2000). Writing: A method of inquiry. In N. K. Denzin & Y. S. Lincoln (Eds.), *Handbook of qualitative research* (2nd ed.), (pp. 923–948). London: Sage.

Ryan, G. W., & Bernard, H. R. (2000). Data management and analysis methods. In N. K. Denzin and Y. S. Lincoln (Eds.), *Handbook of qualitative research* 2nd ed., (pp. 762–802). Thousand Oaks, CA: Sage.

Shephard, R. (1993). Elementary media education: The perfect curriculum. *English Quarterly, 25,* 35.

Tchudi, S., & Lafer, S. (1996). *The interdisciplinary teacher's handbook: Integrated teaching across the curriculum.* Portsmouth, NH: Heinemann.

Volavkova, H. (Ed.). (1994). *I never saw another butterfly: Children's drawings and poems from Terezin Concentration Camp, 1942–1944.* Schocken Books.

Wasserman, S. (2001). Quantum theory, the uncertain principle, and the alchemy of standardized testing. *Phi Delta Kappan, 83* (1), 28–40.

Whitin, P. (1996). *Sketching stories, stretching minds: Responding visually to literature.* Portsmouth, NH: Heinemann.

Wiggins, G. (1989). True test: Toward more authentic and equitable assessment. *Phi Delta Kappan, 70* (9), 703–713.

Wilson, B., Hurwitz, A., & Wilson, M. (1987). *Teaching drawing from art.* Worcester, MA: Davis.

Wolcott, H. (1994). *Transforming qualitative data: Description, analysis, and interpretation.* London: Sage.

Zindel, P. (1999). *The effect of gamma rays on man-in-the-moon marigolds.* Minnesota: Econ-Clad Books.

ABOUT THE AUTHORS

Lynn Bustle is Assistant professor in the Visual Arts Department at the University of Louisiana at Lafayette where she teaches art education. She has an undergraduate and graduate degree in art education from East Carolina; her Ph.D. in Elementary Education is from Virginia Tech. She has published in professional journals and presented at a variety of conferences. Her work is devoted to artful approaches to teaching and learning, topics related to image, inquiry, literacy teacher education, and qualitative research.

Elizabeth Altieri is Assistant Professor of Special Education at Radford University. She coordinates the undergraduate teacher preparation program in mental retardation and teaches courses in special education and strategies to support inclusive education. She has undergraduate and graduate degrees in special education; her Ph.D. from Virginia Tech is in elementary curriculum and instruction. Her scholarship is focused around her work with pre service and practicing general education teachers, and what is needed to help them feel comfortable and capable with students with labels of disability who

are included in the general education classroom.

Rosary Lalik is Associate Professor in the Department of Teaching and Learning at Virginia Tech, where she teaches courses in literacy studies. In 1982, Rosary earned her Ed.D. in reading and language arts education from Syracuse University. She has published her research in various professional journals such as the *Journal of Literacy Research, the Journal of Curriculum Studies*, and the *Journal of Research in Science Teaching and Educational Research*. Rosary is most proud of her contribution as a teacher. She is the recipient of the W. E. Wine award for outstanding university teaching and is a member of the Academy of Teaching Excellence at Virginia Tech.

Kimberly L. Oliver is Assistant Professor in Physical Education and Sports Studies at the University of Georgia. She teaches graduate and undergraduate courses in physical education teacher education. Her coauthored book with Rosary Lalik, *Bodily Knowledge: Learning about Equity and Justice with Adolescent Girls* is published by Peter Lang. She has also published in *Teachers College Record* and *The Journal of Curriculum Studies*.

Studies in the Postmodern Theory of Education

General Editors
Joe L. Kincheloe & Shirley R. Steinberg

Counterpoints publishes the most compelling and imaginative books being written in education today. Grounded on the theoretical advances in criticalism, feminism, and postmodernism in the last two decades of the twentieth century, Counterpoints engages the meaning of these innovations in various forms of educational expression. Committed to the proposition that theoretical literature should be accessible to a variety of audiences, the series insists that its authors avoid esoteric and jargonistic languages that transform educational scholarship into an elite discourse for the initiated. Scholarly work matters only to the degree it affects consciousness and practice at multiple sites. Counterpoints' editorial policy is based on these principles and the ability of scholars to break new ground, to open new conversations, to go where educators have never gone before.

For additional information about this series or for the submission of manuscripts, please contact:

> Joe L. Kincheloe & Shirley R. Steinberg
> c/o Peter Lang Publishing, Inc.
> 275 Seventh Avenue, 28th floor
> New York, New York 10001

To order other books in this series, please contact our Customer Service Department:

> (800) 770-LANG (within the U.S.)
> (212) 647-7706 (outside the U.S.)
> (212) 647-7707 FAX

Or browse online by series:

> www.peterlangusa.com